A LOVE LETTER TO
THIS BRIDGE CALLED MY BACK

The Feminist Wire Books
Connecting Feminisms, Race, and Social Justice

Monica J. Casper, Tamura A. Lomax, and Darnell L. Moore

EDITORIAL BOARD
Brittney Cooper, Aimee Cox, Keri Day, Suzanne Dovi, Stephanie
Gilmore, Kiese Laymon, David J. Leonard, Heidi R. Lewis, Nakisha
Lewis, Adela C. Licona, Jeffrey Q. McCune Jr., Joseph Osmundson,
Aishah Shahidah Simmons, Stephanie Troutman, Heather M. Turcotte

ALSO IN THE FEMINIST WIRE BOOKS
*Black Girl Magic Beyond the Hashtag: Twenty-First-Century Acts of
Self-Definition*, edited by Julia S. Jordan-Zachery and
Duchess Harris

The Chicana Motherwork Anthology, edited by Cecilia Caballero,
Yvette Martinez-Vu, Judith C. Pérez-Torres, Michelle Téllez, and
Christine Vega

Them Goon Rules: Fugitive Essays on Radical Black Feminism, by
Marquis Bey

A LOVE LETTER TO
This Bridge Called My Back

EDITED BY gloria j. wilson, Joni B. Acuff,
AND Amelia M. Kraehe

THE UNIVERSITY OF
ARIZONA PRESS

TUCSON

The University of Arizona Press
www.uapress.arizona.edu

ISBN-13: 978-0-8165-4408-0 (paperback)

Cover design by Leigh McDonald
Cover art: *Paper and Thread I* by Michelle Bae-Dimitriadis
Designed and typeset by Leigh McDonald in Warnock Pro 10.5/14, Ellington, and Agenda (display)

Publication of this book is made possible in part by support from The Ohio State University.

Library of Congress Cataloging-in-Publication Data
Names: wilson, gloria j., 1973– editor. | Acuff, Joni Boyd, 1982– editor. | Kraehe, Amelia M., editor.
Title: A love letter to This bridge called my back / edited by gloria j. wilson, Joni B. Acuff and Amelia M. Kraehe.
Description: Tucson : University of Arizona Press, 2022. | Series: The feminist wire books: connecting feminisms, race, and social justice | Includes bibliographical references and index.
Identifiers: LCCN 2021041162 | ISBN 9780816544080 (paperback)
Subjects: LCSH: Feminism—Literary collections. | Minority women—Literary collections. | Feminists—United States—Literary collections. | American literature—Minority authors. | American literature—Women authors.
Classification: LCC PS509.F44 L68 2022 | DDC 810.8/09287—dc23/eng/20211013
LC record available at https://lccn.loc.gov/2021041162

CONTENTS

ACKNOWLEDGMENTS

THIS BOOK would not have been possible without the support of Kristen Buckles, Monica Casper, Tamura A. Lomax, and Darnell L. Moore, along with everyone at University of Arizona Press.

A tremendous thank-you to our brilliant editorial assistants, Amber C. Coleman, Gia Del Pino, and Sharbreon Plummer, for providing thoughtful feedback along the way and contributing to the editing process. We are, indeed, indebted to the fierce writers, poets, and visual artists whose work inhabits these pages. We thank our foremothers, the original radical women writers of *This Bridge Called My Back*, who blazed the trail and inspired this text into being. There are few words that describe our humbled spirits.

A special heartfelt thanks to the Coalition for Racial Equity in the Arts and Education (crea+e). Their unwavering support and love throughout this project invigorated us to bring the book to completion. Finally, endless thank-yous to our family members for their sacrifices made and grace given to support this project. Much love, appreciation, and thanks to you all.

A LOVE LETTER TO
THIS BRIDGE CALLED MY BACK

INTRODUCTION

On the Bridge Between Intimacy and Collectivity

GLORIA J. WILSON, JONI B. ACUFF,
AND AMELIA M. KRAEHE

IN 1979, Gloria Anzaldúa and Cherríe Moraga introduced the world to *This Bridge Called My Back*. It was a trailblazing text that presented a vision of "revolutionary solidarity" for and among women of color (WOC). Assessing the conditions of their lived experiences and the experiences of other WOC, Anzaldúa and Moraga's youthful optimism propelled them forward to begin what would be considered a radical project to uplift what they referred to as "Third World Feminism." The WOC authors in *This Bridge Called My Back* introduced contradictory experiences of womanhood that are starkly different from the myopic mainstream narratives that once forefronted the women's movement. The narratives offered in *This Bridge* highlighted the varying social, cultural, and spiritual languages of WOC. *This Bridge* was a space of curiosity and experimentation and gave WOC the permission, and audacity, to develop and support theory and practice that attended to our intersectional experiences, thoughts, and movements.

Anchored by *This Bridge Called My Back*, *A Love Letter to This Bridge Called My Back* serves to elevate the lived realities of WOC living at the intersections of race, class, gender, ethnicity, and sexuality. Even more, it encourages WOC to be in charge of their own storylines, as well as reveals the ways our stories overlap, intermingle, and are relational. This kind of continual, concentrated relationship building amongst WOC is

significant because it results in fortress-like community strength that can buttress revolutionary, activist-oriented work. At its core, this book honors the legacy and central theme of the original Bridge. *A Love Letter* is a promise to continue Anzaldúa and Moraga's interventionist work, using the contemporary context as an adjusted lens. WOC authors in *A Love Letter* illuminate, question, and respond to new (and historic) political currents, progressive struggles, transformations, and acts of resistance and solidarity. It is imperative to advance the ongoing and ever-shifting conversations brought about by and with a new generation of WOC working toward what it means to be feminist conscious as women of color. With aims of bringing together a collection of voices of socially and politically conscious women of color of the Global North and South, this book is a continuation of the foundational work laid by Anzaldúa and Moraga toward gender and sexual justice. It serves as a site to generate, circulate, and preserve WOC narratives, as well as a space for renewal and healing.

In this chapter, we—gloria, Joni, and Amy, the co-editors of *A Love Letter to This Bridge Called My Back*—introduce the collection through a conversation. In it we reflect on our motivations for the book, our personal relationship with *This Bridge Called My Back*, and the social, political, and historical context in which *A Love Letter* came into being. The conversation, which took place via Zoom video conference technology in the summer of 2020, has been edited for clarity and brevity. Portions that were excised contain details of the project's formation and our philosophical meditation on the book. We hoped to avoid overshadowing the voices, experiences, and expressions of contributors with a lengthy introduction, and so we determined a P.S. or postscript at the end of the collection to be the appropriate treatment for our deeper musings.

AMY　　gloria, why did you feel called to return to *This Bridge Called My Back*? What made this the right time?

GLORIA　I discovered this text in the summer of 2017 when I was invited to write about transdisciplinary feminism. I recall the immediate and profound impact it had on me and my work. In reading each chapter, I experienced a range of emotions—joy, sadness, anger, to name a few. Joy because the writings resonated with me on a register that I had never experienced before. Sadness and anger

because of the realization that the text had existed for over thirty years, and I had never come across it before.

This Bridge gave me an expanded vocabulary to articulate living at the intersections of notions of racialized hybridity (a Black American father from Mobile, Alabama and an Asian Hispanic mother from Cebu City, Philippines). I not only have adjacency to Deep South Black Americanness but also of non-citizenship and migration from another country. I recall a visit from my mother in 2019 and my father's insistence that she carry her citizenship papers with her, so as not to be profiled and detained because of her appearance. Prior to the 2016 U.S. election, I don't believe my father would even think to articulate that insistence. The quotidian gratuitousness of state-sanctioned surveillance of human bodies reminds me why a book such as *This Bridge* was, and still is, necessary. What was also revealed to me on the pages of the anthology were the voices of all types of women of color, raised in passion and dissent. When I realized that the fortieth anniversary was approaching, I had a desire to connect with and honor these "radical" women writers.

AMY What do you mean by that?

GLORIA Meaning that the notion of a "theory in the flesh" resonated with me, deeply. I interpreted it as an embodied reality. Like Moraga writes, the physical reality of my life—skin color, facial features, and lands where my parents grew—have fused together to form a politic of necessity and experience born of resistance and refusal. Moraga provides an opening and articulation of what I have felt and not been able to give voice to smoothly. Joni and Amy, you both have heard me describe this feeling of being snatched—from one racialized identity to another based on my geographic location. Our "love letter" anthology is an attempt to revisit and articulate a contemporary theory in the flesh; to bridge a present-past and the complexities therein; to question what it is to be part of a "bodies of color" community operating within and into a still-whitestream feminist movement—what it means to center the voices of sisters of color, and in excess of the original writings. To insist other ways of being a woman of color in refusal of codified ways of being and knowing.

AMY It became so clear to me in my first reading of *This Bridge* that thought leaders can be found anywhere. The kind of writing that can be considered theory can take all kinds of forms. You don't need a full-length dissertation in order to put forward radically new and important and world-shifting ideas. That continues to impress me every time I come back to the book. It excites me, it's an inspiration. And to think about women, and especially women of color, being the thought leaders, I think is an important take-away for me. It's an inspirational piece for me. So, writing back to the original authors, in some sense, is how I think about our book.

JONI Well, to build from your last point, Amy, I connected to the book so closely because I felt like it realized, actualized, and operation-alized theory that I studied in grad school. I wish I would have had *This Bridge* as a companion text in my critical theory courses. It wasn't until around 2018 that I finally purchased the book after seeing it referenced in multiple papers I was reading about Black feminist thought. As I flipped through it, I realized that I had already read some individual chapters but not within the context of the entire book. Audre Lordes's piece comes to mind, for exam-ple. But I missed all of the gems in between, which were intimate manifestations of the things that I tried to wrap my head around in grad school.

Although I learned different theories in classes, I didn't always connect to them in ways that initiated a desire to dig deeper and learn more about them. This is even true about feminist theory. I have never called myself a feminist, for this reason. The disconnect was real. But after reading *This Bridge*, I could see how my actual body could be the theory, and the work that I was and am still committed to is Black feminist work. So, for me to see and read the stories and realize the theorizing that these women of color were doing just in their day-to-day lives, it was powerful. I never actu-ally named myself as a theorist, and then this book told me quite clearly, "You *are* theory." To be able to take on that identity was encouraging and propelling for me. I knew that my experiences as a Black woman from the U.S. South meant something, but this book supported that and gave me a language to articulate it.

Why aren't these stories offered alongside the "traditional" theoretical literature? Why aren't lived experiences used as illustrations for theory? That's why I've really made a point to assign chapters from this book and other books that narrate theory to my students. I want to support this kind of intimate learning that I feel I missed out on.

GLORIA The formatting of *This Bridge Called My Back* refuses traditional academic forms of writing and publishing. Joni, I think this relates to your question and points directly at the nature of academic institutional traditions. It seems that many institutional norms imply that the lived experience isn't seen or valued as theory; it's not seen as belonging within research, that it should not and could not be conceived as research or considered through a researcher's lens. We refuse these logics.

LOVE, A RADICAL ACT

AMY So why create a collection of love letters? What is the significance of that framing?

GLORIA Perhaps it's because I grew up listening to stories my mother told about my father writing so many love letters to her during their courtship! It signifies deep commitment to human-being and living.

AMY gloria, that sounds so intimate.

JONI It's *very* intimate. Meaning, it takes more time and effort. When you think about a love letter, you don't think about somebody typing something out on a computer. You think about a handwritten letter, in cursive. It's a romanticized representation of something mundane. It is illustrative of how something so simple can be presented in a profound way. Crafting a love letter is time-consuming, it takes effort and intentionality, and it also takes patience. It's a different kind of energy, meaning that it's an opportunity to be vulnerable in ways one might not be face-to-face.

AMY The intimacy that's conveyed and captured in a love letter can, like you said, Joni, be about quotidian happenings, but life's texture and

complexity are contained in the everyday. So much insight can come from sharing the small bits of life. Those bits are passageways to deeper levels of understanding of another person and their condition. They are symbolic spaces for relationship, and those spaces are opportunities to touch or come into the presence of another being.

gloria, you said that your dad wrote love letters to your mom. We now have digital technologies that allow people to engage with each other very quickly all the time through text and social media, but a love letter is a classic form that has existed across time and in different geographic and cultural locations. It is inflected culturally and differently depending upon who is writing and the tradition that they come from, but it endures as a classic form of dialogue. I think that is important here. This book is in conversation, a deep, committed kind of conversation with the original *Bridge* authors, and with thousands of other folks. If we look at the number of Google citations for *This Bridge Called My Back*, it is in the thousands, and they keep climbing every day. That is just citations, to say nothing of the incalculable numbers of other readers who thumb the book's pages each day. So *A Love Letter* is in conversation not only with the original *Bridge* writers but also with everyone who is reading that text and, like us, is passionate about theory in the flesh, sensing and making sense through aesthetic forms of philosophy, knowledge, communication, and collectivity. That is exciting to me, and maybe it is only possible through a love letter.

GLORIA Yeah. You know, as I was thinking about this question, I was thinking that one has to be vulnerable. So when I think of a love letter, I think of it as a radical act of care. It's like humbling yourself to someone else, opening yourself wide and performing an act that is so private and personal. You know, a love letter is not intended for the world to witness, necessarily, although there are examples of public pronouncements of love. In all, it's intended for the recipient in a very direct manner.

When I think about love letters that I have written, I recall including traces of myself in the form of swatches of fabric from clothing or artwork, with the intent of distilling, suspending, or cementing a memory. In the case of this *Love Letter* anthology, my desire was to offer an extension of the sentiments tied to the

expression of a love letter, and yet I felt the need to share a space and record it collectively and in material form—record it with others for whom the original book has made an impact. In doing this, the question I thought with and attempted to answer was: *What opportunity might be created as an acknowledgement of thanks for each of these women, for their work and its impact on my life because it may not be possible to do so in person?*

My response was to attempt a collective love letter, as an insistence *for* radical love for women of color in the wake of forced silences and settlements via colonialisms and imperialisms; it is an aesthetic pronouncement—an outward declaration of gratitude. But in excess of this, to create an archive of collective voice. Moraga and Anzaldúa would refer to the contributors to *This Bridge* as "women from all kinds of childhood streets," who speak to past, present, and current conditions of life in and into the afterlives of containment, migration, silencing, diaspora. For the contributors of the original text, *This Bridge Called My Back*, who are still present in this life and for those who exist with us in the afterlife—this book serves to express that I am thinking *about* and *with* them; thinking with their thoughts and sentiments and creative pronouncements, which reveal the conditions of their existence forty years ago. This *Love Letter* might illuminate traces of what is still occurring and what might emerge as contemporary conditions and our current moment. And that's what is, in my opinion, the most radical act of care, like we said in the beginning. Like Joni said, it's something that you put energy into, writing it out.

AMY　Along the same lines as *This Bridge*, a collection like this one can be healing for so many people. Many contributors returned to the idea of bridges and bridging. Can a love letter be a bridge? Here I'm thinking not only of connection but also healing. Love letters heal in ways that may be different from bridges. Bridges enable us to move and transition. They connect one realm to another because they are liminal spaces, in-between spaces. But love letters might do something else. So in that sense, *A Love Letter* does not seek to replicate *This Bridge*. It is not an addition to a series or an attempt to replicate the original text. It is intending something different and for a very different moment in time.

WOMEN OF COLOR: EXCLUSIONS OR EXCESSES?

AMY I think one of the challenges of crafting *A Love Letter* may be a universal challenge of putting together a collection like this. Our strengths, our social and professional networks, and the platforms we tapped into when spreading word of the project also set limitations on the book. As academically trained writers and artists, we thought a lot about how not to inadvertently call forth other academics since our intent was to be much broader than that. There are other ways in which our positionality, our age, and our life histories were assets, but they also placed constraints on the project. We brought in students whom we know and work with. They are a generation younger than the three of us, and they brought a whole different way of thinking about how to further open up the collection to an even broader range of voices, perspectives, and experiences. Their contributions were invaluable to the reviewing process and to tapping into communities to which we do not have access or relationships. There are still gaps in this collection. Perhaps additional *Love Letter* collections that can fill those gaps would be a good thing, so there might become a portfolio of *Love Letters*. The limited number of international pieces and the fact that this collection is in English are indications of that need for more collections.

GLORIA Yes, and the articulation "women of color"—how do people, in general, understand that concept? How do we as North Americans understand it? How are we defining it, or how have we defined it? And what does that term mean when we talk about including voices of women of color? There's one piece that does include a white woman. It's a collective voice of women who insist that they write together. Considering the past and recent instances of racial identity co-optation, by the likes of the "Rachel Dolezals," I did not know how to process it. While the collective voice is not an example of co-optation, these are important experiences to think with when considering how to unpack this concept.

JONI How did we negotiate that?

GLORIA Well, they're not named individually. They're named as a collective.

AMY One of the desires we had for the book was to assemble a collection that would address themes related to Global North and South women of color feminist experiences, visions, and practices. We did not define what "women of color" meant because the book was not necessarily about identity. The emphasis was on experiences. It was on visions and on practices. It depends upon how one is politically situated, geographically and culturally located, and socially positioned. For example, what does it mean to be a woman of color in Brazil? That same person's self-concept, their self-identification, may not translate in the United States, or it may not translate in parts of West Africa. In other words, categories of personhood surely differ from one context to another.

JONI Amy, to me this calls to mind the most recent cases (in 2020) of white women in the U.S. who were called out in the national spotlight for "trying on" and profiting from a Black identity. Let's name them! Jessica Krug, a Jewish white woman who co-opted Blackness, specifically an Afro-Caribbean identity, and gained employment as a college professor of African and Latin American Studies at George Washington University. Then there is CV Vitolo-Haddad, an Italian American non-binary graduate student at the University of Wisconsin in Madison who toggled between being Black and being Latin depending on context. Vitolo-Haddad used these identities to insert themself into Black organizing spaces and to gain social capital within the antiracist organizations they belonged to. These stories of racial appropriation illustrate the continuity of sustained violence against Black women and the ongoing theft of our bodies. One of our *Love Letter* authors, Tyiesha Radford Shorts, wrote a poem about Rachel Dolezal, the very first internationally recognized white woman thief who assumed a Black identity. Dolezal taught African Studies in the university and even headed her local chapter of the National Association for the Advancement of Colored People (NAACP).

In her poem called "For Rachel Dolezal Who Performs Black Womanhood When White Privilege Isn't Enuf," Tyiesha shared an impassioned rage against this type of "body snatching for profit" by white women. Meanwhile, Black women are punished, neglected,

and even abandoned for inhabiting their bodies. Tyiesha's words scream from the pages, and you can feel the aches in her body. We want to avoid reproducing that kind of trauma, which can be triggered by inviting (or welcoming) white women to take space in this communal conversation. Therefore, I think being open to honoring experiences is important, but we must also be extremely careful about this idea of self-identification. Is it safe to say we don't believe in "transracial" identities?

GLORIA Yes!

AMY Hell yes!

GLORIA Loretta Ross explains the concept "women of color" in a way that it is not a biology-based description but more so a politics of solidarity. Her description was sparked out of Black women's concerns at the 1977 International Women's Conference in Houston, Texas. Black women insisted their concerns be placed on the agenda. So other women of color, who had also been excluded, found that they, too, benefited from the insistence of these Black women. My engagement with Ross's articulation has really helped me think about the concept women of color. It does not exclude biology, but it is actually in excess of that understanding.

MULTIPLICITIES—VOLUMINOUS AND COMPLEX

AMY Another challenge in crafting the collection was how to organize it. We received a large volume of submissions, and many were thematically complex. They were not simplistic pronouncements that were about one thing only; rather, they were intersectional and looked at the interdependence and interaction of social structures and identities. Whereas some books are organized by geography, ethnic identity, or racial identity, that was not possible nor desirable with this collection. The contributors expressed multiplicity in the experiences they were drawing from and describing. Therefore, the chapters seemed to demand an organization that would recognize the larger themes contributors were wrestling with. On top of that, many chapters easily could have been assigned to two

or three other sections. So, we had to make certain decisions about how to group the chapters and which pieces should dwell next to which other pieces. Surely there are other ways in which the collection could have been curated, but those complexities are part of what we wrestled with.

GLORIA I think an exciting, yet quite challenging, aspect of assembling this collection was the sheer volume of contributions. We've talked about this before—the call yielded numerous submissions! This speaks to the impact that the original book has made. I wish we could have made time and space to accept them all. There were many powerful narratives, yet some were not a perfect fit for our present collection. It's never easy to turn away contributors.

AMY Right!

JONI Well, I think the sheer volume of contributions is itself a testament to how many stories are out there, sitting idly, waiting to be shared. Yearning to be shared! And at times, *needing* to be shared for healing.

ALTERED REALITIES

AMY We also grappled with which publishers would be able to understand the significance of the project as well as support the published work in getting to the right audiences. On top of that, the book project overlapped with the COVID-19 pandemic. Many of the writers and artists contributing to the collection were of the same demographic groups who were most negatively impacted by the failures of governance, failures of the healthcare system, failures of social services and housing policy—all the things that oppress in any given year. This year in particular was, and continues to be, devastating. So our need to be adaptive had to be balanced against the urgency to get the book into publication so that people might find in it some hope and healing. To see our own experiences through another prism can stave off despair, help us feel less alone, and give us additional strategies for moving forward.

GLORIA Amy, I think what you have said about publishers and audiences is important. Many of the writers and artists contributing to the book are creatives (poets and visual artists), and we have discussed the possibilities of publishing and how the powerful visual work might be amplified and represented. And yes, your mention of COVID [deep sigh]. Many contributors necessarily requested extensions beyond our original deadlines. Since the pandemic, many of the contributors needed to be caregivers, in different ways, to their families—needing to care for elderly parents while also caring for their children and other loved ones, while simultaneously needing to maintain full-time jobs. In thinking about what this book project aims to do, which is allow for certain voices to be amplified, we have also needed to be flexible in the midst of these conditions to allow contributors extra time to submit something for the collection. We tossed out old timelines and deadlines in order to offer support and solidarity for their work to materialize.

JONI Everything is happening so fast, though. As soon as you write about something, days (or even hours) later, your situation may have changed. It's always a moving target when you are writing about lived theory. Our experiences as women of color are always transitioning. So, I appreciate and have deep compassion for the women who are attempting to push the stop button on an experience and share a piece of it through story. The rawness of their experiences may impact their submission deadline, but also, it most definitely impacts the stories. These complex stories are those that readers will be able to connect with, or at the very least be empathetic to.

GLORIA I agree, Joni. There was an author who seized the moment to shift, not only the content of her writing, but also the form in which she represented her concerns. She wanted to write a *testimonio* instead of her original. So, I think what you say is true. The many aesthetic pronouncements, which have been offered to this project are truly powerful responses to the current moment.

PART 1

Taking Heed of the Sacred, Spiritual, and Ancestral

1

OLD AND BLACK, A PRAYER

CHARLENE A. CARRUTHERS

I will watch my relatives
grow old

so old
that they remember
battling twenty-five tyrannical presidents

so old
that they know
paper food stamps and free land

so old
that they meet
my great-granddaughter's daughter's best friend

so old
that they remember
that one time so I don't have to

so old
that they watch
this empire fall and never strike back

so old
that they rest and witness
us win.

2

UNBOUGHT AND UNBOSSED

Black Womanist Resistance

KEYA CRENSHAW

Rågē

When you so casually and callously call me Negress
As if the word has been on the tip of your tongue for a
 millennium
I bite my lips
Until blood pours forth like the Nile

Because I am not the dancing minstrel you need me to be
My resistance takes other more volatile forms your eyes cannot
 see
But
I don't scream
I have never screamed
If I were to scream it would annihilate everything that was, is, or
 ever shall be now
until the end of time

Tîmę Immēmôriäl

We
are at war
A daily choreography of battles fought and never won
a bloody and consistently unforgiving assassination that has
 lasted for centuries
my mind is overcrowded with recurrent and dark ancestral
 memories
Fragmented and cracked and half understood
The odds are stacked against us
still
Because as Mother Lorde said
We Were Never Meant to Survive

You see
Time is unforgiving
and Black America has been in a state of emergency since 1619
When the first ships full of enslaved and already-dead bodies
 reached the virgin shores
of a new life they didn't ask for

Learning to half thrive in a world not made for us

a sinister utopia created to break and degrade us
Making us delete our long ago and recent memories
repressing all our histories
Forget they said
let go
you
are the enemy

But I remember
It lingers on the fringes of my reality
Fragile and split and vague
Refusing to be silenced in the light
Forced to survive in a world that was not made for me

But
My ancestors
both the dead and undead
the buried and the yet to be reborn
walk the great migration up the back of my throat and their words
 spill out of my mouth like the blood they shed to build this
 land
I can no longer live in persistent silence

And yet
as time passes by
we still mistake violence for a safe space because it's all we have
 come to know
all we have been allowed to feel
Lynchings and shootings and hunting
See I'm confused
Is this the 21st century or 1760
Because not much has changed as far as I can see

Black bodies gorged and broken
still swollen still deformed
Still swinging
Still
swinging
still
swinging
from the magnolia tree
the krick krick krack of the frayed leather noose
white petals covered in thick black blood
There's no way this is the dream of Doctor King
deadly and depraved and obscene
This can't be what the revolution is meant to mean
Swing
Swing
Swing . . . swing
Still . . . swinging
from the magnolia tree

Rësistâncė

Born of voodoo spells and moon dust
Of Bayou Magic and third sight
Of soothsayers and root workers and divinity times three
I
am rooted in the teachings of the universe
In histories and my people's cries
In the Middle Passage
In rebirth

I can't put it down

Visions of sweating wet hot sunbaked skin
cracked and beaten
Rivers of sinew and pus and bowels stain and mark the red earth
The memory of a former life gone forever
Sankofa
to go back and fetch

I can't put it down

The blood memories of slit throats and shattered teeth
Of chains forged from the heaviest iron that choke and bind
 headless bodies
are documents I carry through many lifetimes
A currency for passage
death is an old friend and more often than not
a very welcome visitor

I can't put it down

An unrehearsed fight for survival
suspended midair
someplace between terror and hope
We could only halfway heal our septic wounds with choked stac-
 cato melodies and promises of a brighter day

Swing low, sweet chariot
but
nothing came to carry us home

I can't put it down

So
you can keep your shaded condolences and silent prayers
as ghost bullets shatter the dreams of our next generations
the Ancients reveal to us your true nature
The delight in filling our lives with endless pain and sorrows
 bound in joy
A gift wrapped and tied pretty

I can't put it down

If left up to you our destiny would be to become collectors of
bones and grief and too many stories left untold
halted mid-existence mid-sentence
The beautiful unborn ones escape if as by magic
thick feathers snapped and misshapen
flutter against a cerulean infinity
escaping before it's too late

I can't put it down

Because
like the old
your new mouth speaks strange words of hate
unintelligible to our Ancient ears
We cannot understand your disjointed language of a twisted
 tongue that cannot form the syllables of our names

I can't put it down

Centuries pass, and we learn to interpret your double meanings
We

being of a different time a holy place cannot conform to deception
but old habits make new friends
and this is your most clever ruse

I can't put it down

Despite your deception
I am ancestor adjacent
My foremothers passed on the power of Oya & Oshun
Of Yemaya & Oba
of Eshu
Shango
Olódúmaré
My soul bones vibrate too high for you

I can't put it down

And there's a price to pay when you don't pay the ancestors
what the ancestors are due
So daily I give them my offerings to end your torment of my kin
Because we are the next generations
The future
The chosen ones of the Orishas
The first of our name
Ashé.

Bēn•ë•dic•tiôn

Tell me your soul story

Demanding
A disoriented language of yes and please and missed
 opportunities
(Sorry | Ma binu)
How does it speak
Flickers

Of sharp-tongued memories from our past lives enter my third
 eye
You are
(Love | Ife)
Come as you are
Bright
Like the hot summer sun glistening on wet pavement
(Peace | Alafia)
We met years ago & even before that
A welcome salvation
You showed me Jinn & Orishas & time
(Promise | Ileri)
Brown skin on brown skin
united and consecrated and divine like the blessed sacrament
(Holy | Mimo)
We believed we made it
This time this century
despite the nuclear war against our love
right now in this union
no lynchings no shootings
lucky us
so we become greedy and hopeful
(Success | Asevori)
Needing another morning and another and another
But
Tomorrow is today and we're only closer to being farther away
 together
(Lost | Sonu)
Because
Black man
they are vehemently hunting you
Because
as Black woman
they are relentlessly breaking me
(Paradise | Párádísè)
Here
in this lifetime and in this world

when it comes to our Black Love
Nothing is certain except obstacles and pleasure
divinity and pain
The weight of many histories
running far apart together
to where now meets forever
(Fear | Iberu)
But what they did not count on was the ability for Black Love to
 withstand all the tests of time
A smokeless flame in the distance shines
dances and guides us to ourselves
Joined
back together
Burning atop rough waters
(Light | Imoleina)
You
Are my favorite season

Made of dreams and home and passion
(Madness | Isinwin)
I don't fear our destiny
because maybe I was just born of two bodies
believer and atheist
both healer and assassin
Unbounded in hope and grace and favor
Simi
(Breathe)
(Breathe)
(Breathe)

3

ALIGHT

ELIZABETH JONES

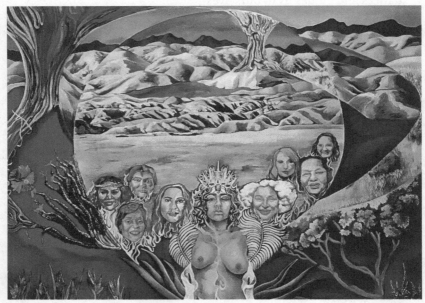

ALIGHT, 2020. Oil on canvas, 36 x 48 in. (91.4 x 121.9 cm)

The painting is a loving acknowledgement of my journey from attempted self-erasure toward accepting, embracing, and nurturing my magical nature. I am preceded by teachers, healers, and community builders. My great-great-great-grandma Ton Ton was a medicine woman for her community. My grandma Jo, a teacher and mother of over twenty children and grandchildren, had a vision of her deceased mother veiled in glowing brilliance. Women in my family share stories of premonitions, of being

moved by the spirit, of heeding the warnings of their intuitions. Since I was small, I have cultivated faith in pain, knowing loss to be inevitable. Never believing that I deserve the love given to me. There is so much strength in receptivity, in being able to feel and understand. Like my mothers, I have done this for others. I am learning to feel and heal my own body and spirit. I am learning to build a home, an anchor within myself that acts as a compass and a shelter. There is a healing light inside, an unrelenting resilience, that burns even when I close my eyes to it. This painting is looking deep into my reflective eyes that shine light onto the parts I have hidden, ashamed of feeling so much. This painting is me and my mothers blending with the trees, rocks, beetles, and stars who have kept me company and made me feel welcome on the earth. It is the fire of fierce love in my gut running up through my heart to form a crown. It is me listening and translating unspeakably large feeling into color and line that come alive. This is an opportunity for me to express my vast unseen, unheard experiences. To create a bridge for them to move into something that can be more readily, tangibly, widely experienced.

4

THIS IS MY BODY, THIS IS MY BLOOD

Reimaging Ritual in the Creation of
Mexica-Feminine Sacred Spaces

RAQUEL HERNANDEZ GUERRERO

. . . Our altars are literally fed with the stuff of our wombs, our children and our blood originate in the same space . . . and we merge ourselves in a ritual act of earth giving, of soil blending, of utterances . . . they are all connected, a oneness of space from which we emerge, renewed, re-created, reimagined . . .

My daughter digs out the cold earth with her tiny, child hands and fingers. We work together, intent on creating meaning in the earth. Beneath overhanging branches, a naturally occurring alcove exists, a gentle roundness folded over the air by skeletal wisps. Come springtime it will fan out as an overhanging belly of leaves sprinkled with light between the green. She carves out a circular pattern in the earth, "a spiral," she insists, and we decorate it with white quartzite stones found scattered throughout the yard. Reverently, she places feathers at the base of the center of three small stumps. Later, my son creates an enclosure out of dead branches to surround the sacred space. We add a *vela* with the image of La Virgen de Guadalupe imprinted upon it. Later, I bring a medicine offering of sage, full of the past of the beginnings of my children. I kept it for years as it slowly turned to feathered

dust in my home. Sage that I grew, crushed, and placed behind my ears (to listen) and held to my breasts (to breathe), brought to my face, burned, and inhaled in movement to birth my children.

The seasons move and the sage I seated at the foot of La Virgencita, Tonantzin, becomes scattered by snow, wind, rain, and time, eaten up, carried away, buried as nourishment. To bury is a sacred act. To scatter is the stuff of Ollin, a cosmic movement, a dance of medicine. Such disintegration is not a loss, but an eventuality, a coming together of medicine that came from the earth and now returns to it in scatters. My son's carefully placed branches are likewise bent by the elements and disassemble their placements, waiting to be replanted in the earth again by his careful hands. The placement of the sticks is his offering, a quiet way he may participate in the creation of the space. This is no static altar, it is full of movement, of the elements, of the animals that move through it, a ritual space fed with the offerings of a mother and the prayers of her children.

A lightheartedness accompanies the heart of my daughter as she moves through the grass and weeds barefooted with me to bring our little offerings to the earth. Each month, during my moontime, we make a tiny pilgrimage to the backyard altar to make our offering at night, and it is there we offer up the blood of my body.

. . . this is my body, this is my blood . . .

When Coyolxauhqui—the (dismembered) moon—is shining, we make our humble offerings, and She receives us. I explain to my daughter that the cycle of the moon is twenty-eight days, a sacred cycle that our bodies replicate and that we carry the moon within us. I explain how we possess the ability to carry an ocean inside of us that moves with the moon, an ocean that nourishes and brings forth life. The mystery of it fascinates her, and it is a moment of sacred education. She is only six years old, and she has been accompanying me on these journeys of offering since she was a baby. Our previous home (her birthplace) is the site where

half of her placenta lies buried, under a now-withering cherry tree in the old backyard. The other half I ingested, raw, sinuous, and mixed with berries. In this way I carry half of her double with me, the other half of her double remains forever a part of the space upon which she was born. As I offer my blood, I invoke my ancestors and the divinity of La Virgen de Guadalupe/Tonantzin (*virgencita/madre de tierra*), Coyolxauhqui (*la luna desmem-brada*), and Coatlicue (*madre de la luna, de las estrellas, madre de teteoh*). Utterances of thankfulness and requests for protection and blessings to ensure our connections to the earth and to each other remain close. Spirit ancestors in the form of birds, moths, rabbits, or insects always make an appearance . . . *tlazocamati, el es dios* . . . When my daughter offers *la palabra*, a whirlwind radiating love moves through her with an honest and full child's expression of ritual. At times she incorporates a slow series of movements she invites me to follow, along with some whispered invocations to spirits and ancestors. It is in these movements and whispers that I am witness to something powerful, to the origins of ritual itself . . .

We leave our space, regenerated, renewed, the feminine corpus re-collected and re-membered. When we create sacred spaces with our children and offer our moonblood / womb blood to the earth, we imbue them with a sense of the divinity within their own bodies, and of their intrinsic connection to the earth. When a life-giver's womb blood spills into the earth, it is a womb blood that the child is eternally connected to, centered from the place of their origins. Mixed in with the dirt, we embody a rootedness to the soil—intrinsically linked to *madre tierra*. The creation of sacred spaces accompanied by ritual acts that honor the femi-nine are viscerally beautiful and crucially necessary as we live in a culture shrouded in feminine shame. We are raised in a society that debases, distorts, and dishonors the blood mysteries of our bodies. We must look to our indigenous ancestral traditions to re-member ourselves as life-givers, where all manifestations of nurturing and mothering are intrinsically connected to the earth and to creation itself.

In the tradition of my Mexica ancestors, childbirth was concep-
tualized as a celestial battlefield from which the child was pulled
from the stars, out of the spirit realm and onto this earth. When
we mix our womb blood—thick liquid of life force—into the
earth, we are blending ourselves into the earth. Our wombs are
spaces that inhabit the spirit world and function as conduits to
the cosmos and the underworld. While in labor with both my
children, I not only inhabited that liminal space, I became it, an
in-between crossing between the material and the spirit, and
only in that space could I bring flesh into life. Becoming simul-
taneously nonmaterial and animal, liquid and solid, "I" was both
dissolved and replaced, aided by a spirit I have come to associate
with Coatlicue. I learned the *danza de Coatlicue* while pregnant
with my son, and it was her *danza* that allowed me to under-
stand in a visceral way how to give life to life, how to morph and
move as a double-headed serpent in a dance of life and death. It
was an embrace of duality, an absolute tearing apart and coming
together. *La danza de Coatlicue* is one of transformation and life
giving. It is a dance of destruction and creation. Through *danza*
my body became sacred space. Through the ritual acts of preg-
nancy, labor, and birth, the body becomes ceremony.

While in the full tilt of my moontime, I sometimes embark on
a journey aided by sacred medicine. Recently, when twilight
moved into night, the combination of the sacred medicine with
my moontime allowed me access to the powerful and numinous
space of the spirit world. I knelt weeping before a tree whose
branches were lacework, enshrined by three old spirit women
of various sizes at its base, their long, greyed hair and bodies
fused with the skin of the tree, rough, long, grey. The violet night
sky materialized images of La Virgen, and the divine feminine
in every manifestation. Her stars moved together and back in a
forma of fractal perfection, a weaving of the threads of the cos-
mos. Her children surrounded me as images of the feline, the doe,
birds, elephants, and the rabbit appeared in the trees, sky, and
space. On a previous journey, I encountered a doe in the moun-
tains, and this doe and I shared a close space for what seemed

like an eternity. Time was motionless as our eyes locked and we moved towards each other slowly. It was a moment of sacred communication and connection of feminine spirit. As I relate these stories to my children, they receive them as only children can—beyond an innocent faith, they are fully accepting of the mysteries of our interconnectedness to the natural world.

Our cells and the cells of my children are a part of the earth and of the cosmos. As my life-giving blood mixes with the earth, my children and I become conduits, existing as connections to the underworld, the earthly plane, and the cosmos; we become a sacred umbilicus. As my ancestors before me, I traveled to the spirit world, to the cosmos to pull their little spirits from the stars and the liquid of the cosmos. We pull creation from the cosmos, from Ollin. Our children originate in a primordial space which is the spirit world of our wombs that simultaneously inhabit and are habitat for earth, waters, and the cosmos. As conduits and connective tissue to sacred realms, our wombs become axis mundi.

5

TALES LEFT UNTOLD

Tribal Women and Their Windows to the World

AMI KANTAWALA

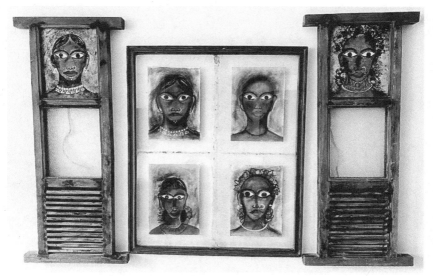

Tales Left Untold, 1996. Enamel and gold on copper with wood and glass, approximately 48 x 52 in. (122 x 137.2 cm)

This work was inspired by Indian tribal women. Growing up in Mumbai, India, and often visiting interiors of Indian villages on school trips, I had vivid memories of these women, their beautiful jewelry and strong character. Untouched by the life of the city, these women carried within them a sense of pride and cultural connections. They were comfortable in that

space and in being who they were. I often wondered about their lives and imagined their gaze looking out of the beautiful wooden windows in their village homes. Did these women want a life outside of their village and traditions? Did they desire education? Did they want a different life experience, to see city life? These questions will perhaps never be answered. It was indeed humbling to see their routine, a sense of simplicity and contentment, the stark disparities between our cultures, the stories buried behind these windows and tales left untold.

PART 2

Fragments, Fractures,
and Fumblings

6

A BLACK* COMPOSITION

GLORIA J. WILSON*

[asterisk. /ˈastəˈrisk/. noun.
a symbol () used to mark printed or written text, typically as a
reference to an annotation or to stand for omitted matter]*

March 28, 2021

What are the aesthetics of liberation?

Liberation from living in the omissions?

Annotated lives, embody the Black.

35,000* Middle Passages.

Geographic inheritances.

Elmina. The door of no return.

Middle. Passage. Womb.

Produces the Black.

Ovaric.

Atmospheric. 35,000* ecotones.

Partus sequitur ventrem.

Precarious birth, blackness.

Precious cargo. Shipped. Held in the hold.

Black, within the hold(ing) of the ship.

How, then, does Black create a space out of no space?

What does it mean to be held there?

What are the logics of legibility in the no-space?

Black moves, in no space arrangements.

Possibility out from dispossession.

A Blackened composition

Aesthetic arrangements. Legibility.

Blackness, infinite*

Atemporal. Consciously, historic.

Spatial. Arrangements of pathways and thruways.

Geographic. Diasporic.

Ecological blueprints.

Self-liberation.

Polysensorial.

Collective utterances, blackness.

Imagine otherwise worlds.

Blackports, errant.

Determined refusal. Nonlinear logics.

Sonic. Haptic. Visual. Kinetic.

Defend the dead.

Compose

A writing such as this, although seemingly authored by one person, only comes into existence and fruition through years of intense being/reading/living with the ovaric workings of Black women creatives. Their work accompanies me, daily, and has carried me this distance, as of March 28, 2021. I am humbled. The following list is incomplete:

{alphabetically}

Beloved; Dionne Brand; Tina Campt; *The Dark Laboratory*; Julie Dash; *Daughters of the Dust*; *Dear Science: And Other Stories*; *The Disordered Cosmos: A Journey into Dark Matter, Spacetime, and Dreams Deferred*; Torkwase Dyson; Tao Leigh Goffe; Alexis Pauline Gumbs; Saidiya Hartman; *I Can Drink the Distance*; *In the Wake: On Blackness and Being*; *Listening to Images*; Tiffany Lethabo-King; *Lose Your Mother: A Journey Along the Atlantic Slave Trade*; *Mama's Baby, Papa's Maybe: An American Grammar Book*; *A Map to the Door of No Return*; *M Archive: After the End of the World*; Katherine McKittrick; Toni Morrison; M. NourbeSe Philip; *Origin of Others*; Chanda Prescod-Weinstein; Christina Sharpe; *Scenes of Subjection*; *Spill*; Hortense Spillers; *Theory*; Sylvia Wynter; *ZONG!*

Salamat: A Love Letter to the Matrilineal, 2014. Filip-
iniana dress (terno). Mixed media collage on copper,
2'5" x 5.75" x 3.25"

For
Lola, Lucia
Mommy, Gloria Rosario
Sister, Ellen Rosario
Auntie Baybe (Virginia)
Auntie Joy (Remedios)
Auntie Nenen (Nenita)

7

HOW TO SURVIVE LIGHTWEIGHT TRAUMA AND DEATH THREATS

Home Is Where You Can Live Now

VIVIAN FUMIKO CHIN.

Have you ever given birth to a tongue? Or spontaneously ejected a fibroid that was the size of a tongue and looked kind of like a miniature version of a yarn-wrapped sculpture made by an artist at Creative Growth who was institutionalized throughout her childhood?

You, that you who is the dissociated self. We dissociate to survive, and we stay close enough to bear witness. This is not a privileged theft of a religious practice, some New Age meditation. Be with the breath so that we can survive.

After you take your remedy, slowly measured out in an eyedropper, completing the careful ritual of stirring it into a glass of water, you may feel a blob slip out of you if you believe enough in homeopathy and are walking in the country on a silent meditation retreat. Go behind some bushes, and check it out. Take a minute, break vows, and do an online search just to make sure that all is well.

That type of thing is rare. Not the fibroid but the "spontaneous ejection." Let it be useful as a real-life metaphor. In her office, the gynecologist may want to show you diagrams that seem to be from the 1950s. She will want to show you the different types of uterine fibroids, the one on the stalk that starts with a *p*. It's all she has to one-up you on your experience. So never mind. Know that you have produced a tongue and that it can speak.

One day you may find yourself without a livelihood. If your workplace environment is starting to seem like a rerun episode from *Survivor*, try to be alert. Think of where else you might be able to live and what other job you might be able to find. Know that it's also a gift to be alive at your own funeral, to hear eulogies, to feel the flames of cremation, to rise again, just like a phoenix Jesus.

"When one door closes, another opens." This is an extremely irritating and useless thing to say to someone who is feeling that a door just got slammed on them and their head, with lips still moving, is now rolling on the ground. Say something else. Probably curse. If you are not the type to curse, then tears will be helpful. At least later those tears will be remembered.

"Oh, how the mighty have fallen" is a phrase that may come to mind throughout the day, or maybe every time you do the laundry. When you're trying to time it so you don't interfere with anyone else, you will see that new dryer—bought from some white salesman with bad breath who demanded a hug, just weird and gross—settled on the tiles in the house by the cat-killing coyotes. It's too much to think about, that dryer so far away, spinning and efficiently drying someone else's laundry.

Anyway, let me try to tell you how this story goes. It could happen to you. One day you may find yourself suddenly lost. Everything that gave your life its edges, corners, and direction, just gone. Some might say stolen. It was just a job, but it was more than that because we can sometimes become what we do, or our livelihoods suit us, and our jobs become who we are. So when suddenly that

job gets withdrawn, then what? How do you start all over from scratch and reinvent yourself all over again? Like a non sequitur come to life, you are a blank slate, an empty page.

Make a cup of tea. Open the jar of tea bags, take in the smell of mint. Light the stove and boil some water. Home is where you can live now. If you need to walk into the forest to smoke a cigarette, all the better. The ground is damp, and you won't start a fire.

Remember that day when you put out a cigarette in an abalone shell and set it next to the door? You decided to take the recycling out the front door and heard the sound of fire, saw flames burning. Processed that image—the house was on fire. The first thing that came to mind was that if you called 911, you would end up evicted. Then you saw the hose right there and unwound it and turned it on and put out the fire yourself. The sunlight must've reflected on the shell, mother of pearl, or all of those aerosol cans in the plastic drawer were releasing flammable gas and the plastic caught fire and the flames grew. Soak the siding, make sure the wood is very wet. Get rid of the melted plastic. Put sand in the shell. Wait until the wood dries, sand it, match the paint, and no one will ever know. Disasters can be hidden, glossed over, repaired.

Many women of color grow fibroids. Avoid a hysterectomy, don't get plastic shot into your uterus, talk to other women about it. If you are gushing like Niagara Falls and every month it seems like you are miscarrying octuplets every five minutes, take iron supplements and use a silicone cup. Eat liver or oysters. Buy plenty of pads and use two at a time along with the silicone shot glass. You'll feel less embarrassed than if you have to buy adult diapers. Try taking birth control pills, and figure out the lowest dosage to slow the flow. Eventually it will all pass.

Years ago, you were driving around on a small island, finding beaches and wondering how to live there. Later, looking out the window at the Golden Gate Bridge, imagining how the water

would hold you in a loving embrace when you jumped, you remembered that it would be more like hitting concrete at one hundred miles per hour. And you would regret it midair. After a year of printing up parking permits, leaving the house before the sun rose, being prepared, and hopefully forgetting nothing, something else may show up if you look for it. In the meantime, check the BART seat with care before you sit down, put your hair up and hope no one with lice or scabies just sat there, remember to squirt sanitizer on your hands while you wait for the shuttle to carry you to your destination, two hours away. Teach classes full of students with rbf (it's too crude to spell out) who saw your name and are hoping you will be nicer than someone named Smith or Baker. Bake for your students. Although they may all think linearly, try to mix things up. Try to learn a useful approach from a student who follows you into another class the next semester: self-advocacy. Make it mean *find a chorus*.

When you feel suicidal, make a playlist of Tupac. Compulsively listen to "Changes." Use a list of Tupac song titles as a short speech. It's still there on your old phone—charge it up and find it again. Whisper them. The lyrics will show a progression.

A specific person, someone in a similar situation, a very white man who never had imposter syndrome and who could not picture himself anywhere else may end his own life. Know that is a choice. Do not erase this.

Before any of this happens, a young student of color might tell you that she thanks the toaster and that will be enough to change everything. Give thanks, consistently. This is not about feeling blessed, this is about feeling gratitude. There is a difference. It could always be worse. So what. Make a vow to give compliments and to cook your own food. Produce your own nourishment. Thank the toaster or the rice cooker or the source of fuel.

When you move out to the end of a dirt road, trade in your son's hot rod—the one you almost paid off, that you shipped here

because he got a DUI. Get a car with higher clearance. Leave
the HE>i sticker on and add a do-it-yourself Protect Mauna Kea
image. Respect and protect the sacred mountain. Stand behind
sovereignty. Pray. Learn how to keep your eyes on the road and
straddle ruts.

Now the anxiety may come in waves of fear. Press on the spot
above your upper lip, purse your lips like you're exhaling smoke
and breathe it out. Not to trivialize, but look up "Emotional Free-
dom Technique" or "tapping." While you're at it, look up "alter-
nate nostril breathing." People have been doing that for thousands
of years. Eat the food you like. Lie down on the smooth lava and
feel the earth's embrace. Remember that word that starts with a *p*.
Peduncle: a stalk-like structure. It is also a type of hallucination.
Away from the asphalt you can breathe.

8

BECOMING MIDDLE GIRL

AMELIA M. KRAEHE

Becoming Middle Girl, 2006. Nine photograph prints on mylar, Scantron paper, graphite, metal, 11 x 13 in. (28 x 33 cm)

Becoming Middle Girl is part of a larger meditation on growth—personal growth, the kind of growth some civilizations call Progress, and the thickening growth of reproductive processes that swell, extend, and proliferate into structures and rituals that become us, make us, and contain us. To grow is to dwell in the contradiction of being subject and object at once. The Scantron portraits of the artist as a young girl and her two siblings invite questions about selves in the making. Middle Girl wears her hair too fuzzy to be homecoming queen. She speaks too "proper" to fit in with her cousins. She inhabits a body that will not go unnoticed by grown men on the sidewalk, and yet that body will fail to be seen when sitting in math class. She is transforming and being transformed by the visible invisible, the always present and uneven matrix of power within families, schools, and society, through which gendered, racial, and classed identities are cultivated and contested.

9

FLESH, SKIN, AND BONES @MARIMACHASPEAKS

TANYA DIAZ-KOZLOWSKI

Saturday, January 18, 2020

Dear Chula,

Francisco is burrowed under the cobija. We have already had our argument. You know the one where he gets mad at me because I have the audacity to take him outside in the cold? The sky is gray, the landscape motionless. I put my coffee on top of my pile of books. *Bridge*, *Yearning*, and *Chicana Lesbians* are my makeshift table. I only have a couch, a table, a desk, and two chairs. Sofia took all the furniture in our divorce.

> *Forgiveness comes to those who wander in the storms*
> *Brave the wind*
> *DIG*
> *for courage*

The wind thrashes and the tree behind my apartment bends in willful resistance.

> *Don't tell me there aren't wolves everywhere*

June 2019. I am in Chicago. I open the door to the hotel room. His words seethe. ***YOU DON'T BELONG IN HERE, DYKE.*** His forearm crushes my windpipe. December 2019. I am walking up to the security checkpoint on my way to Long Beach. I put my boots, phone, and keys in a tray. *I need a female assist.* **ARE YOU HIDING ANYTHING IN YOUR POCKETS?** No. **ARE YOU SURE?** Yes. **DON'T LIE TO ME.** I feel the TSA's hands slip under my chonies. *Are you wearing boy short underwear?* Yes. *You shouldn't.* September 1986. *Take those pants off. You cannot keep getting dirty.* My right knee is cut, and blood pools under the fabric. *I don't know how many times I have to tell you good girls play nice. Don't you want to be pretty? You were supposed to be watching your brother. Who was protecting him while you were out running in the streets like a fast girl? Keep your goddamn legs closed. Stop embarrassing me.* August 2014. **ARE YOU A MAN, OR ARE YOU A WOMAN?** Are you talking to me? *The police are on the way. This is the women's locker room. You look dangerous.* February 2018. *If white men in your classes walk out while you are teaching gender and sexual preference stuff, then maybe you have a classroom management problem.* Men explain things to me. October 1996. *You got a 19 on your ACT. Stepdad?* A mechanic. *Mom?* A secretary. *You are a people person not a college person.* The wind opens up these wounds, and it hurts to write these words to you. But I know I have to tell you these truths in this way, understand? Culture is made by those in power—men. Men make the rules and laws; women transmit them. Trauma has a way of eroding your internal compass. My coffee is cold.

I am the river; you are the rain.
The fault lines
 crumble
 under
 the weight of flesh.

Remember when we met in San Francisco during NWSA? Fifteen minutes after we exchanged numbers, I had to text you. "Hi . . . I know this is very uncool but I can't stop thinkin about u. Can I buy u coffee?" You responded. "Come find me ☺" I made my way through the convoluted hotel to a plenary session. You were sitting in the last row, crocheting. I sat down, and your jeans skimmed mine. All the words I knew got

jammed up in my throat. Finally, I asked you if I could help. You turned and said, "Well, why don't you untangle this ball of yarn for me." Your eyes sunk into mine, held me. How did you see me? I let you.

Pull me close to you
Deeper
Deeper
 than that
Deeper
 than a breath of self-doubt

Do you remember how my hands trembled? I leaned into you responding in a whisper, "It would be my pleasure to untangle your yarn, professor."

Beyond this moment there is a place where your music BURSTS
into colors
Where my words m o v e mountains
Pull me close to you
Deeper
No deeper
 than that

━━━━━━━━━━━━

Slender fingers moved to their own rhythm; the beginnings of a blanket draped over your knees. I fumbled. Strands of orange, white, and green coalesced into a knot. This Chicana butch was flailing. You leaned over putting both hands on top of mine. Suddenly we became entangled. Close enough to start a war. I dared to imagine what it would be like to kiss you.

Hold my face in your hands
Do not let me look away
T r a c e every curve,
every
 edge
 of my brownness

Touch
 the *dispossession*

Remember how we told each other truths? Astrological charts. Eating meals out of Tupperware while driving. Audio books. Emails. How did I get home? Fog. Hail. Snowstorms. Brake lights. Dog kisses. Schmidt. Francisco. Power naps in the driver's seat. Adjunct faculty. Chronic. Contingent labor. Parental estrangement. Student debt. Their footsteps hurried behind the Espresso Royale. Legs pinned. Ripped jeans. Gravel. Palms bled. Seven white frat boys. Boot marks on my neck. Little deaths.

Strangled souls, cry out

Religion. Recovering Catholic. Academia. Broken promises. Familia. Divorce(s).

Tears have histories of blood and ink

All the yarn spilled out. Complex entanglements. What do we do with these truths?

Surrender

 Uncertainty

Come to me
 show me

Before we were told time only had two hands

Remember by the end of that conversation we could have kissed each other? Urgent chaos. Time ceased to exist in its colonial construction. Eramos un sitio una lengua. Unraveling each other. We still do not understand.

Ambiguity

We are not strangers to desire between queer women of color

Precarious

All of your flaws, all of my flaws
O *p* *e* *n*
 U
 P
Stand in the darkness
Waves crash

 back and forth
Nothing but the sound of yearning
Return
To ourselves
 To each other

brown bodies
 brown bodies
Hands in your hair
Tongues
 lick
 slow-fast *slow* *slow* *slooooow-e-r*
Mouths
 bite
Lips
 suck
Hips
 grind
Fingers
 slide
Softness
 d
 r
 i
 p
 s

Backs
> *arch*
puddles
wetness
say
> *my name*
Brown bodies
> *twisting*
>> *trembling*
>>> *exploding*
Chasing fire
> *Restless*
insideeachother
> *wanting*
>> *speaking* *searching*

A week later we found our way to each other.

Relentless
> *Unapologetic*
>> *Know me*

The silence between us became its own conversation.

Spinning
> *Faster*
>> *Faster*

Remember when I told you about the night terrors, the sleepwalking, the pain?

RAGE.

His hand had all of her hair, and he looked like a superhero picking her up. The baby clutched a green blanket draped on the crib, and he cried so hard that he looked red instead of white. There was so much noise in such a little room. There were so many tears. How could a little baby produce so many tears? I had no tears. I made no sounds.

RAGE burned inside shooting towards the back of my throat and raced up behind my ears and crept into my cheeks, came out my eyelashes, slid down my esophagus into my chest, then down my legs, settling into my feet. I stood still. Eventually he turned towards her grabbed her neck with his free hand and completely lifted her off the ground only to throw her against the wall. CRASH. The baby just wailed.

RAGE.

He walked past me out of the bedroom. I followed him. He stopped, turned to look at me. I stared at him.

RAGE.

Gasoline. Grease. The belt marked my body. SNAP. Sometimes I provoked him, and other times I left a cup on a table without a coaster, or I didn't get all As on my report card. It didn't really matter. There didn't need to be a reason. The last time I was twelve. I threw a glass candleholder at his head with all my strength. I missed. SNAP. "If you touch me again, I will kill you."

RAGE.

She was standing with her back to us, a towel draped over her shoulder as she looked out the window above the sink. She said nothing. He stared at me. I had no tears, only **RAGE.**

———————

Francisco is still sleeping. His legs stretch, and his feet dig into my thigh. Remember I read "Boys will be boys" to you the other night by @nktgill? I read it to my students last week, and they responded in writing. The WGS classes we teach are so much more than just classes. I need more coffee.

Women are not to be trusted
He did it to my sister first
It happened to me next
I was 5
I didn't ask for it
Aggression is not affection
My brother molested me
(I was raped in high school)

MY PARENTS DID NOTHING
Low-key I'm still mad
I was 7, he was 11
(Could you keep this between us?)
I didn't know I could say no
I'm a Black girl
This is bigger than us
Where do we start?
Do you believe me?
I am numb
Dr. Ford told the truth
FUCK THIS
Men are killing us
SAY HER NAME

What I'm trying to say is:

I didn't see you coming
 Flesh
I want you, to stay
 Skin
I am not walking away from this
 Bones

Contigo,
Tanya

10

NOCHIPA IPAN NOYOLTSIN (ALWAYS IN MY HEART)—BATALLAS COTIDIANAS

LILIANA CONLISK GALLEGOS

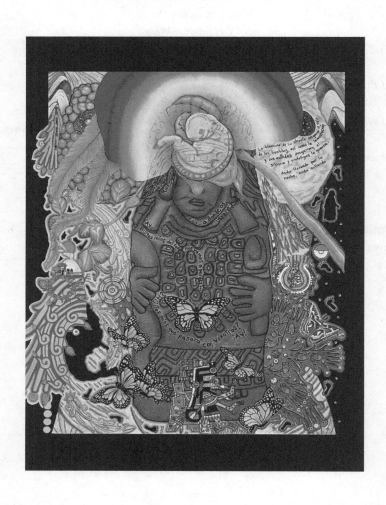

Se abren caderas de piedra y parece que la tierra misma temblará, pero no es posible porque, ¿cómo puede comenzar lo que siempre ha sido?

As I sit on the toilet waiting for the next contraction to exploit my insides, siento el pisotear de la flaca escarbando surcos de pena en mi esperanza, dolor cultivado por matriz conquistada. Sin papeles no hay médico ni medicina que entienda tu lengua y aun dentro de este reino de paredes, entronizada, me siento madre, tierra.

To distract myself, I virtually escape, browsing the wall of my social media profile. This wall, like all The Walls, producing, reproducing a baby daughter forever swaddled between her father's wet back and the empty void of the black of his shirt. In the darkness that cannot be left behind, where everything wears you but you have nothing else to wear and only hope to give. Floating, face down, in the obscene and ironic obscurity of pornographic posts, no names, floating before they crossed, floating after, in between, face down en el Río Bravo.

Ya llorar nos suena a melodía, coro entrelazado de madres, tierras, parteras, nepantleras, guerreras y monarcas de otros tiempos y espacios, de todos los tiempos y todos los espacios, somos legión . . .

¡Hijitos míos, pues ya tenemos que irnos lejos; Hijitos míos, ¿A dónde os llevaré?[1]

Browsing, in the in-between of their image re-reproduced, a thousand deaths of forgotten mothers, fathers, and children we never hear or see, swaddled between the obscurity of their "wet backs" and the empty void that is this American dream. Nestled in the covered in-between of the womb of Mother Earth where everything that will be and ever was resides.

¡Oh, hijos míos! Del todo nos vamos a perder. Oh, hijitos míos, ¿A dónde os podré llevar y esconder?[2]

This virtual wall begins to bury me. I swipe up on the screen. In a second that image is gone, y empieza la sensación anestesiante del "como si

1. León-Portilla, *Visión de los vencidos*, 23.
2. León-Portilla, *Visión de los vencidos*, 26.

nada." A meme, another, a birthday, a like, a filtered selfie of a stranger who upon closer inspection I realize is a friend I see quite often. No los reconozco, no me reconozco. De repente, un pedernal de filo torpe se me clava in the center of my life force, y luego el rojo, crimson red, siento que me muero, no cesa, no puedo ver, estoy ciega. Me arde la conciencia. No poder salvarte ni protegerte, me tuerce el alma . . . por lo que fuimos, somos, y pudimos ser. Matriz aplastada.

¡Ay, hijitos míos!, . . . ¿qué pasará con vosotros? ¡Oh, en vosotros sucedió lo que va a suceder![3]

Floating, face forward, entronizada me siento Madre Tierra flotando sobre Río Manso sostenido, donde mi maternidad y yo somos desechos. Al jalar la cadena mi dolor en espiral con el pesar de su insistencia, de Cihuacoatl, que es el dar la vida misma, mientras se hunde entre mis piernas un chícharo de sangre sin seguro, sin cara y sin nombre; sin por qué. Ese es el lujo que hoy es *el vivir*.

NOCHIPA IPAN NOYOLTSIN[4]

"Calzones empapados de sangre.
Se que yo callada no soy nada.
Desdichada,
muy lejana con boca hinchada,
vomitando algo amarillo,
revolviendo y repitiendo palabras sin sentido.
Siento algo reventandose
en un lugar interno.
Estoy parada en la orilla
de una noche oscura."[5]

Temazcalteci Cihuacoalt le dice al pedernal: my babies left my body en historias contadas en rojo silencio y noche oscura, como el negro de esta

3. León-Portilla, *Visión de los vencidos*, 52.
4. Siempre en mi corazón (Always in my heart).
5. Anzaldúa, *Borderlands/La Frontera*, 136.

tinta de recuerdo en pedazos y habla entre ecos. Mis hijos caminan sobre pasos ya marcados, cicatrices de guerra que no sanan. Tatuajes en mi piel. Luchamos contra la muerte segura de una lógica contaminada y a veces el esfuerzo es solo para adelantarla. Qué fácil perderse en este norte. Cuando lloro por mis hijos, pido que vuelvan y en sus pasos se acerca su abrazo. Los abortan de mí a fuerza, los encierran, los encadenan, y vuelven a mí.

Nochipa ipan noyoltsin

Yet, when you look at me, de repente, me miro como si nada.

Dentro de mí habita un grito sos
 te
 ––nido––

¡Ay mis hijos¡ ¡Ay de mis hijos!

"En un lugar interno alguien se queja."[6]

Se me vino el niño, *I* lost the baby. Yo, yo lo perdí!! El agua de mis ojos gets trapped and flows into my insides, como la lluvia atrapada en casa from the goteras in my tata's house and the marañas que se metían in my nana's eyes. Mientras, otras madres saben que el bebé nunca vendrá y su matriz misma se convierte en la maraña de sus ojos, en la pérdida imaginada de su creación reproductiva, reproducida por el qué dirán.

¡Ay mis hijos! ¿Y qué ay de míííí?

The water overflows para todas las que somos tan diferentes y las cadenas nos quedan por igual. Pero que no te vean llorar, mija, no les des ese gusto. Yet my tears are like war paint and weeping my war cry. Sometimes I don't give birth, only to give life.

La blancura de su atavío desgarra el velo de las tinieblas así como el de la lamentación y sus aullidos desgarran el silencio y profetizan la guerra.[7]

6. Anzaldúa, *Borderlands/La Frontera*, 137.
7. Bernadino de Sahagún, *Códice Florentino*.

"La bestia noche entra armada con navajas,
. . .
Miro que me saca las entrañas,
que avienta la matriz en la basura—
matriz sin tumba."[8]

Filtro mas no internalizo suciedad, soy Tlazolteotl, me la trago y escupo chalchihuitl.[9]

Stress is another battle, the turmoil in the body can make you lose your child, lose life. When versions of life are denied, our hearts beat faster, en esta bestia noche armada con navajas, noche alargada. Passive-aggressive shanks burst blood pressure in our veins, matándonos las entrañas, matrices sin tumba. Una línea roja se dibuja en el espíritu entre las paredes de este reino de toxicidad. The settler toxicity fiending on our souls, failing to appropriate our light. Este lujo no es vida y aun así yo doy vida, la mía.

¡Ay, de mis hijos! ¡Ay, mis hijos!
Nochipa ipan noyoltsin.

Come to me caravans, escape the darkness of this beastly night, return to the sweet bath, Grandmother Temazcalteci Cihuacoatl. When life itself is denied, your footsteps are the beat of my heart. Your travels of sacrificial blood and flowing life-giving waters of your spirit, tus hijos que también son los míos, son mariposas de obsidiana que encomiendo al paraíso de Itzpapalotl, donde habitan los santos inocentes, para completar el ciclo hacia el lugar de donde todos son y fueron creados. Y sus historias de mariposas irán y vendrán, así como si nada.

¡Ay de mis hijos! ¡Ay, mis hijos!
Nochipa ipan noyoltsin

8. Anzaldúa, *Borderlands/La Frontera*, 136.
9. Jade; precious object to the Mexicas / objeto precioso para los mexicas

Nehua Temazcalteci,[10] ni mo yolpachojtok,[11] I remember your future inside me, por eso mi yollotl[12] será su ayatl[13] cuando vuelvan a mí, por siempre, para siempre

"¿Estoy muerta? Ie pregunto.
Por favor entierren mi matriz conmigo."[14]

My children left my body en rojo and in the black of this text that speaks to you, through me, because of them. Y es así de muchas formas diferentes, en lugares distintos, en tiempos múltiples, en cuerpos de sombras café.

Porque nos tocó nacer del color de nuestras tierras.

"Me sangran, me sangran.
Tengo señas de la muerte:
. . .
Sueña de una cara tiznada,
de una boca escupiendo sangre."[15]

Giving birth es muchas cosas. Giving birth is a ceremonial battle and women who die giving life, con o sin matriz, are fallen heroes. People who migrate are warriors fighting para darse a luz, and many re-enter the womb eternally in silence. Es una cadena.

10. Yo Temazcalteci / I Temazcalteci. Temazcalteci es "diosa que se llamaba la madre de los dioses, corazón de la tierra y nuestra abuela . . . adorábanla los médicos y los cirujanos y los sangradores y también los adivinos que dicen la buenaventura o mala, que han de tener los niños, según su nacimiento." Bernadino de Sahagún, *Códice Florentino*.

11. Literal: Tengo el corazón aplastado / My heart is flattened; Metaphorical: I'm depressed / Estoy deprimida.

12. Corazón/heart

13. Cobija/blanket

14. Anzaldúa, *Borderlands/La Frontera*, 137.

15. Anzaldúa, *Borderlands/La Frontera*, 137.

Kani tiwalaj, ma titlajtokan totlajtol nochipa.[16] Purifícate en el temazcal del conocimiento, salte de la yerma cuna que nos imponen, así como si nada.

> "Padezco de un mal: la vida,
> una enfermedad recurrente
> que me purga de la muerte.
> Me sangra, me sangra.
> Derramando un aguacero,
> vierte la muerte por mi boca.
> Volteo la cara,
> revuelvo y repito palabras sin sentido:
> la vida enema, matriz sin tumba.
> En un lugar interno algo se revienta
> y un agitado viento, empuja los pedazos."[17]

Hoy, vivir es guerra eterna por el derecho a escapar de la tumba. Somos matrices sin tumba, somos Temazcalteci Cihuacoatl, somos Tlazolteolt, somos yollotol, somos ayatl.

No somos pedazos en el viento, somos el viento que hace a la vida misma temblar, somos la tierra misma, tlajtoli kipiya chikawalistli,[18] tiene poder, la lengua . . . vierte la muerte por nuestras bocas

> Estamos cansadas, sentimos choquizotlahua,[19]
> mientras la tierra tiembla,
> así como si nada . . .

16. A donde vayamos siempre hablemos nuestra lengua. / Wherever we go, let us always speak our tongue.
17. Anzaldúa, *Borderlands/La Frontera*, 137.
18. La lengua tiene poder / the tongue is powerful
19. Sentimiento de cansancio por tanto llorar / feeling of being tired from crying too much

REFERENCES

Anzaldúa, Gloria. *Borderlands/La Frontera: The New Mestiza*. San Francisco: Aunt Lute Books, 1987.

León-Portilla, Miguel, ed. *Visión de los vencidos: relaciones indígenas de la conquista*. México: Universidad Nacional Autónoma, 1959.

Sahagún, Bernadino de. *Códice Florentino*. 1540–1895. México: Secretaría de Gobernación, 1979.

PART 3

Pedagogies of Liberation and Resistance

11

GENERATION AFTER GENERATION

SAMA ALSHAIBI

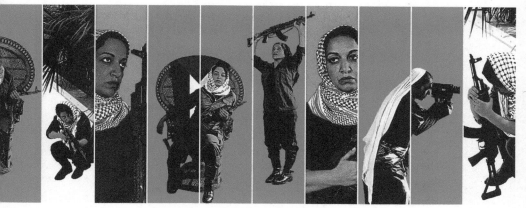

Generation After Generation, 2019. Mixed-media screen prints

Generation After Generation considers how the Middle East was and continues to be imagined through historical representations of women. It honors Arab print histories made by anti-imperialist and national sovereignty movements of the 1960s. Screen printed political posters were wheat pasted on public walls and represent a shift toward graphics that were cheap and easy to produce. Powerful feminized representations of national aspirations and collective identity are made through the Arab female fighter and farmer. It challenges Western imaginings of Middle Eastern women's oppression. The black and white checkered kuffiyya scarf of the farmers, and adopted by revolutionaries, symbolizes dispossession and resistance. *Generation After Generation* displaces the internalization of a Western and Eurocentric social order and renders Arab women as gendered equals in the struggle for self-determination on their land.

12

WHEN LOVE IS NOT ENOUGH

Choosing to Heal Ourselves When the World Wants Us to Burn

SHANTEL MARTINEZ AND
BIANCA TONANTZIN ZAMORA

They used to burn us at the stake
Fires blazing
Naming us traidoras
When in reality,
They feared our powers
Our powers to heal
Our powers to transform
Our powers to create knowledge
Our bodies bastions of libraries
We held the erotic between our thighs
Table of contents in our brown skin
And theories on our backs
Consciousness that could take over the world
 Or at least change it
They tried to stop our bloodlines
Thinking that destruction would be the final act
Tried to erase our existence.

But they didn't know the power that runs within our sangre
Mamis and abuelas and the abuelas' abuelas prepared us with our
 embodied knowledge
 Gritando even with wounded tongues
We are the soldaderas
The curanderas
We lift comadres in the academy
 birth brown scholar children and grandchildren
 are asked to save everyone
 Until the blood runs out
 Until we became ghosts in our own bodies
We do this all out of love.
Love for our community
Love for those who came before us
Being told that our love
 will save us.
Transform systems.
Set us free.

We told you that we loved you
our love would be unconditional
We dedicated our careers
 Lived in constant struggle to fight and make room for fellow
 womxn of color
 Utilizing our bodies as sandbars, bridges, and drawbridges
 Always putting ourselves second to your grand demands
We ignored the signs. Thinking we could change you.
We gave you
 Our tongues
 Our spirits
 Our flesh
 Our happiness
And you branded us like cattle
 To claim and own
 To parade around when it served *you*
We did this willingly
Thinking that you also loved us

We told our families
It was going to last.
 It was true love.
 Golden wedding bands cuffed to our wrists.
 Our education would save us.
How would we know that you were the one
 they warned us about.

Your love is toxic
With each kiss comes death
Every whisper brings doubt and insecurity
Every "I love you" comes with "if you do this . . . for me . . . then
 maybe"
Our love is never enough because we are never enough in your
 eyes.

And so on death's door
As you built the pyre to burn us at the stake
When you kissed us for the last time
 We decided
 to unlock the golden handcuffs[1] and break the love spell
 walk away
 choose us

We choose
To nourish the sun and light
That you claimed had no place in the white castle
To scream maldiciones and call out systems
To retreat to our islands

To nurture ourselves back to life
To fill our bellies—our spirits
To put down the sleeping pills

1. This is an idea from my friend Faith Kazmi, who states that the golden hand-
cuffs are a metaphor when everyone thinks that they want what you have; from the
outside looking in, you have the perfect life, work at a desirable institution, live in
a popular area of the country/state, have an amazing position/job. And so you feel
like you cannot leave, even though it is toxic.

To take our sun back
To reclaim our laughter and drink in moments of joy
To dance merengue in our kitchens, in the clubs.
To feel attached to our own bodies.
To heal our hearts from deep scars.
To hold possibilities of other futures.
To release memories and trauma.
To be the wild womxn within.
To remind ourselves that we are worthy, brilliant, capable
To return to the womxn you feared.

You tried to burn us at the stake.
Tried to teach us that it was normal to squirm in the fire
 That the flames purified our bodies
Told us that we had to perform magic, but that *we* were not
 magical
Demanded we extinguish the systemic fires that you created
But this time,
 we drew the salt circle
Called to our ancestors
 Moraga
 Anzaldúa
 Rushin
 Chrystos
 Lorde
To remind us that wounds can heal
And broken hearts can be mended
Reminding us that
Love is being alive,
 Living grounded
 Speaking our truths
 Affirming our brilliance
 Embodying our sun.
We listen to their words
To breath. To exhale. To be. Repeat.

We choose to heal ourselves.
To win the oppressors' game.
To unlock the chains.
To choose ourselves when love is not enough.

No more swallowing oppressive acts
Or twisting our tongues for your comfort
It will be you who will wake up to the nightmares of the white
 castle
Wake up
and see that we set it ablaze.

13

PROFESSOR BECKY AND I

SANA RIZVI

For ages I have struggled,
my words failed me,
my heart was angry.
You could see the hurt in my eyes and hands,
and yet you looked baffled and said,
"I don't understand, I'm fighting your corner."
I couldn't pinpoint what it was,
What it was that made you, you?
So eloquent in telling my story,
and me so plain.

How you came to explain my pain,
and others believed my truth through you.
Believed you unquestioningly,
without flinching, patiently,
without skipping a beat,
listening intently.
Yet when I speak, they listen only to interrupt with,
"however," "but," "an interesting angle,"
I could not pinpoint what it was,
that made me so plain.

I watched as eyes would listen,
when you spoke with such calculation.
unmoved, detached, so matter-of-fact.
As you uttered the final word:
"I call it micro-minoria l'agression," you said,
with just the right dose of pious supériorité,
"but that doesn't mean anything," I whisper, "it's malarkey."
"exactly," you say almost as if you were ready to reply.
I try to pronounce it, "micro . . ." I struggle.
"It's micro-minoria l'agression,
you will get there, eventually," you say.
I don't need to say it, I live it.

You receive applause and sympathy,
for showing my pain, my story, my history.
I saw the disbelief in the very eyes,
that expected my loyalty,
my unconditional gratitude,
toward you, but I couldn't.
I flinch, just a little,
but I'm screaming mad on the inside.

At what point did you become the expert?
So sophisticated, so nuanced,
so well versed, so well researched,
in my pain, in my story.
Or am I fooling myself?
Is the only voice worth listening to yours?
And I'm just a dilettante.
My story could only be heard through your eloquent voice,
For I lacked depth, sophistication, finesse,
so incapable according to you, the onlookers, and the doyens.
"I did not want to trouble you," you reassure me.
And I was so plain.

By now everyone who has heard my story,
has heard it from you.
People walk through me,

"We cannot believe this . . . this tragedy happened,"
"What was it? . . . ahhh it's micro-minoria l'agression,"
They whisper shaking their heads, left to right.
I see their pitying eyes piercing my soul,
I feel it enraging my blood even more.
I see you stand by me,
till the last person leaves,
for only as long as you take to tell my story.
Then we return to our separate worlds.

I know now what makes you, you,
and me so plain.
It takes a certain you,
calculated, so complicit,
waiting for the right time,
to establish peace and order on both sides.
To hold my hand and my enemy's at the same time.
I could never do that.
It would eat me on the inside to smile,
and say it's just a conversation.
It's my blood, my image, and my roots,
To you, it's a conversation.
A sign of progress and civilization,
to erase passages of oppression and violence,
to write it so eloquently,
that both sides emerge as the same.

You may greet me every day with the same reassuring smile,
"We are okay, right?" you will say.
But I can tell the difference,
between friendship and a transaction,
between respect and courtesy,
between empathy and pity,
between living and surviving.
My plain self can see through all your eloquence.
Your comforting words don't fool me anymore,
I refuse to be the product of your illiberal liberalism.

14

PUT IT ON BLAST

ARAM HAN SIFUENTES
(WITH ISHITA DHARAP AND CAROL ZOU)

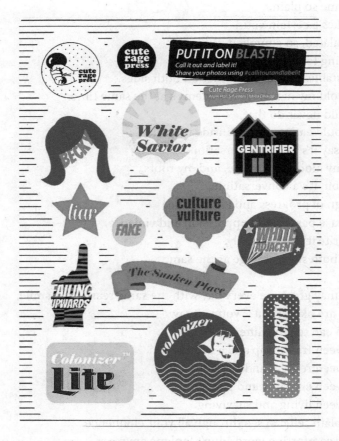

Put It on Blast! Call It Out And Label It!, 2019. Kiss Cut CMYK
sticker sheet on UV laminated white polypropylene, 7 x 5 in.
(17.9 x 12.7 cm)

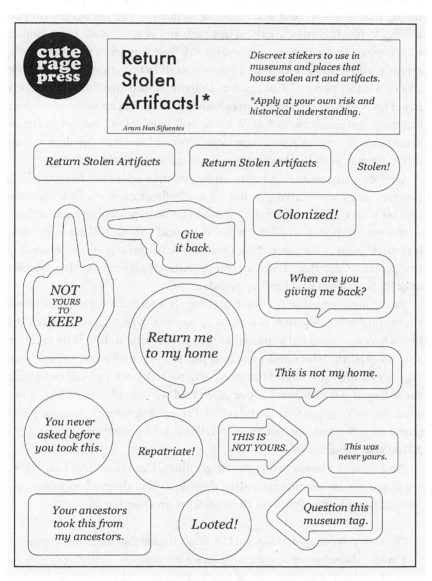

Return Stolen Artifacts!, 2019. Clear CMYK sticker sheet on UV laminated clear, 7 x 5 in. (17.9 x 12.7 cm)

I am a callout queen. Popular culture likes to put down "callout culture" saying that it is toxic and that there are better ways to tell people they're wrong. When it comes to calling out racism, I've tried it all: to be gentle; to reference texts, quotes, readings; to deliver a perfect shit sandwich, starting and ending with "but I know you didn't mean it" and "I know you're a good person." Calling out individual and institutional racism never goes well, and frankly, I'm exhausted. I could keep my mouth shut, but that's not really an option. What people call "callout culture," I see as accountability. As an Asian American femme, I see it as my duty to call out racism, especially since no one finds me *initially* threatening.

One day, my awesome artist, designer, arts educator friend, Ishita Dharap, and I were talking about all the bullshit racism and sexism we deal with on a daily basis. I said, "Wouldn't it be so perfect to have stickers where we can just label all the bullshit around us?" and Ishita said, "Yes, let's do it." And as simple as that, this was the beginning of our collaborative project, *Cute Rage Press*, a project centered on empowering womxn of color to call out and label oppression.

Everything we make is cute. *Cute Rage* is a term that describes when something is so cute that you want to express rage and aggression. It's like when you see a baby animal and you just want to bite it or eat it or tear its ears off. Ishita and I are also pretty cute, and we are filled with rage, so we are *Cute Rage*. How much can we talk back and call out under the safety of our cuteness? We're often told we're really cute when we're mad. So, we're going with it and using it to call out white supremacy and patriarchy. We use our cuteness to talk back to power and to *Put It on Blast: #callitoutandlabelit!*

And so as not to leave out our Anglo allies, Carol Zou and I are offering ourselves as consultants so that they don't find themselves in precarious situations with *Put It on Blast* stickers on their backs.

"You asked, we obliged. We, Aram Han Sifuentes and Carol Zou, are offering a public, shareable version of our rate sheet for white people trying to 'pick our brain' and otherwise express their feelings about the racism. And yes, we are for real open for consulting! We are two women of color with backgrounds in ethnic studies, gender studies, and community arts who have extensive teaching, facilitating, and organizing experience on racism & the arts. Pay us to tell you NOPE."

—*Carol Zou*

ARE YOU A WHITE ARTIST WONDERING IF YOUR ART ABOUT RACISM IS WELL INTENTIONED BUT MISGUIDED?

PAY A PERSON OF COLOR TO TELL YOU!

SUGGESTED RATES*

$600 initial consultation & project review

+$400 if your project is so egregious that reviewing it causes the reviewer mental or emotional harm

+$400 for each email the reviewer has to tolerate from you disagreeing with their decision

+$600 for white fragility

+$1200 for white aggression

+$1800 for white tears

+$1200 for validations that you are not racist and in fact, one of the good ones

+$600 hourly rate for R&D requests including but not limited to, asking for suggestions on what to read, asking for suggestions on what artists of color to look at/reach out to, asking for suggestions on how to make your project less racist

*DEVELOPED BY ARAM HAN SIFUENTES & CAROL ZOU. NOT TO BE USED AS A GENERAL RATE SHEET.

Pay Us to Tell You No, 2020

15

A NOTE TO SELF

Ruminations of Black Womanhood X Leadership
X Resistance

PORTIA NEWMAN

A note to self.

I've worked hard this week, and the reality of the "crooked room"[1] is setting in. I am ninety days into a pandemic, and media outlets are flooded. There are protests for Black liberation, demonstrations for justice for Black death (George Floyd, Ahmaud Arbery, Breonna Taylor . . . a never-ending list of names), and I am exhausted by briefings on our public health crisis that is disproportionately killing Black folks. I AM TIIIIIIIIIIRED. I don't think I can handle any more "Are you ok?" or "I can't believe this is happening!" commentary from my colleagues. I posted my away message on my email as an act of resistance, and it read, "Caring for myself is not self-indulgence, it is self-preservation, and that is an act of political warfare."[2]

. . . and so here I am.

1. A concept from *Sister Citizen* by Melissa Harris-Perry, 2011.
2. Audre Lorde, *Your Silence Will Not Protect You* (London: Silver Press, 2017).

As a Black woman scholar and educator, I find my position in education at the intersection of resistance and leadership. In leadership roles, formal or voluntary, I am always working against the perceptions of who I am as a Black woman. It is a daily act of survival. In my workspaces I actively challenge my colleagues' perception of who they think I am. The truth is—I am the granddaughter of Hazel Mae, a nurturer and caretaker; the niece of Lois Jean, full of good vibes and energy; the daughter of Essie Mae, a provider and resilient. If only other people knew that I embodied such a tapestry of Black womanhood, perhaps they wouldn't question my presence. There would be no reason to challenge my leadership, and if anything, they would learn to appreciate what I bring to the space.

The ideas about who Black women are and how they exist are political and performed behaviors that Black women adopt as we develop our identity. Who I am has everything to do with what I learned from my elders. I am guilty of making decisions to be sure my colleagues feel comfortable, and I recognize why watering down my sass and big energy is important to their ego. I am sure that's what my grandma did as she cooked and cleaned houses for other families. My mom, a provider by nature, will help anyone, even if it's detrimental to her spirit. That's a technique I use when dealing with difficult people; I extend so much grace. In moments like now when I am processing the hypervisibility of Black death and the neglect of Black women in the media, I am reminded of the strategic approach my aunt would take. She lived a full life, and she chose joy! This is my reminder that this too shall pass. Choosing joy, finding value in their work, and extending grace was their form of resistance. The Black women in my life chose not to be defined by circumstance; instead, they found power in moving forward. Their life has been so influential to my leadership practice. I am learning ways to channel my struggles into skills.

. . . and so here I am, trying to make sense of my own value. I'm wondering where and how resistance meets leadership.

Perhaps the resistance meets leadership in the crooked room. In that space, the shortsighted assumptions about Black women fail to acknowledge my leadership power. This is a recognition of how complex it all is

for me. As Black women, resistance and leadership do not come without sacrifice. What I learned from my grandma, my auntie, and my mom is a testament to what once was a survival tool becoming an instrument of justice. I can see it much clearer now as folks are not just fighting within the walls of their companies but in our streets. This fight is growing, and every day I think about how to re-energize to sustain myself.

. . . and so here I am, in solitude. I am reminded that who I am is important and necessary and critical to this moment in time.

When I start to connect the pieces, I can't help but fall back on my studies of Black feminism, which validates the vision for diverse, equitable, and inclusive workplaces and challenges power structures to create opportunities for Black women leaders. Black feminism affirms the leadership of my elders. It speaks to how I am able to impact and inform critical decisions. Memories of my grandma serve as a foundation to my service, compassion, and pursuit of justice for Black lives. The restricted perceptions of Black womanhood do not ignore the implications of unconscious bias and blatant racial discrimination; instead they inform the strategies I use to navigate spaces. I am challenged to address my own experiences of leadership, practicing resistance.

Reflecting on the lives of my family has been keeping me grounded to the work. It has been my reminder during this pandemic and continues to serve as a guide to think about the new ways the world will work after this moment has passed. A deep hope that I will see changes in policy orients us toward new practices. As a Black woman, I think I will find room to stretch my mind and use my talents in ways that I have never seen before.

. . . and so here I am.

I am finding ways to comfort myself in solitude, which only means I am thinking more deeply about my place and space. For once, my leadership is not defined by productivity but by my manner of grace. In a time when Black womanhood is misrepresented in media and political headlines and underrepresented in leadership, I am finding some voice

in the history of the Black women in my life. They remind me that there is power in existing as a Black woman.

. . . and so here I am. In the fullness of my Black Womanhood, a leader, and doing so as an act of resistance.

PART 4

Diasporas, Departures, and Displacement

16

CAN'T YOU SPEAK PERFECT ENGLISH?

The Language That Troubles Me

MICHELLE BAE-DIMITRIADIS

IN THE early 1990s, I immigrated to Los Angeles, U.S. during my twenties with some American fairytale-like dream as other immigrants have. At the arrival, I realized that the dream shattered immediately but was replaced with new life struggles of survival. During the early days of my immigrant life, I engaged in an initial job search in the food service industry and approached both White-centered spaces in Santa Monica / West LA and Korean/Asian-centered spaces, most of which were located in Koreatown and downtown LA. The first question I was asked during each interview was, "Can you speak perfect English?" With my "insufficient," rough English, my applications were often rejected in both places, which, for their female staff, seemed to prize "perfect," soft-voiced English speakers who expressed the hyperfeminine both in body and attitude. In other words, their employees were expected to not only be fluent in English but also adhere to the cultural expectations of the Americanized feminine.

In the White-centered job market, my language intersected with my identities as an ethnic Korean, immigrant, and a woman, and because of this, I was often treated as a stranger, inferior, and unattractive. When I looked for a job in the Korean and Asian immigrant communities, I also found that my language was undesirable within my own community. As

such, I came to realize that the types and the amount of jobs available to Asian immigrant women in the U.S., especially those with "nonstandard" English proficiency, were extremely limited. My untamed English language often gave an impression of being educationally incompetent, living in the U.S. for only a short time, and belonging to a low social class. In particular, I learned that educational status in the U.S., especially attending a highly ranked university, is considered a great merit within the Asian American community. Despite the histories of trauma associated with the "model minority" stereotype, I noticed many Asian communities tended to pursue "model minority" status with all the elements that entailed, such as high socio-economic skills to bring high income, education, and family/marital stability, through which English fluency is the primary means to achieve. The pursuit of a minority model within the community reinforces classism in favor of able-bodiedness. By being model minorities, such communities believed they could generate and sustain an ethnic power that would parallel the hegemonic, White-centered, ableist model within the U.S. settler colonial system. Being a model minority would make Asians "capable" in the sight of the dominant U.S. ideology. Such settler colonial imperatives made me feel that as a woman of color who was not fluent in English, I probably would never meet the cultural qualification of being a fully "capable" person in the U.S. but would, instead, be considered "disabled."

The social and educational systems in the U.S. emphasize the English language as the sole and primary instrument for utilitarian promotion of colonial business to create a colonial elite. These systems intensely and continually demand that immigrants master the English language as a required part of the "happiness formula,"[1] by which immigrants, and particularly immigrant women of color, are "turned toward the norms, values, and practices of the colonizers."[2] As a naturalized U.S. citizen and immigrant, I have worked in higher education in the U.S. for a decade. In recollecting my past experiences and considering present ones, I question what it means to "master English" and to speak "perfect English." While examining my journey toward the mastery of English, I realized that this question is not merely an issue of language itself but also the effects of

1. Ahmed, *The Promise of Happiness*, 125.
2. Ahmed, *The Promise of Happiness*, 128.

language on all parts of life, as well as its associations with gender, race, and class. In other words, as a woman of color and an immigrant, I am expected to gain language proficiency and to have the "right" accent (i.e., that of White, middle- and upper-class, Midwest Americans); at the same time, though, because of my intersecting identities, I am simultaneously pressured to remain silent, which is the "place of struggle."[3]

When I was young, my grandmother told me that during the Japanese colonial period in South Korea (1910–1945), she and her mother (my great-grandmother) were forced to change their Korean names to Japanese ones and to speak Japanese rather than Korean. When they went to school, all the young children were required to use Japanese only. Japanese colonial forces prioritized Korea's Japanization, and Korean language was phased out by systematically prohibiting native Koreans from speaking their mother tongue. Colonizers know how important language is in defining and claiming one's cultural identity and relationship with the world, as well as finding one's place in that world; as such, the colonizers' removal of the mother tongue of the colonized is a form of symbolic violence.[4]

Such language politics continue to play out in the contemporary multicultural U.S. settler colonial context, in which the marginality of immigrant women of color is reflected in both the ways they are expected to speak and the ways they are spoken of. My journey of language struggle accorded with Anzaldúa (*Borderlands/La Frontera*); my mother tongue was forced to be cut off. I was immediately asked to choose between White and Black America for my new life, and stark contrasts were drawn between them: Whiteness represented success, power, and Western superiority, while Blackness was portrayed as non-Western, obscene, and ignorant. Faced with the duality of White versus Black America, I was taught to adopt the accent of White, middle- and upper-class, American women's English, characterized as soft and smooth, and expected as a standard for all women's language in social and educational settings.

As I continued to pursue my education and career in the U.S., I recognized that entrance into the U.S. educational system is a sign of

3. bell hooks, *Talking Back: Thinking Feminist, Thinking Black*, 28.
4. Fanon, *Black Skin, White Masks*; Shakib, "The Position of Language in Development of Colonization," 117–123.

submitting oneself to White America to become a "good" citizen. It primarily demands fluent English, which enables the attainment of settler colonial knowledge and perspectives. I was passionate about becoming an art teacher, which took me on a long journey through several standardized tests for California teaching certification, including CBEST,[5] MSAT,[6] RICA,[7] and TOEFL.[8] As my first step to becoming a certified teacher in California in the 1990s, I attempted to take CBEST. A section of CBEST required the completion of two essays within thirty minutes; completing those essays required speed writing and thinking in English, which can be incredibly challenging for those with English as a second language. I failed this essay test several times before passing successfully, which entailed painstaking efforts and enormous test fees.

At first glance, these standardized tests appeared to be neutral in terms of race, class, gender, and first language, and fooled me to believe that they are an objective measurement of candidates' skills (despite their language differences, immigration status, abilities, and so on). However, I came to know that the tests were structured using settler colonial logic, by which White settlers determined who was permitted to belong to the educational system by designing an apparatus of pass and fail.[9] Test results evidenced that teacher candidates of color passed such standardized exams at lower rates than their White peers.[10] At the same time, multiple studies have shown that the standardized tests for teacher certification do not translate to effective teaching performance.[11] What I came to realize is that these tests covertly perpetuate a racialized, hierarchical order, which comes at the expense of immigrants of color and English

5. CBEST refers to California Basic Educational Skills Test, designed to assess teacher candidates for California credential.

6. MSAT is Multiple Subject Assessment for Teaching, which is required for teacher candidates to show knowledge competence of multiple subjects.

7. RICA is Reading Instruction Competence Assessment, a test to ensure California teacher candidates for Multiple Subject Teaching Credentials and Education Specialist Instruction Credentials attain the knowledge and skills for the provision of effective reading instruction to students.

8. TOEFL is Test of English as Foreign Language.

9. Tuck and Gorlewski, "Racist Ordering, Settler Colonialism, and edTPA," 197–217.

10. Nettles et. al, "Performance and Passing Rate Differences."

11. Angrist and Guryan, "Does Teacher Testing Raise Teacher Quality?"; Shuls, "Raising the Bar on Teacher Quality."

language learners, who experience multiple barriers to succeeding at such tests, including a language barrier.

The language that troubles me in my immigrant life will never make me a desirable, full-fledged ableist participant in higher education, where the monstrous U.S. settler colonial logic forces my labor as capital. The settler's logic considers what it takes without apology, monitors my altered tongue, and forces my body/flesh to be kept to fit the system so that the settler's logic is continuously in charge of its racial play. However, I am turning my language into a decolonial tool to rage against the ambivalent play by continuously telling stories, stories of body/flesh, with untamed tongue yet assertive voice.

BIBLIOGRAPHY

Ahmed, Sara. *The Promise of Happiness.* London and Durham, NC: Duke University, 2010.

Angrist, Joshua D., and Jonathan Guryan. "Does Teacher Testing Raise Teacher Quality?: Evidence from State Certification Requirements," *Economics of Education Review*, 27 no. 5 (2008): 483–503.

Anzaldúa, Gloria. *Borderlands/La Frontera: The New Mestiza.* 4th ed. San Francisco: Aunt Lute Books, 2012.

Fanon, Frantz. *Black Skin, White Masks.* rev. ed. Translated by Richard Philcox. New York: Grove Press, 2008.

hooks, b. *Talking back: Thinking feminist, thinking black.* Boston, MA: South End Press, 1989.

Shakib, Mohammad Khosravi. "The Position of Language in Development of Colonization," *Journal of Languages and Culture*, 2 no.7 (2011): 117–123.

Nettles, Michael. T., Linda H. Scatton, Johnathan H. Steinberg, and Linda Tyler. "Performance and Passing Rate Differences of African American and White Prospective Teachers on Praxis™ Examinations," *ETS Research Report Series*, no. 11–08. Princeton, NJ: Educational Testing Service, 2011.

Shuls, James. V. "Raising the Bar on Teacher Quality: Assessing the Impact of Increasing Licensure Exam Cut-Scores," *Educational Policy.* Advance online publication, 2017.

Tuck, Eve, and Julie Gorlewski. "Racist Ordering, Settler Colonialism, and edTPA: A Participatory Policy Analysis," *Educational Policy* 30, no. 1 (2016): 197–217.

17

STICHES IN THE FLESH

Subversive Rewriting

MICHELLE BAE-DIMITRIADIS

Imposed to learn the script,
The logic of the west,
The logic of duality,
The logic of lifelessness,
The logic of blindness,
My mind responds in a still deep sigh.

Uncontrollable quietness commands my hand.
An unruly stitch jumps over the rules of logic,
A disruptive stitch claiming liveliness.
Reclaiming the terrains of alterity,
A willful stitch moving backwards
refusing rational minds,
Desiring western lines vanish
Stitches in the flesh
flamboyantly dancing liberation.

A relief.

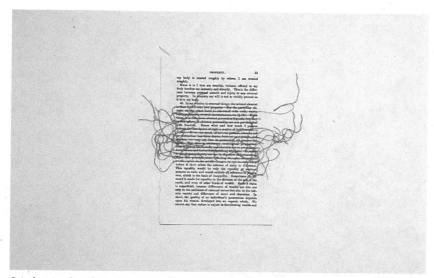

Stitches in the Flesh: Subversive Rewriting 1, 2019. A sheet of book paper and yarn, 5.5 x 9 in. (14 x 22.9 cm)

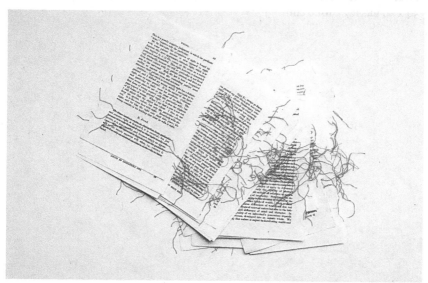

Stitches in the Flesh: Subversive Rewriting 2, 2019. Sheets of book papers and yarn, 20 x 24 in. (50.8 x 61 cm)

Stitches in the Flesh: Subversive Rewriting 3, 2019. Sheets of book papers and yarn, 50 x 40 in. (127 x 101.6 cm)

18

LEVELS TO THIS SHIT

Racial Categorization, Mixed Skin, and the Isolation of Bridging

VANESSA LÓPEZ

I SHOULD START by saying I don't consider myself mixed. I neither like nor use that term. My daughter refers to herself as mixed. I disagree. I think she is Black. Period. I think her father and I are of the same *casta* but on different sides of the color spectrum.[1] *Cocolo; Negro; Prieto; Mulato; Indio quemao; Jabao; Trigüeño; Trigüeño claro; Indio lavado; Blanco jipato; Blanco; Rubio.*[2] The color spectrum or racial categories we did not create but keep playing by. To be clear, I do not refer to myself as a Black Woman—to do so would feel inauthentic and insincere. I am not Black. I am also not White—to identify as such would be delusional and opportunistic. I am what some might call "olive-skinned" or "warm beige." My hair is naturally curly but easily straightened. No lye needed. My eyes are hazel, mostly brown, sometimes greenish. I used to refer to myself as Latina but no longer do.[3] I am a Woman of Color (WoC). While I know WoC is neither a race nor ethnicity, for me it stands as a marker on the spectrum, a choice in ambiguity. I inhabit skin that is contrary,

1. *Casta*—the Spanish word for "lineage," given to all persons of mixed ancestry.
2. Roberto Carlos Garcia, *black/Maybe: An Afro Lyric* (Detroit, MI: Willow Books, 2018), 23–243.
3 *Latino/a/x* is used as a pan-ethnic term that creates a de-racialized identity and groups different cultures together. This term no longer serves me.

malleable; skin that can be treated as a costume or a performance; skin that belongs in multiple places, spaces, and times. I know that skin does not function the same for every Woman of Color, and I know that my skin can be seen as a privilege. But more often than not, for me, it has felt like a curse.

I am Dominican American. Both my mother and father were born on the island of the Dominican Republic, and I am the first in my family to be born in the United States of America. Dominicans have been in the United States, and more specifically New York, for some time. Take Juan Rodriguez, who in 1613 was the first immigrant to settle on the island Manhattan and was of Dominican descent.[4] Given that history, you would think I would make more sense within the context in which I grew up. I was born and raised on the island of Manhattan—Upper Manhattan, Hudson Heights to be exact. Situated above Harlem and adjacent to the Bronx, Washington Heights, as it was called back then (read: pre-gentrification), was a predominantly Dominican and Black neighborhood. All of my friends growing up were island folks: from Jamaica, Barbados, the Dominican Republic, Puerto Rico, or from the island of Manhattan. We all had the shared experience of poverty and struggle and a common history of colonization and exploitation. Our positionality linked us as people of African descent historically and contemporaneously, mapping a shared historical experience of slavery, systems of inequity, and relationships where racialized identity was created and re-created.[5]

Yet there were times when I felt different. I was peculiar for lots of reasons. I was the in-between; *ni de aquí, ni de allá*. Spanish is my first language, but from an early age I communicated by making and creating with my hands; I observed, I reflected, I became an artist. I was a tomboy, una marimacho.[6] I cut my hair short and didn't like make-up. I was annoyed by the women on Sabado Gigante. But I was also different because of my skin. My skin did not match the story of the island from which I originated or the story folks had for that island. Dominicans were supposed to be dark-skinned, Black, and I was not that.

4. "Juan (Jan) Rodriguez," *Wikipedia* (accessed January 15, 2020).

5. Kimberly Eison Simmons, *Reconstructing Racial Identity and the African Past in the Dominican Republic* (Gainesville, FL: University Press of Florida, 2010).

6. Slang for girls that act and dress masculine and exhibit behaviors considered typical of a boy.

My family actively practiced endogamy. That is, they did the "work" to remain "White," to remain light-skinned, to remain privileged within a Black country. Now to be clear, Dominicans don't think of themselves as Black per se. The Dominican Republic functions as a pigmentocracy and with that abides to many of the unspoken rules of white supremacy.[7] The "one drop" rule functions in reverse in the Dominican Republic. If you have one or multiple drops of European blood, you will claim "Whiteness" to your benefit, regardless of phenotype, for as long as you can, and it will be honored and accepted by others just as mixed and delusional as you. So, my skin, this mix, somehow seemed to fit the idea of "Whiteness" in the Dominican Republic but contrastingly did not fit the idea of Dominicanness nor Whiteness in the United States. Perhaps my skin, my shell, was too ambiguous. Too hard to place. Too mixed up. Add to that my demeanor, my vocabulary, my style of dress, my likes and dislikes—I was often made to feel as if I did not belong among Dominicans.

Although Dominicans claim the Mirabel Sisters as revolutionaries, the word feminist was, and is still, a dirty word. To be a Dominican woman meant to be subservient to men and not be too smart or too angry. To be a Dominican woman meant to be desirable and sexy; thin but not too thin with long (relaxed) hair and red lips. My performance of gender and sexuality did not align with Dominican ideas of womanhood. I was angry and not interested in pleasing others, specifically men. And so I was not Dominican enough. In Black circles I had very much the same experience of otherness. I was not White but also not Black enough. My racial ambiguity drew (reasonable) suspicion. It was even worse within White circles. White people did not know where to place me; I was light enough to be "acceptable" but angry and still exotic enough to be fetishized. In White spaces I was constantly made to feel uncomfortable. For a long time, I yearned to comfortably belong in one racial or ethnic group. I wanted people to see me and know, know that I belonged.

But that is not the skin I occupy. I possess skin that can be flexible, ambiguous. Skin that changes meaning depending on context, season, dialect, costume. Skin that holds the history and complexity of conquest. Skin that is a visual effort in memory and amnesia. See there are levels to this shit. Race and gender are constructed, but their effects are real.

7. Ginetta E. B. Candelario, *Black Behind the Ears: Dominican Racial Identity from Museums to Beauty Shops* (Durham, NC: Duke University Press, 2007).

We all, consciously or unconsciously, play along. Our systems, structures, beliefs, and actions make race and gender real. Shit, I actively write, teach, and lecture about black feminist theory and racial equity. Yet my skin and my performance of womanness, this mixed-up shit, complicates the discussion. This in-between shit highlights society's limitations and contours. My identity, my skin, my way of being inhabits all the spaces. Not just the margins. I choose to identify as a Woman of Color because that choice inherently complicates the Black-White race conversation. Because being this type of woman expands the definition of feminine. What happens when you are not clearly one or the other? What happens when you straddle definitions? What happens when you possess power and privilege and impotence and burden? This shell throws into question our expectations, assumptions, and judgments.

This shell comes with privilege and with responsibility, but it also comes with a wider sense of belonging. Because of this shell, I belong everywhere and nowhere. This schism is isolating and exhausting, magical and empowering. This shell has allowed me to see both sides of the bridge. The bridge, the space in between either side, is where the healing can happen. And so, I act like a bridge of sorts; a connector. I know this is not for everyone. Shit, sometimes it is not for me. But I know it is not for those who are constantly burdened by racism, heterosexism, and discrimination, those without the escape I sometimes get. The paradox of not belonging anywhere is that a part of you belongs everywhere.

19

FEELING OUT OF PLACE

Friendship and Community Building Across Difference

NOZOMI (NAKAGANEKU) SAITO

Dear Joyce,[1]

I suppose you're surprised to hear from me, given that it's been almost ten years. I wonder if you've gone traveling even more since we last spoke. Maybe you've opened that floral arrangement shop you dreamed about.

I've been thinking a lot lately about our adolescence and what drew us together, you a Korean immigrant and me a Japanese immigrant. Maybe it was going to a school of mostly rich, white kids in an overwhelmingly white, conservative city. I didn't realize it at the time, but looking back on it now, it seems conspicuous that so many of our friends were girls of color. It was like in feeling out of place, we found a way to belong.

You were the first friend who introduced me to the idea of being Asian American. Before that, I always identified as a Japanese immigrant. In you, I found a friend who showed me that being Asian American could

1. Joyce Jung is a successful business woman, avid backpacker, floral hobbyist, and cherished friend. It was while writing this that, serendipitously, we reconnected after having lost touch for many years. I sent her this letter, and it rekindled a friendship that was so central to my own coming into being as an Asian American woman. If you read this, Joyce, thank you. I appreciate you.

make me part of something instead of being the cause of my exclusion. You used to joke about people saying about us, "look at those Asians," and you'd laugh that free-spirited laugh because you didn't give a damn what they thought anyway. Our friendship taught me about being Asian American, years before *Crazy Rich Asians*; before "Asian American" was a tag on Buzzfeed (before Buzzfeed was even a thing); before I ever learned that writers like Mitsuye Yamada, Maxine Hong Kingston, Nellie Wong, Lan Cao, or Nora Okja Keller had been thinking and writing about what it means to be Asian American long before me.

I've been thinking a lot in recent years about what it means to cling to my immigrant identity without also being overly attached to a national one. In my heart, Japan is still the place I call home. But since those days of our youth, I've learned, too, about Japan's imperialist history, including the colonization of my mother's people, the Ryukyuans; the colonization of Korea; and the systematic institution of sex slavery that trafficked women from Korea and other colonized areas. It all makes me wonder what I'm claiming when I say I'm Japanese.

Did it ever bother you, having to explain your friendship with a Japanese girl to your family and friends? I remember when your cousin said all Japanese people are ugly. You defended me, saying I wasn't, and I was part Okinawan, too. I didn't understand his anger then nor the implications of your reply. I think now maybe you were protecting me from the violence of history.

I hope you're thriving, wherever you are. Thank you for being such a significant part of making me who I am today. You introduced me to the Asian American community, and I imagine you are out there, continuing to bring joy to the people around you and making someone else who feels out of place feel welcome.

Always your "crAsian" friend,
N

Dear Tiffani,[2]

Thanks for the video chat the other day. Our talk restored me in a way that only happens from confiding in another woman of color. I'm glad to hear you've built a community of Black women to surround and support you. It's like you said: being the only person of color in a white environment damages the psyche. Now that you have a community of Black women, you seem more vibrant, joyful.

I've been thinking a lot lately about what it means for me to identify as a person of color. I'm not talking about colorism but rather the politics of identity politics.

I saw a Facebook post saying people shouldn't say "people of color" when they mean Black and Brown people. I wondered where that left people like me. One of my favorite Asian American scholars says we don't need to aspire to "second-class whiteness." I love that. But I also met a student who identified themselves as "white" at one point and later as "Asian American," and they weren't separating the two in the sense of being mixed race. I couldn't wrap my mind around what seemed to me two irreconcilable positions. I could understand identifying as "mixed race," but to claim whiteness and then later mention Asian-ness? I wonder if deep down, maybe what disturbed me the most, though, was what that meant for me as an East Asian American to identify as a person of color.

It was something you said that underscored the differences of our oppressions. It was the day the white supremacists invaded Charlottesville. I messaged you, saying I'd never been so scared to be an immigrant and a person of color in America. I asked if you were okay. You seemed tired but not surprised. You said your white friends on social media were shocked but your Black friends were not at all. Your comment was a wake-up call for me. I recognized then that my (in)visibility as an Asian American isn't the same as the hypervisibility of Black and Brown folks who face threats

2. Tiffani Lewis-Lockhart is a Black feminist, published writer, avid reader, pop culture critic, and librarian in the making. She has opened my eyes to many issues, from the intersections of mental health and race to sex positivity and queerness. She is also one of the funniest, grounded, and most thoughtful people to have graced me with her friendship.

of police violence, persecution at the borders for mass deportations and migrant detention camps, or travel bans due to their birth nation.

If I had grown up in Okinawa, my mother's island of birth, the politics of claiming my identity would be different. The island was colonized (the euphemistic term is "annexed") by the Japanese Empire, and since the end of World War II, it has been occupied by the U.S. military. Okinawa's main island holds over seventy percent of the U.S. military bases in Japan, which take up nearly twenty percent of the main island.

Tracing my history through my mother's Ryukyu heritage has become increasingly important for my sense of identity and politics as well as my feminism and spiritual heritage. Last year, I met other Uchinanchu (Okinawans and Okinawan-descended people living outside the islands) for the first time. Being with them, I felt like I could belong. I was among people who truly lived their anti-imperialist politics. In a different context, Cristina Beltran says that *Latinidad* is about what a person does, not who they are. Maybe the same applies for Uchinanchu. If I were to take a cue from you and build a community, it would be with other Uchinanchu.

Sincerely,
Your Uchinanchu friend

––––––––––––

Dear Gabby,[3]

I miss you, and because I don't say it enough, I love you. Pittsburgh became colder and greyer when you left. But I also know that you're where you need to be right now and doing the hard work of molding young kids into compassionate, caring human beings.

3. Gabby Benavente is a trans, Latina feminist and activist for queer and trans rights and environmental justice. She is also an independent scholar, educator, culinary artist of Peruvian dishes, and one of the most intelligent and compassionate people I have the honor of knowing.

I think a lot about you when I think about who carries out the labor of anti-racist practice and dismantling the interlocking systems of capitalism, racism, transphobia, homophobia, patriarchy, nationalism, environmental racism, and climate change. I think about that labor when I remember the differences in our teaching experiences: the openly transphobic, anti-Latinx hostility you faced and somehow stood up to versus the milder forms of bored dismissal and occasional low marks on teaching evaluations directed at me. How differently students read our embodied presences.

You were out of town last summer when I went canvassing for Casa San Jose with some friends. We were tasked with signing people up to create a *zona de respaldo* and informing them about the rights of Pittsburgh's Latinx residents. It was after the announcement of the ICE raids. Honestly, I'm glad you weren't there. I wouldn't have wanted you to suffer the painfulness of people's indifference. Only one person was openly hostile. It wasn't so much what she said (when I asked if she wanted to hear about human rights, her only reply was "No"); it was the cold hatred in her eyes. (You know "the look." The glares both of us have experienced walking around as people who appear visibly foreign.) But the indifference of so many others was what truly made me feel hopeless.

The xenophobia is just too much most days, but I won't do you the disservice of suggesting I know what fears you experience. It's like you've said before, Latinx immigrants are hypervisible in ways that Asian immigrants are not.

Despite the differences of our oppressions, there were so many ways we connected. With you, I could talk about being a person of color and dating a white man; about trying to live up to the expectations of immigrant parents, given all their sacrifices; about being queer, immigrant women of color. It's all the silly stuff, too, our secret JPW club, the guilty pleasure of anime, the joy and emotional roller coaster of *Pose*. With you, I have found that no matter how many ways society may tell us we are out of place, it's possible to belong and build solidarity across difference.

If I don't make it to visit your new city soon, I'll see you on the picket line.

In love and power,
Nozomi

20

WHERE ARE YOU FROM?

ADRIANE PEREIRA

WHERE ARE you from? I am American. An oversimplification of my identity . . . An abbreviation of Cuban American where Cuban is the adjective to the noun.[1] An abbreviation of how "Americana" came to be. *Where are you from?* My mom is from Cuba, and my dad is from Ecuador. So, Cuban-Ecuadorian American. A hyphenated hybrid routed from Europe through the Caribbean and South America.[2] A hybrid of oppressor and oppressed. My mix evidence of conquered and conquistador. *Where are you from?* "Pereira" is Portuguese and Colombian and Ecuadorian . . . Embracing, revering, and becoming my matriarchy and rejecting my patriarchy.

My *Latina Americana* identity is grounded in a matriarchy borne through exile, from the persistence of my mother(s) to resettle and stabilize. My grandmother left behind her one-room schoolhouse (to which she arrived sidesaddle on a horse) to start anew at age 39. My mother entered high school with the task of learning English. As the daughter of Cuban exiles, I was expected to be studious and pragmatic so that my life

1. Anzaldúa, *Borderlands: La Frontera*.
2. Pereira, "Becoming a Woman of Color," 48–65.

would be easier than theirs.[3] My freedom, a reward for their sacrifices, was instilled as pride: "Tu eres Americana." You are American.

But where are you REALLY from? Because you don't look American. Well, I AM, I said to the jolly White man in the apron. I am American, native-born, AND Hispanic. I am also a professor. Imagine that! They call me doctor.

De donde eres? Soy Americana, nací aquí, y mamá es Cubana y mi papá Ecuatoriano. *Y usted de donde es?* Soy Colombiano . . . de Guatemala . . . de Honduras . . . vengo de Perú. Llegé el año pasado . . . hace cinco años . . . estoy aquí desde 1967. Aprendí hablar español en Miami. I learned Spanish growing up in Miami, so please excuse any lapses. I am from a place where the language is neither Spanish ní inglés, but both.[4] A language capable of communicating the realities of living in a largely Hispanic U.S. city. Do you have a *liga*? ¿Vamos al Gualmar? Comemos en Guendis. I am from a place where we greet everyone in the room with a kiss, celebrate Christmas with roasted pork shoulder, and pin azabaches on babies to ward off the evil eye. I am from a city in the United States where I can spend an entire day speaking mostly Spanish while grocery shopping, visiting the pharmacy, fueling the car, and visiting a doctor.

Que chevere que nacístes aquí, the driver says. I am from a place where the intersection of American citizenship and Latin American roots are a privilege and not othered . . . where Hispanic-American is conventional, expected, commonplace, an aspiration. I am from a place where I forget my race, fit in, and belong.

BIBLIOGRAPHY

Anzaldúa, Gloria. *Borderlands: La Frontera*. San Francisco: Aunt Lute Books, 1987.

Moraga, Cherríe. "La Guerra." In *This Bridge Called My Back: Writings by Radical Women of Color*, edited by Cherríe Moraga and Gloria Anzaldúa, 27–34. New York: Kitchen Table: Women of Color Press, 1981.

Pereira, Adriane. "Becoming a Woman of Color," *Journal of Cultural Research in Art Education*, 46 no. 2 (2019): 48–65.

3. Moraga, "La Guerra," 27–34.

4. Anzaldúa, *Borderlands / La Frontera*.

21

KARACHI, "FIRST WORLDS," AND THE SPACES IN BETWEEN

SABA FATIMA AND SANA RIZVI

Saba:

It was March 1998 when I got my acceptance letter to Ohio Wesleyan University.

I felt ecstatic! A full tuition ride!

Then I saw my mother's face. Ammi was smiling but looked sad. I knew she was happy that I got the scholarship. But I saw her and was hit by what I'd be leaving behind, everything I'd be losing. As my departure date got closer, the frequency of my escapes to the roof of our house increased. I'd lie on top of the water tank and memorize the sky, or often just cry. Leaving Karachi for a full ride seemed the logical thing to do, and yet . . .

———————

Sana:

As you left, I felt a sense of guilt. We had fought a few weeks back, and I had decided this time around, I would not be the first to apologize. So when you made amends the day you were leaving, I felt angry that I had lost precious time with you. I also felt betrayed—I was happy for you but angry that you couldn't take me with you. I felt wherever you were going to had to be better than what we had here.

Saba:

The first few years were all about surviving and processing loss of home. I did make good friends in college. But capitalist nationalism was intruding in my life in strange ways. In my first semester, my father's employment was not renewed because of Saudization—a nationalist scheme in Saudi Arabia aimed at employing more locals and expelling brown skilled labor. That was a big blow to Abbu, although he never did want to talk about it as such. The same year, Pakistan conducted nuclear tests in response to never ending militaristic posturings with our sisters across the border. And on the eve of the tests, the government froze all foreign bank accounts and the currency devalued overnight. I ended up with three different jobs, most in the service industry, and navigated the intersections of poverty and xenophobia in Amerika.

Sana:

1998 felt like a decade. At sixteen, I was too young to make the connection between the sudden deterioration of Abbu's and Ammi's mental and physical health and how that was intrinsically linked to our uncertain futures. I could sense their worry with regards to me—I could not see myself in a noncreative field, and yet I was beginning to understand that not all of us had the privilege and cultural capital to pick arts and humanities as our occupations. "There is no respect or jobs for people in

arts," Ammi kept saying to me. It was disheartening to turn down tuition scholarships at Pakistani art institutes. Instead, I decided to prove my usefulness and maturity to my parents, to reassure them that we were all doing better, that we were all fulfilling our parents' dreams for us. I applied and was admitted to a top business school in Karachi.

Saba:

One of my earliest memories of America from my college years was visiting a nursing home while accompanying a friend who was visiting her grandparents. I scanned the neglected bodies as I walked through the hallways. I thought to myself, is this what Americans do? I saw nursing homes as where the elderly were dehumanized, regarded as mere wallets. I saw families working hard to help with the costs so that their parents could be in the best possible facility. I saw the underpaid caregivers. The only entity that seemed to be winning was the for-profit retirement industry. But more importantly, I thought to myself, is this where I was headed, the sort of person who will drown in work, struggle to survive, with little investment of personal labor in service of folks who labored their entire lives for me?

Travel home was expensive and the next time we met was at our eldest sister's wedding. Ammi and Abbu said yes to our eldest sister marrying into a family we barely knew. I felt outraged and also conflicted. What did I know about how marriages are made? I called my elder sister and told her that I'd stand by her regardless of what she chose to do. She stayed silent. I took that as consent.

Sana:

We united for a brief time at our sister's wedding. I think there was more joy of our family being reunited than of our sister getting married. We both became witnesses for the first time to the oppressive practice of

dowry, the price for a groom from *pardes* (foreign land). It was the first time I learned how common the practice of transnational marriages was a way for diasporic communities to maintain their ties with their homeland. Brides from the Global South were that bridge for them. The old colonial threads seem to make our parents dance like puppets in whichever way their strings were pulled by the groom's diasporic family. Suddenly the thought of foreign land seemed exploitative and consuming. Our family was giving so much of us by sending our older sister to *pardes*, and yet they acted as if this was good for her, and we were lucky that they, *pardesis*, were even interested in us.

Saba:

With the eldest sister married, Ammi's eyes turned to me. Ammi always believed that marriage was a patriarchal institution, even if she never used those exact words. She'd say: "If you don't study *beta*, you will end up getting married."

But even when I was leaving home the first time around, various extended family members came to Ammi and told her that she would regret the decision to send me abroad, for who would testify to my purity? Who would be my guardian?

Alas, I did get married, outside of my religious sect but somehow both families (eventually) agreed.

Sana:

I felt less angry when you got married. I think primarily because you tied the knot on your terms in the first place. There was no obligation to feel indebted to the diasporic community who had been gracious enough to pluck someone from the Global South. I have been thinking of this feeling of imposed gratitude. I did not want to feel thankful when it was my

turn to get married to my husband, also from a diasporic community. I wanted to feel happy. But like my elder sister, I was reminded everywhere I went that I was lucky to be emigrating to Great Britain. For them, I had finally gotten closer to becoming a British subject—but when were we ever not?

＝＝＝＝＝＝＝＝＝＝

Saba:

The day I got my American citizenship, I felt a huge sense of guilt and loss. The guilt was precipitated by my now-explicit complicity in the oppression of "my own people" in virtue of my citizenship of the imperialist enterprise. The loss, well . . . at that point in time, Karachi had stopped feeling like home for quite some time. But this was different. There was no more 'my people.' Living within a joint family system, in a non-Shia family with diametric Pakistani and religious politics, existing within a secular academia where folks seemed to be autonomous units with no familial and/or communal obligations—in these worlds, who were my people?

It took years to realize that there were so many resistant narratives within the Global North, first- and second-generation immigrants, folks thriving and fighting, folks who, as María Lugones says, do not necessarily reject the exact same dichotomies that I do, yet live as liminals.[1] These are my people.

＝＝＝＝＝＝＝＝＝＝

Sana:

My first few years in Britain were suffocating. Somehow the promise of a better future was slow in coming, and yet each day I was performing the role of a grateful subject. It was as if the South Asian diaspora was complicit in my forgetting of my home in Pakistan and was quick to

1. Lugones, *Peregrinajes/Pilgrimages.*

forge new memories about how I had finally made it. The old diasporic community was eager for me to embrace the melting pot. My loves began to be pushed out of my mind—my love for painting, singing in Urdu, and wearing *khoosas* (a type of shoes). These were the same things that my in-laws had once seen as the very reasons to bring me in as a bride into their family. I would bring culture back to them, they thought. My cultural expressions that were once seen as symbols of my purity, my morality, had now become proof of my backwardness, my *paindoo*-ness. Like Quintanales, *I paid very hard for my immigrant ignorance.*[2] I had crossed over being a Third World woman to a woman of color.

———————————

Saba:

Today, my children are growing up as part of diasporic communities, connected to the Global South via an increasingly weakening thread. They exist in their brown Muslim bodies yet reside in privilege. They must forge their own sense of self. I find myself praying that their sense of self is linked to their Muslim identity, living an ethical life, casting their ballot with other liminals, with the oppressed. I fear that they will become subjects of this oppressive empire, or worse, they may absorb the neoliberal capitalist mindset. I pray that they land in the spaces in between.

———————————

Sana:

It has been ten years since I crossed the first bridge to Great Britain. I have a son now and want him to love the place where I have come from. I have made a small place for myself within the diasporic community, and I wonder if I would build bridges for my son just so I can feel a little bit at home too? My relationship with Pakistan is complicated; we both don't recognize each other anymore. We both have changed, some aspects of

2. Quintanales, "I Paid Very Hard for My Immigrant Ignorance," 151–156.

us becoming dutiful, liberal, colonial subjects, other parts of ourselves resisting with full force. And while we both have resisted the oppressive systems imposed on us, it is no surprise that in doing so, we have drawn many a bridge between us.

BIBLIOGRAPHY

Lugones, María. *Peregrinajes/Pilgrimages: Theorizing Coalition Against Multiple Oppressions*. New York: Rowman & Littlefield Press, 2003.

Quintanales, Mirtha. "I Paid Very Hard for My Immigrant Ignorance." In *This Bridge Called My Back: Writings by Radical Women of Color*, edited by Cherríe Moraga and Gloria Anzaldúa, 151–156. New York: Kitchen Table: Woman of Color Press, 1983.

22

ASIAN AMERICAN FEMINISM, LETTER WRITING, AND THE POSSIBILITY OF BREA(D)TH

LAN DUONG

This piece is dedicated to my homegirls from San José (Trang, Tam, Odine, and Linh) and in academia (erin, Isabelle, Linda, Thuy, Tram, and Yen). Thank you for letting me breathe in the many spaces we inhabit together.

I. THE VALUE OF HOME AND WORK

In the last few years, I have realized the value of Homework: I have studied the history of our people in this country. I cannot tell you how proud I am to be a Chinese/Korean American woman . . . *I feel now that I can begin to put our lives in a larger framework.* Ma, a larger framework! The outlines for us are time and blood, but *today there is breadth possible through making connections with others involved in community struggle.*

—*Merle Woo, "Letter to Ma," 147. (my italics)*

Six years before the ground-breaking *This Bridge Called My Back* is published, I arrive from Việt Nam to a small town in Pennsylvania in 1975 as a refugee. I am almost three, with a cut to my bangs that runs across

my forehead like a bandit in an open field. Before this, I have no earlier memories of the country and the wars we left behind. We move soon after to San José, California, in 1980 to take refuge in the sun and be a part of the economic boom taking place in Silicon Valley at the time. My siblings and father are low-paid laborers in high technology for most of my life, bringing work home to assemble on the weekends—motherboards encrusted with spikes and pins—and taking side jobs at manufacturing plants on their "time off." Their clothes always smell like industry by Friday. When I come to Cherríe Moraga and Gloria Anzaldúa's anthology of Third World feminists and writers who sing laments and odes to community and collectivity, I am in graduate school, writing poetry part-time because, while it sustains and feeds me, I am too busy trying to tame this new language called theory.

I recount these markers of time and space in my childhood in order to, as Woo states, place the book, *This Bridge Called My Back*, "in a larger framework" and expound on the "breadth" that is possible in connecting the individual with the community, of linking the personal with the political, and back again. My refugee upbringing in San José, California, forms the spine for this short piece: here, I speak of being a refugee poet to celebrate how this foundational text was both a catalyst and a revolution for me, in recognizing how feminism speaks in many tongues, sometimes through the (maternal) body, and always heavy and dense with the braiding together of the stories and lives of others. *This Bridge Called My Back* gives me the language for the feminism I grew up with, a vocabulary to name the injuries of war and patriarchy in the making and breaking of men and masculinity. It has also helped me to appreciate the strength I share with my sisters and the women with whom I form an artistic and academic community.

THE REVOLUTION STARTS AT HOME[1]

In particular, I am inspired by the writing of Asian American feminists and the ways they start their pieces talking about home and family and

1. From the title of the book *The Revolution Starts at Home: Confronting Intimate Violence Within Activist Communities* by Ching-In Chen, Jai Dulani, and Leah Lakshmi Piepzna-Samarasinha.

radiate outwards toward broader critiques of systemic racism, sexism, and homophobia embedded in U.S. society and national culture. In Merle Woo's piece entitled "Letter to Ma," she speaks of the history that bespoke her and called forth her identity as an Asian American, lesbian feminist. I was astonished to see the genre of epistolary writing, which I had thought was reserved mostly for white women writers of the Victorian era, serve Woo in speaking to one's own family in a language that is at once loving toward her mother and father and rageful toward the racial and classist struggles that inhibit her place in the world.

II. STITCHING LETTERS TO MEMORY

Dearest Mother, it's been twenty years, and this is the first time I've written. Ever since I felt the milk on your breath and then was taken away during the fall of Saigon, this is the first time I've written.

Woo's writing about home and homework, story and history, inspired me to write a poem called "A Letter to Mother," which was born out of a desire to connect with my mother who was left behind in Việt Nam in 1975. That year, we took flight to the U.S. before the communists came to Saigon to claim victory over the country in a violent war fought across many decades and between many countries. My mother and I would not reunite for another twenty years, and even then, it was hard to reconcile the lost years between us, those years constituting a whole body of experiences and a vast breadth of memories.

My separation from her was an extension of the isolation I felt within my family in the place we called home. Though written to my mother, the poem dwelled on the separateness of our lives once we resettled in California. I wrote, "Father grows old. He adds too much salt to the fish now. He doesn't know me / Sister 2 loves too many men / Sister 3 loves no one / Brother 2 needs to fight another war / And Father doesn't know me." The poem runs through stories about my mother that were told to me by my sisters. Providing stories like they were morsels of food, my sisters connected me to her, me to Việt Nam, and I devoured every curve of their words. In my poem, I noted the irony that while "I am the youngest, I am

most like her in my stout body and matronly calves," with "hips as wide as a basin," and in my "slender, jadeless fingers" that when placed together, and with the light peering through the gaps between them, foretold of our habit for spending too much money. They told me our hands held too little light, and never enough money. Even though I hold no memory of her taking care of me, it's these details that I have kept in the lining of my skin many years after.

The poem, and more broadly, my poetry, is also an homage to the other women in my life, those women who are my sisters and whose strength and rage inspire me to name what white liberal feminism doesn't see. My sisters and I spent years sleeping together, our limbs entangled, our memories seeping into our blood. For a long time, I knew no other love than this: my sisters shielding me from my father's words and blows, my sisters carrying me through the fire, my sisters teaching me what strength is and what weakness means, what joy is to be had in creating beauty, life, art. Their heartache and the way we love are stitched into the seams of my poetry. Their fury fuels mine, their stories feed me within a house ruled by a father who bruised them with military-issued hands. In our home in San José, I witness their strength and vulnerability and their fights against patriarchal rule and social norms. They forge personhoods that are too much for my father to bear years later when he is, finally, weak, and enfeebled. Western feminist theory cannot begin to describe this.

THEORY TURNED FLESH

In the home I grew up in, where I was without a mother but with many sisters, I was part of and participated in a feminist practice—of making home livable and inhabitable for us women. And when I was in graduate school, squirreled away in a carrel at the library, where it was dark and quiet, I found in the *This Bridge* a bridge between home and the world, between the work of homemaking and homeworking that we women did for our family. It is something we still do in fact. I think of my sisters and, relatedly, of the community I want to be a part of in creating and forming—a radical community of color that is committed to revolutionary thought and action. *This Bridge* compelled me then and now to think about the ways in which the home is the site of revolutionary feminist

thought, one that is as transnational and radically transformative as our lived experiences require it. The book, and the words contained in it, have provided me with a way to bridge my scholarly and personal life, my creative and critical worlds, in ways that have framed my thinking and feeling about feminism and importantly, my voice and place in it. Its bold language of assertion and anti-racist, anti-classist, anti-sexist stance has helped me make sense of the wilderness that was the Vietnam War and my refugee childhood, enabling me to negotiate the language and class barriers that one makes in that crucial passage from student to scholar, from witness to writer. Indeed, *This Bridge Called My Back* has given me the grounding to say: I am a first-generation Vietnamese American refugee writer and scholar, and I have come to feminist language through my poetry and scholarship.

23

THE WATER AND THE BRIDGE

Dilemmas of In-betweenness

MANISHA SHARMA

South Asian. brown. woman. middle class. Brahmin. privileged
and powerless.
immigrant. alien. educated. bilingual. brown. woman. privileged
 and powerless.

I am here
My heart divided (or is it multiplied?)

Do I write from *there*, from where my foundational knowing
comes
Or *here* where I (hope I) touch lives on a daily basis?
And how do I categorize the knowing that comes from living in
 multiple worlds, expressions of multiple languages?

I am torn
Constantly
with these thoughts

To whom do I speak? Of whom do I write? Whom do I reference
in order to be heard and to resonate and what vocabulary do I
use—what are the consequences?

Calls to declare academic allegiance and affiliation are even
 harsher, more punishing, than nationalistic genealogies as they
 ask: Where do you belong? What scholarship has your primary
 claim of belonging? Declare your claims, check the appropriate
 boxes and we will put you in the correct place, issue the appro-
 priate passport.

But I want to travel, unfettered, with love, to the places that have
 given me a sense of home! Why do I have to choose, reject
 one over the other? Why must allegiance and belonging be
 exclusive?

My back is scarred from trying to be a bridge across two banks of
experience
as the river that I try to ford swirls muddier and murkier.

I seek clarity, commonality without dilution as demanded: An
endless, impossible task.

The problem with a bridge is that it must rise above the water

But then I am the water too,
Running through two lands, the silt of two histories blending,
 separating.

Safe ground on one bank, if I be the water: desi, Brahmin, wife,
sister, friend, cherished daughter.

Slippery slopes on the other:
Brown and foreign (pardesi)
In between black and white, separate but with a gut understand-
 ing of both for
I have lived the privilege of whiteness in the Global South, the
 travails of color and foreignness in the Global North.

In the United States, I am Asian, but not Asian, Indian but not
 Indian.
In both, I am a middle-class intellectual, that most awkward of
 things.
What am I fighting for, who am I trying to be? I ask myself as a
 daily mantra.

I am safe when invisible, or that's what I was told.
My family, my community tell me: Safe and nice. Be safe and nice.
Someone will listen
But safe and nice isn't real so no one really does; I am rendered
 invisible, not safe.

As a woman—as a woman of color—it's never been safe, and
invisibility has only made me diaphanous

So how do I navigate waters, banks, bridges, foundations when
there are no clear demarcations anymore?
In traveling, I become
more than I was.

Time and experience weave their wonders
I have become formless, invisible
One with everything
And nothing at all

I am (sometimes) at peace with this becoming
everything and no one
Connecting, disconnecting, flowing while still trying to have
 a substantial bed for the river to flow, not stagnate like still
 waters often do.

I've learned to do dispassionate work with passionate causes
Lead a dispassionate life with passionate pauses.

Its lonely work, such traveling
And solitude is not tranquil

Know this: the process of internal work is not tranquilizing but
 can sometimes be numbing.

Sometimes I feel as if my work, my life touches everyone, touches
no one.
Can *you* tell, my readers, my students, my communities: To whom
 do I speak? Of whom do I write? Is it you? Is it you? Is it all the
 me's that I embody?
What is my role but to be the truest version of myself I can be in
 making sentences, actions, art
with hope that I sparked recognition and solidarity somewhere.

Be patient, be strong, and above all, be brave. I chant this mantra
as time and experience weave their wonders

As bridge, as water, as artist, teacher, wife, sister, friend, daughter
I become,
more clearly
south asian. brown. woman. middle class. brahmin. privileged but
 not powerless.
immigrant. alien. educated. bilingual. brown. woman. middle-
 class. privileged but not powerless.

Afterword: My thanks and gratitude to Vedanta, to my Christian
schooling, to my Buddhist studies, to postcolonial, decolonial,
critical theory, to the English, Spanish, Japanese, Hindi, and Urdu
forms of expressions that allow me to see, feel, express and expe-
rience the world in myriad ways that form the waters, bridges,
banks and beds that drive me to be a better being in existence, to
become the water, the bridge and a safe bank for others.

PART 5

Mothering and Sistering

Sissy My Playmate; Sissy My Enemy; Hand-Check-Slap, 2009. Three digital archival prints

24

SISSY MY PLAYMATE; SISSY MY ENEMY; HAND-CHECK-SLAP

SAMA ALSHAIBI

"Sissy My Playmate; Sissy My Enemy; Hand-Check-Slap" from the project *The Pessimists* invites a contemplation of the invisible forces that police the behavior of individuals; the "pessimists" control one another by planting doubt, worry, and fear, gestures that often engender stagnation. The perpetuation of behavioral norms relies on those policing virtue via their agents; the family and friends of one's inner circle each have a role to play. The tryptic photographs depict two bodies standing opposite each other, cycling through familiar childhood games that recall and repeat the power dynamics of the strong and the weak. The two figures pattern behavior in either cooperation or conflict escalation, performing the psychological negotiation between the oppressor and oppressed.

25

THE DIFFERENCE IS—MY LIVED EXPERIENCE!

SONIA BASSHEVA MAÑJON

Mi Abuela, 2015. Dedicated to the memory of Emilia (Milita) Rymer Rodriguez (September 23, 1915—March 21, 2016). Photograph by Sonia BasSheva Mañjon

My Abuela always instilled in me a sense of pride about who I am and was an example of how to live with dignity and respect as a Dominican woman in the world. She taught me about my ancestors, my great-grandmother and great-great-grandmother, whose photos I display prominently in my home. I learned of their journeys through the islands

(Trinidad and Puerto Rico), finally settling in the Dominican Republic, where she and my parents were born. She also stressed the importance of understanding what it means to be a proud *Dominicana* and of our struggles as women in a patriarchal society, how to choose wisely, marry carefully, and to always remember that our children are our most valued treasures. September 26, 2015, we celebrated her one hundredth birthday. Abuela was the matriarch of the family, and her children, grandchildren, great-grandchildren, and great-great grandchildren celebrated her near and far. As the self-appointed documentarian of the family, I was equipped to document the event to contribute to the body of family narratives I have been collecting since 1984. It all began with my undergraduate thesis, "Dancing Merengue with a Dominican Club in Los Angeles" where I explored *merengue* as a national dance and music form of the Dominican Republic. This shaped who I was becoming as an artist and dancer, my underlying cultural formation, and my identity as a Dominican *mujer*.

Turning one hundred is considered a major milestone, but in my family it's expected. My Abuela is one of twelve children. Her oldest sister died at 113, and her *Tia* was even older when she made her life-death transition. Our family all expected that this would mark a new phase in my Abuela's life journey. She was in relatively good health; she had cataracts and used a wheelchair, but she was still *la reina* of the ball, the merengue/salsa/bachata queen at every party. Sneaking sips of her favorite drink (gin and tonic), which she drank from a straw, her preferred way of having her cocktail, was an amusing pastime she shared with her grandchildren. My *Tio* (her son) forbade it, but we were all too happy to abide by her request. She was constantly in her glory and splendor and we, *las mujeres Dominicanas*, secretly admired her will and tenacity to have things "her way," which is how I have always known my Abuela. This set the context for my coming of age, my journey understanding my bi-cultural (Dominican/American) and intersectional (Latina/Black/first gen) existence. I constructed myself through my grandmother and my mother's stories. Their experiences as strong independent women would forever be my North Star. Their stories taught me to live by my terms, learning from my challenges and disappointments, while celebrating my accomplishments. My Abuela made her life-death transition March 21, 2016. I dedicate this to her memory.

MY STORY

I never knew I was different until I was identified by my third-grade teacher as Black on a questionnaire she was filling out on racial demographics of each student in my class. It was 1968, Compton, California. Some students were asked to identify their ethnicity and given a choice, i.e., White, Black, Chinese, Japanese, Mexican, other. I wasn't given a choice; I was identified based on the color of my skin. I wasn't given the opportunity to self-identify. "*Yo soy Dominicana*, my family is Dominican." "What's that?" one of my classmates asked. "That's who I am," I replied to the student and to my teacher. "Where is that?" another student asked. When I explained the location of the Dominican Republic, it was a geography lesson. "It's an island in the Caribbean, on the other side of Haiti, next to Jamaica, between Cuba and Puerto Rico." The looks were even more perplexed, not only from the student who asked the question, but from all my classmates and probably my teacher as well.

She informed me that Dominican was not an option and I would have to be listed as Black. "What are the other choices?" I asked, not trying to be difficult, but my Abuela always told me that I was Dominican. "*Tus Padres son Dominicanos y tu tambien*," she would tell me. My teacher read off the options as they appeared on her questionnaire: white, Black, Hispanic, Asian, Native American, and other. Now I was confused. I couldn't identify with any of the options given, so I told her I would ask my mother and let her know when I came to school the next day. When my mother arrived home from work, I asked her, "Mom, what am I?" The confused look on her face said it all. "What do you mean?" she asked. I began the story as it happened in my class that morning. "You are a person," she said, outraged. "If anyone asks you again, you let them know you are a person and if they want to put something on their form, they can mark 'other.'" Well, that was her answer, but not mine. I knew I wasn't "other," I was Dominican, just like my Abuela told me.

Growing up in a Dominican household in Compton, California, in the '60s and '70s to parents who immigrated to the U.S. in the '50s was a lifelong lesson in bicultural existence and intersectionality. I was considered "in-between" and "not quite" African American and Hispanic. I couldn't just be Dominican because we were unknown among the

Spanish speaking immigrants in California, nor could I be Afro-Latina as the term wasn't being used in my circles. I was relegated to the "other" category. My long talks with my Abuela would guide me through the maze of identity politics, which would remind me of my strong matriarchal lineage of women who navigated countries, loved and lost partners, and raised children to conquer the unknown.

My own migration journey started at birth in 1961 in Fort Campbell, Kentucky, on an army base and has led me through multiple states and countries, including Alaska, California, Connecticut, Ohio, Puerto Rico, Costa Rica and of course the Dominican Republic. These experiences shaped in me an understanding of who people are, how they operate, and the difference location and demographics make on how I am perceived and expectations of my performance or lack thereof.

THE ACADEMY

Coming of age in the '70s was empowering. Women's liberation, Black Power, and La Raza completely emboldened my world and my consciousness. My experience as an academic and university administrator at four different institutions shaped my body politics about structural and institutional racism and unconscious bias. I began my academic career in 1995 as an adjunct at a small liberal arts college, while completing my master's degree. Moving to a larger art college, I quickly rose through the ranks as a center director in 2000, chair of diversity studies by 2002, founder and chair of a newly created major in 2003, and was awarded an endowed professorship in 2004 when I completed my PhD. I became a vice president in 2008 at a private liberal arts university, while continuing my research and teaching. In 2013 I was recruited, with tenure, to a research university as inaugural director of an endowed center and held various affiliations in other departments. At each institution, I fought for recognition and support of invisible identities, those at the margins, and diversity at all levels. I organized partnerships with communities and organizations historically abandoned by these institutions. I developed study abroad experiences for students who would not have had that experience due to cost restrictions. I was tapped for various committee

work, especially those needing diverse representation, all while teaching and publishing.

What I came to understand through twenty years of "the academic grind" was that I was never fully seen for who I am. My *Latinidadness*, my power as a woman, my multiple experiences, my love for art and dance, my vision of an inclusive world, and my gift in seeing possibility outside of the structures of colonialism, patriarchy, hierarchy, and all the -isms that benefit the status quo, which I was not a part of. My worth in academia was based on my production of books and articles, teaching evaluations by students, committee work, and number of students I mentored through graduate studies. The body politics that determined who gained what accolades was reserved for the class, gender, and race that I did not represent. The clawing of certain individuals to gain more power, more visibility, more money was a game I ultimately chose not to play. When I called out tokenism and inequalities, as so many of my colleagues had done before me, I was quickly discounted and banished. Entering the academy to influence a different way of thinking and being was too much of a radical distraction for those who chose to play by the rules. Besides, the academy was doing exactly what it was intended to do, support a system of privilege. My work with under-resourced communities and students of color was not the priority they claimed it to be. I came to understand the Academy not as a place for higher learning for all, but a business that existed on supply and demand, or "butts in seats," as my dean would tell me. What I realized through my experiences and hard lessons is that structural bias and institutional racism is completely ingrained into the fabric of the academic infrastructure, and it works for those who are willing to go along to get along.

LESSONS LEARNED

I left the academy in 2017, wounded, defeated, angry, and scared. But I am my Abuela's granddaughter. I had to remember a very important lesson she taught me in the third grade about my identity, my power, and my resilience. She taught me that no one has the power to define me and that my voice and my conviction would be my most powerful tool.

She would always ask me why I worked so hard and what was I trying to become. *"You are who you are and that is your gift,"* she would tell me. You will rarely be accepted as you are unless you fit into the paradigm that has been constructed by a society who has never accepted the other. My worth can not be determined by the status quo because the status quo is blinded by a false doctrine. One that believes my Dominican Black female body, mind, and spirit do not fit the description of the status quo. One that would only use my talents if they conformed to the structures that have been laid out before me. The structure that tried to fit my third-grade self into a category that was not designed for me.

Many of my mentors, who are African American, Latina, and Native Indigenous women, have supported my work and also warned me of the roadblocks that I would encounter because I chose to draw outside the lines and not play nicely in the sandbox. The systems of inequity that we encounter want us to disown ourselves so we can assimilate into the dominant culture. My Abuela also warned me of that. She would caution me about becoming "too American." "But I am American," I would remind her; "I was born here." "Pero, no esta tu cultura," she contended, *this is not your culture.* Her words would remind me of the shoulders I stand on. Strong women who navigated new countries, new languages, survived patriarchy and systems of oppression, and still persevered, survived, and thrived. I miss my long talks with my Abuela, but I hold her spirit inside me, her love for music and dance, and her ability to dictate life on her terms. I come as I am—a proud Black Dominican woman. I have learned when to push buttons and how to allow my gifts to shine. I have become unapologetic about doing things my way. I will continue to hold on to the one thing that guides me, especially when I lose my way— my Abuela's fierce spirit, love, and acknowledgement of self.

26

NOT SO MICRO

RAE SCOTT

Mother:
We were in a fabric and crafting store.
Looking for floating frames.
I remember her hair.
We've always affirmed its beauty.
Taught her freedom grows from its roots.
And whether her coils continued to extend to the sky
Or chase gravity down her back,
Her hair is hers in every way.
Her expression.
Her boundaries.
Her burdens.
She need not be apologetic about HER.
I'd be fibbing
If I said,
It didn't take much
Convincing
Our 4-year-old
That something so natural
Is worth loving.

I understand though,
When
Elsa and Anna greet her at the end of every aisle,
Frozen in perfection at every checkout line;
Why she might wander from our
endearment.
It's subliminal at the least.
More of an abusive ritual.
There's no rule of 7
For Doc McStuffins and 'em.
They are limited to two shelves.
Making
the teaching
and understanding of self
most imperative.
Like air.

Especially,
When we were riding high.
Felt like we struck gold
On a buy one,
get one free
So, we bought four frames.
But.
Patronizing doesn't promise protection.
Or yield disrespect.

Father:
We were considering customized frames
In order to properly preserve and hang our
Batik of the Maasai tribe.
They were gifts from my travels.
Delicately chosen
To
Ignite curiosity
And
Fuel the wonder of our children's

Future
Journeys.

But there is a price to pay
For customization;
With no guarantee of authenticity.
It's not our style
To dim what's inside.
So, here we were
Looking for glass instead.

We had a plan
Beeline
To the frames.
Of course, a 4-year-old mind
Always has a detour.
That soft spot daughters
Occupy,
Helped us gently put her back on our path.

It's a blessing to witness
A second time around.
The way she embodies Grandma's spirit:
Clapping and dancing down every aisle
To a tune
Only she can hear.
She tries to convince us
She can buy everything with her sole dollar.
Ox strong and unwavering.
That day, she stepped out bold.
Expressed her hair
Macy Gray–style.
Exquisitely unconfined.
We were proud.
Our delight dismissed
Nay-saying eyes.
Because what mattered were hers.

And I knew what mattered
for her was
Her mother's and mine.
So I kept my furnace cool.
Until.
See,
Words are a different kind of kindling.
Audacity is the match.
The choice to whisper
At our daughter
Was admission to his guilt.
See,
I hear better when I know
Ammunition stays seated at the base of their throat.
My weapon of choice
Was calm.
Because
Escalation
Never ends well for us.

Store Clerk:
I was rearranging the stockpile of wool yarn
When she skipped by.
Her hair blended so well
I barely noticed her.
She had a cute face for a little brown girl
And she was humming a tune
I
Thought
I recognized
But am sure SHE
Wouldn't know THAT song.
It caught me off guard
How ungroomed she was.
Her parents didn't seem like
Normal Black people.
Her father,

I am guessing that's her father,
Wore slacks.
It wasn't even Sunday.
I wondered what her mother
Was mixed with.
She had good hair and a light complexion.

Lucky for them
They checked out with a good deal,
That's for sure.
I am proud we can pass on savings to people in need.
It was the perfect end to my shift.
After I clocked out
We all approached the exit.
The girl
was too cute to walk around with her hair like that
So I told her
"Girl, you need a comb!"

Daughter:
I don't really care about what you sayyyyy!

27

ALL OF IT

DIONNE CUSTER EDWARDS

E VERY OTHER weekend you board the crowded bus with other
travelers—everyone on their way to somewhere else: Columbus,
Erie, Akron, Cleveland, Canada. The span of highway Interstate
71 through Ohio can be measured in twos and threes. Two to three or
more hours of travel from southern to northern Ohio. Two seats on each
side of the center aisle. Two, maybe three, bathroom breaks. The coach,
a crowded box of transience and adventure. Inside smells like a mix of
musk and urine, anxiety and exhilaration. Each seat on the bus covered in
the hours' rub of backs and tailbones, a rancid, royal blue fabric of wide-
awake and desperate to get somewhere. Everyone moving through time,
space, and circumstances. You turn your attention away from the long
ride, the abundance of stale odor, to focus on the waiting, to get home.

You are a short distance between here and there; a little while longer
on a one-way ticket home. The ride is slow. You do not arrive in time to
make it to the hospital before your mother dies. You are just short of a
few last words, of some kind of closure or feeling close to her still-warm
skin, shallow breath, her not-quite death. A few weeks ago, while in hos-
pice, she laid her hand across the swell of your waist. Reassured you that
when life leaves one body, it finds another, reminds us to be present in
the living. Perhaps your mother anticipated, imagined, that a baby on

the way might disrupt your grieving. A birth might remind you there are days after death.

The dingy fluorescent lights in the bus station and hospital have the same cold glow. The white sheets gather the stillness, the indents of the body and head. The well-worn foam bed in the hospital room remembers and forgets. After someone dies, extended family, friends, fill the gone and holes for a while. There is food and visitors and laughter. Little room to slow down, to linger and mourn. Soon after funerals and death cleaning, people scatter; find their places. In that space, having survived something, it can feel the most vacant. You do not yet show your grieving. You hold the hole open and closed. Fill it with practical matters: working, tending to family and friendships, pregnancy.

Blood in the third trimester is the first sign of trouble. A few weeks of bed rest, ankles and hips elevated, is not enough to spare a life. Your body trying to hold on to a hunger, something not yet realized. You go to the hospital. They keep you for a few days, then concede there is nothing more they can do to help you. The doctor sends you home to rest. Prepare for another loss of a body, of a person you do not know but already love. You go home to hope against the stress and odds. Wait. The lungs need two more weeks to be able to breathe outside the womb. The baby needs more time to be "viable." More time is not a choice; it's a chance. A tender nebulous space between life and death.

The sallow line of fluid runs down your leg. The cramps and contractions come later. The white sheets fill with sweat and flesh. The medic holds your knees and thighs in a wide *V*. He never says "push," but you know you have to allow contractions to do what they do: gather themselves, faster, harder. You lean into his shoulders, into the sound of his calm voice. Your eyes fixed on the contrast between the fluorescent stripes on his sleeve and the dim light behind his shoulders. The pressure in your abdomen, along your forehead, spreads a faint cast of pinhole glint; floating stars in your eyes. You surrender, allow your body to feel, pulse, pain. There was no other choice but to stretch and press until the knot unraveled. The tiny body, ball of thin skin, little bit of breath, here, then gone.

Grieving sounds like an empty hallway with a crisp impersonal draft. Anguish or ache spreads west to east along slight faults in the walls. A peeling away by small fragile ends: one elder, one infant, one reluctant

loss after another, from two separate ends of a bloodline. In a family of five, you become a matriarch, a messy notion, a strange and unsure young elder. Stuck with performing an impossible expectation of keeping things the same as they are steadily changing. Keeping a father, a long and short family history, two younger brothers close. Keeping the memories of a mother and family traditions intact. Mourning a daughter, what once was, what could have been. Trying to decide what to do next. After death, everyone negotiates new roles. Arrives to different things, newer fresher wounds, on short notice, with little control.

After so much loss within a few short months of each other, what do you call that persistent empty space after death? That anxiety and vibration in the bones. There are no words anyone can offer to anchor the loose threads, the known and unknown. The days are hard and holed and something like a drought.

After living in northeast, southwest, central Ohio, moving again and again, almost in circles, it is hard to stand still. You are waiting for grieving to feel different. For a phone call, for someone to show up at the door without a reason. You search for home, for family, for someone to call mother, for words to describe the pits and crests. You work to bury the alone. To sustain independence, livelihood, the pieces of certainty and chance. You work long shifts, sometimes multiple jobs. Fill in the hurt and hollow with more tasks and goals. Look for substance in the hours it takes to make a living, to pass the day. You are present and pain awake, with new truths about being in a life. You know how to revise. Pick yourself up after not quite falling, after moving or standing in place. You keep the flooding and sinking to yourself. You look strong, infallible, and unshaken. But those words carve you up as if melting into seams and disappearing for a while is not an option.

Sometimes we need to define our own spaces of grieving and being. There are many days that require us to appear and disappear. Shape and change and perform something like normal. Define and redefine. Do what you know when everything is shifting. Do something different when the shift seems to stand still.

Not long after the loss of the baby, your brother dies. It is all over the local news. Late one night after work, he walked opposite the crowd, the old buildings, along the waterfront downtown. It was an ordinary night. His back covered in moonlight. Just a few hours earlier, there was a

conflict, a fight, at the club where he works. Maybe it was mistaken identity, a wrong place, wrong time. Someone fired a gun into the dark. Colored the night with light and noise in the exact spot where your brother was walking. Unaware he was hit by the gunfire. He walked. Then ran. Then fell onto the sidewalk. An off-duty officer, too late to spare his life, plugged the holes of his near-death body with hope and air—then called for help. The off-duty officer stayed with him, so he would not die alone.

Then there is fresh grieving and another funeral. Everyone crowds in a small room, in a house, sitting around, talking, barely eating, being still. No one knows what to say when another person in the same family dies, again. When a family of five, in a short period of time, becomes three. When you mourn a mother, wife, grandchild, baby, uncle, brother, son, out of order and in a hurry. You wonder what to do with all the loss. You do not stop long enough to name the pain you are in. You acknowledge the blur between life and death, the distance, the sharing of space. You make the best of something out of these hard days. You do not call it grace, but it must be called something other than grief.

In twenty years, the body, without instructions, raises the threshold for bearing. Makes a heart and lung flood with air or fluid. Loss repeats itself like echoes in an atrium, in a sanctuary, in a field of graves. Grief is a crawl of uncertainty. The body full of known and strange things. Questions with so few answers. Something that just is.

Your youngest brother was in remission until he wasn't. Over a lifetime, he needed bone marrow, transfusion, chemotherapy, radiation again and again. As an adult he started a foundation that garnered national support. Named a life's work after the disease he, your mother, and soon you, would battle. This last diagnosis was old and new. He fought, sometimes with his own body, until he found a space with permission to be tired. There was a point when you thought there would be more time with him. You tried every natural remedy you can access after traditional medicine fails, again. You bury your youngest brother on a warm summer afternoon. Everyone is there: family, friends, and strangers. Your face and posture, solemn, resolute. You do not fall apart in front of anyone. You never do. You make appearances. Have a miracle distance and presence in all of it.

And now what? Funerals have become a social sanctuary. A day carrying death, care, and greetings. When people gather to express a loss,

the songs, stories, long hours of standing, sitting, almost smiling, ease the alone. There is little time to recover between kicks and wane. The mind has practiced living with long sorrow. The body holds it in the heart and pores.

When you got your diagnosis, you expected it. Genetics are an imprint carved in all of us. As if some vibration or ripple in the blood. As a woman, sister, lover, friend, you carry an abundant heap of unimaginable circumstances and conditions in the seams of your body, in the living. Your body swells of burden and resilience. You do not give up or give in. The many social and circumstantial stones of a life pool. And now this: more hard things. Up close and from a distance, you say nothing and everything about all of it.

27

WE WORK / WE SWEAT

KHALIAH D. PITTS

we work / we sweat / we love, Our Mothers' Kitchens (OMK) founders Khaliah D. Pitts (L) and Shivon Pearl Love (R) with Chandra Brown, youngest daughter of OMK foremother Vertamae Smart-Grosvenor after completing the 2019 Summer Workshop for Black Girls at Sankofa Community Farm, 2019. Photography by: Gabrielle S. Clark.

We have stood / in sun
in shade
in someone's cemented backyard
we / sweat

sweat from full breasts / kissing thighs
prayerful fold of fatty elbows

sing / groundshaking gospels /
prophecies pulled from air
holding church / in hands / holding, hands
holding homes.

we / work.
done stood
stood at / sink
washed in / water, hot

we / sweat.
done stood / at counter
done worked
kneaded stories into truth / needed
spirits into flesh

we, we
also sat / down
heavy-bottomed, long sigh / 'round
lil' tables

sipped / from glass
done laughed / over glass
laugh hard so we
sweat / from eyes / sweat

sipped on
coffee-cocktail-tea / sweet fruits, bleeding herbs
even them glass sweat

under sunbrowned woman hands / hands that done the work
that done work
that work.

PART 6

Paradoxes and Personifications of Expression

29

AIN'T WE CLEVER TOO?

PAMELA HARRIS LAWTON

A S AN artist, I have been most influenced by the works of Elizabeth Catlett, a Black woman artist, who managed to break into the white male–dominated art world at a time when few white women, let alone artists of color, had access to opportunities and galleries that would launch their careers on the national and international art scene. As a sculptor, painter, and printmaker, Catlett created works elevating working-class Black and Brown women to heroic status. She has been described as "usually modest and gentle, but injustice hits her like a flint and sends off sparks of determined assertiveness."[1] This determination, pride, and resilience are evident in her work.

Catlett embodies artist and art historian Freida High W. Tesfagiorgis's theory of Black feminism that "focuses on the Black woman subject as depicted by the Black woman artist, exploring the distinct manner in which the latter envisions and presents [the] Black woman's realities."[2] Tesfagiorgis coined the term *Afrofemcentrism* in 1984 "to designate an Afro-female-centered worldview and its artistic manifestations."[3] The

1. Lewis, *The Art of Elizabeth Catlett*, 1.
2. Tesfagiorgis, "Afrofemcentrism," 475.
3. Tesfagiorgis, "Afrofemcentrism," 476. Since the inception *Afrofemcen-*

first works by Catlett that I encountered as a graduate student were from her Rosenwald fellowship *Negro Woman* series of fifteen linocuts from 1946–47 highlighting the lives of both famous (Sojourner Truth, Harriet Tubman, and Phillis Wheatley) and unknown working-class Black women. These bold, resilient, women spoke to me personally, and evoked memories of the strong Black women who influenced my childhood and inspired me as an artist scholar. My MFA thesis was a series of prints depicting the Black professional women in my family.

Much of my work, including the piece described in this chapter, adheres to the tenets of Black feminism: (1) depicting Black women as subject rather than object, the exclusive or primary subject, and active rather than passive; (2) sensitive to the self-recorded realities of Black women; and (3) imbued with the aesthetics of the African continuum—sustaining a personal vision that embraces Afrocentric tastes in color, texture and rhythm.[4]

In July 2019, I was selected to facilitate a weeklong, community-based art project with people visiting the Tate Modern in London. My proposed project, *Artstories UK*, involved altering thirty fiction and non-fiction books written from the white male/colonizer perspective. The idea was to use these historic texts as a collaborative artistic medium, inserting the too often overlooked and silenced voices of the marginalized, thus altering the stories to reflect a variety of life experiences. As a Black woman artist/educator, my work, which I refer to as "artstories,"[5] is a platform for me and those like me—Black, Brown, women of color, and our co-conspirators—to author or insert ourselves into narratives that purposefully exclude us, from historical to contemporary times. Artstories are works that combine written, performed, and visual text using a variety of media—works on paper, textiles, assemblages, books, sculpture, photography, and digital media.

Over 1,800 participants worked altering books in the Tate Exchange gallery over the course of five days. Friends, families, strangers, tourists,

trism in 1984, the author, Freida High W. Tesfagiorgis has replaced it with *Black feminism* to expand upon the "ideological and geographical limitations" of the term. Freida High W. Tesfagiorgis, *Department of Afro-American Studies* (University of Wisconsin-Madison, 2019), para. 4. Retrieved from https://afroamericanstudies.wisc.edu/staff/freida-high-w-tesfagiorgis-emeritus/.

4. Tesfagiorgis, "Afrofemcentrism," 476–477.
5. Lawton, *Artstories*.

and Londoners sat together around tables filled with a variety of materials to alter books and have conversations. Sociopolitical concerns around Brexit, the political landscape of the U.S., and the ripple effect on other nations dominated much of the dialogue. The books are now part of the Tate Britain artist book collection, where I hope others will encounter them.

As I visited a variety of secondhand bookshops in Edinburgh, Scotland, purchasing materials for the project, I found one book that spoke to me personally, providing the perfect complement to what I hoped *Artstories UK* would be: *Clever Girls of Our Time, and How They Became Famous Women*, written by British author Joseph Johnson in 1862. The book, republished and reprinted repeatedly up through 2018, is an illustrated biography of the lives of famous women of the era. Johnson, having previously authored a similar book about boys who became great men, wrote the book for girls as "incentive and encouragement" to live lives of "industry and perseverance." If Joseph Johnson were living today, I would send him the following letter along with my altered book version of *Clever Girls* (see the figures at the end of this chapter):

———————————

Dear Mr. Johnson,

Thank you for your thoughtful book, *Clever Girls of Our Time, and How They Became Famous Women*. I take heart that you, a white, Victorian-era, male author, felt it important to illuminate and make accessible the lives of extraordinary women as aspirational role models for girls of your time. However, my praise is tempered by disappointment. Where are the girls/women of color? Surely, you've heard of Phillis Wheatley, the Black prodigy, poet, and former slave from Boston? She visited London in 1773, where she met the Lord Mayor of London. Her portrait hangs in the Tower of London among those of other celebrities who visited the site. And what of Edmonia Lewis, the Black / Native American sculptor and contemporary of Harriet Hosmer? You profile Hosmer in your book. They both studied with expatriate, white, male sculptors in Rome before establishing their own studios there and achieving financial success. Where is Mary Seacole, British citizen and contemporary of Florence

Nightingale? She nursed soldiers in the Crimean War, yet her story is overshadowed by that of Nightingale. There are so many more: singers, doctors, scientists—whose important contributions have disappeared into obscurity.

Your negligence in publishing a more inclusive herstory led me to alter your text by inserting the stories of women of color, doubly discriminated against because of their race. I hope you will read this altered version of your book, conduct more research inclusive of racial diversity, and be more intentional in future publications targeting impressionable young girls.

AIN'T WE CLEVER TOO?

But where are the clever girls of color, the ones who look like me?
Without them, this book is duller, and that should never be.
Oh, dear reader, do not fear their omission in this book,
For I have inserted several here; please take a look.

BIBLIOGRAPHY

Johnson, Joseph. *Clever Girls of Our Time, and How They Became Famous Women.* London: Darton and Company, 1862.

Lawton, Pamela Harris. *Artstories: Perspectives on Intergenerational Learning Through Narrative Construction Amongst Adolescents, Middle-Aged and Older-Aged Adults* (Unpublished doctoral dissertation). New York: Teachers College, Columbia University, 2004.

Lewis, Samella. *The Art of Elizabeth Catlett.* Claremont, CA: Hancraft Studios, 1984.

Tesfagiorgis, Freida High W. "Afrofemcentrism and Its Fruition in the Art of Elizabeth Catlett and Faith Ringgold." In *The Expanding Discourse: Feminism and Art History.* Edited by Norma Broude and Mary D. Garrard, 475–485. Boulder, CO: Westview Press, 1992.

Colorful Clever Girls (book cover), 2019. Altered book, 11 x 8 x 1.5 in. (27.9 x 20.3 x 3.8 cm)

Colorful Clever Girls (frontispiece), 2019. Altered book, 11 x 8 x 1.5 in. (27.9 x 20.3 x 3.8 cm)

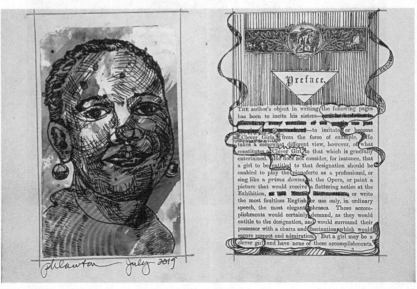

Colorful Clever Girls (preface), 2019. Altered book, 11 x 8 x 1.5 in. (27.9 x 20.3 x 3.8 cm)

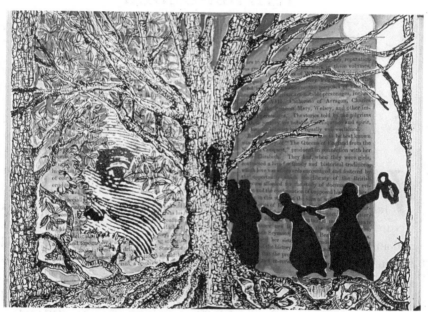

Colorful Clever Girls (Harriet Tubman). 2019, Altered book, 11 x 8 x 1.5 in. (27.9 x 20.3 x 3.8 cm)

30

JULIA PASTRANA AND THE EYE OF THE BEHOLDER

TAMILLA WOODARD AND
LAURA ANDERSON BARBATA

JULIA PASTRANA and The Eye of the Beholder (work in progress) is a multidisciplinary and transdisciplinary performance mash-up about exposing automatic responses of judgment; it combines a lecture format style, dance, projections, music, flash workshop sessions and audience interactions and participation. It was developed with and directed by Tamilla Woodard and created and written by Laura Anderson Barbata.

Victorian, Mexican Indigenous mezzo-soprano Julia Pastrana was billed as "The Ugliest Woman in the World" by her manager-husband Theodore Lent. Lent exhibited Pastrana in the United States and Europe both during her life and after her death—the latter in an embalmed state. The exhibition of Julia continued for over 150 years until Pastrana's body was included into the Schreiner Collection in Oslo, Norway. I successfully worked for 10 years to have Pastrana removed from the collection to be repatriated to Mexico for burial. This work addresses the urgent need to unlearn mechanized systems that assign meaning and value to what we see. It prompts the audience to "see without their eyes" in order to experience the world and people before us in a humane and ethical manner.

Composed of elements of TED Talks, flash workshop sessions, audience interaction, dance, music, and multimedia that combine to create

a participatory performance mash-up, *The Eye of the Beholder* invites audiences to an experience of radical empathy.

Through storytelling and thought experiments, we introduce the audience to the automated systems operating through their eyes and brain. Thought experiments become hands-on tasks as the audience constructs a box containing a sheep. In their first encounter of how quickly meaning is assigned to what they see before them, the audience is led through a series of exercises on how to shut down the eye-brain responses and see with their heart. This culminates in a moment of re-envisioning—in the dark.

JULIA PASTRANA AND THE EYE OF THE BEHOLDER

PERFORMING RESISTANCE, PART 2. THE FEMINIST ART PROJECT (TFAP), CHICAGO, 2020

Performance Script Part II[1]

Developed with and directed by Tamilla Woodard
Created and written by Laura Anderson Barbata
2018–2020[2]

(image 1)

1. Performed during The Feminist Art Project: Performing Resistance, Part 2. At the College Art Association Conference, Chicago, 2020.
2. *The Eye of the Beholder* is a performance work in progress initiated in 2015. Developed at Amphibian Stage in Fort Worth, Texas (2018), at BRI-Clab in Brooklyn, NY (2019) and at the Rockefeller Bellagio Center (2019). For additional images and information: www.lauraandersonbarbata.com and www.juliapastranaonline.com.

What is the first word that comes into your mind when you see this image? One word, call it out. Elegant, strong, poised . . .

This woman was a **sensation** in the 1800s.
She traveled the world
she was admired
applauded
courted
celebrated
sensationalized
eulogized
immortalized
written about
observed
she was called "Wonder of the world"
she sat in the company of royalty.

All because of her hair.

(image 2)

This is Julia Pastrana.
She was an artist.
She was an opera singer.
She was a dancer.

On the 27th of December, 1854, *The New York Times* said this about her: "Christmas Holidays cannot be more agreeably passed than attending the Levees of Julia Pastrana, whose dulcet voice enchants the ladies."

This is Julia Pastrana.

She was bought
sold
trafficked
forced to perform
probed
exhibited.

And *The New York Times* continues its column this way: "Dr. Mott's impressive epistle concerning the duality of "La Mujer Osa" astounds the public. The troglodyte of ancient days is recognized . . ."

This is Julia Pastrana.
She was called:
uncivilized
gross
melancholy
a disgusting, deformed creature
a monstrosity
orangutan girl
bear woman
baboon lady
ape woman
hirsute
the non-descript
misnomer
hybrid
female hybrid
wonderful hybrid
Indian
semi-human Indian
from Mexico
a human monster
half woman, half beast
the missing link.

(image 3)

———————

The New York Times ends the column this way: "Four feet in height, with eyes like an owl, gifted with speech—the link between mankind and orangutan. Admission 25 cents."

(image 4)

Rosemarie Garland-Thomson in her essay for the book *The Eye of the Beholder* tells us:

> Julia Pastrana's body was recruited in order to question five foundational cultural oppositions that structured nineteenth-century Western social order:
>
> -human vs. animal
> -civilized vs. primitive
> -normal vs. pathological
> -male vs. female
> -self vs. other

(repeat image 2)

———————

Julia Pastrana was an **Indigenous Cahita** woman born in 1834 in the state of Sinaloa in Northern Mexico. She was born with conditions called hypertrichosis terminalis and hyperplasia gingival, which means that her face and body were covered with thick hair and her jaw was overdeveloped. Little is known of her life as a child. Historians in Mexico tell us she was bought and sold from a very early age. By the time she was a young adolescent, she was living in the home of the governor of Sinaloa, and we believe that it was there that she learned to sing and dance.

Julia became an accomplished mezzo-soprano who spoke and sang in four languages: Cahita, Spanish, English, and Frénch. She was also a graceful dancer.

She performed extensively in the U.S. and in Europe and became very successful. She married an American, who was also her manager. He controlled every aspect of her life, even forbidding her from going out in public with her face uncovered because, he said, people would not pay see her.

(repeat image 1)

Let us go back to this image. In this photograph, Julia Pastrana is **not alive**. She is dead. She is embalmed. Really. Takes a little time to process this . . .

She was twenty-six years old when **this was done to her**. She had just **given birth** to a baby boy born with her same condition. He died thirty-six hours after being born. She died three days later. Her husband **sold her, his wife, and their newborn child** to the attending doctor at the hospital in Moscow, who had been developing embalming techniques and wanted to try them on human bodies. Two years later, Julia's widowed husband, former manager, father of her deceased child visited the hospital. When he saw the incredible results of their embalming, he **demanded** that the bodies of Julia and his son be **returned** to him. The request was denied.

He then petitioned the U.S. consulate's assistance in **reclaiming them**, and with their intervention he was successful.

He put Julia and the infant inside a glass case
and began to **exhibit** them **throughout Europe once more**.

His **commercial success . . . was greater** than when she was exhibited alive.

It did not end there for Julia. She was bought and sold, she passed from hand to hand for over 150 years. This photo is from the 1970s, taken in the US.

(image 5)

When I heard the story of Julia Pastrana in 2004, she was in a wooden box with an inventory number in the basement of the University of Oslo as part of the Schreiner Collection. I felt it was **my duty** as an artist and as a woman—**as a Mexican woman**—to do everything I could to have her removed from the Schreiner Collection in Norway, because if I did not do so, she would remain with an inventory number and an inconclusive existence.

I began by trying to understand the reasons that justified keeping Julia in a collection, while at the same time working with other people to **understand her, to change the conversation around her**, and to collectively attempt to restore her dignity and the rights she had been denied during her life and death. For example, I organized a memorial mass for her following the religion she practiced, along with the publication of her obituary in a local Norwegian newspaper. It was the first action done for her that **recognized her humanity**.

It took a long time for the Schreiner Collection, the University of Oslo, and the Ministry of Health of Norway to recognize officially that Julia Pastrana had the right to be removed from the collection and repatriated to Mexico to be buried in her homeland. And in 2013, after almost 10 years of efforts and more than 150 years after her death, custody of **Julia Pastrana** was officially transferred, and she **was repatriated from Norway to Mexico**.

Julia Pastrana was taken out of the wooden box and placed inside a white coffin with flowers, and she traveled from Oslo to Paris, to Mexico City, to Culiacán, and then to Sinaloa de Leyva, where she was received by

thousands of people, and hundreds of thousands of white flowers that arrived from all over the world to bid her goodbye and to close the cycle of her exploitation.

(image 6)

———————

My work related to Julia Pastrana did not end with her burial.

I believe it is important to show how the systems that justified Julia Pastrana's oppression and exploitation are still operating **today**. I address these issues through zines, performance, artworks, and writing.

———————

La Extraordinaria Historia de Julia Pastrana. Zine 6, 2018–2019. Created in collaboration with Erik Tlaseca, distributed to the audience after the performance. (selection of interior pages follows)

Julia Pastrana was an Indigenous Cahita woman born in the northern Sierra Madre of Mexico. The current Cahita population is 40,000, living mainly in Sinaloa and Sonora. From the numerous pamphlets and posters, we can see how Julia Pastrana's Indigenous identity was utilized, manipulated, exploited, exaggerated, falsified, exalted, and distorted by her manager-husband to promote her exhibition to paying audiences. But ultimately, those promotional materials underline her silencing and the impossibility for her to ever be a part of society by condemning her to always exist as an outsider. This perpetual "outsider" status—even after her death—isolated her and facilitated the exploitation of her body, the denial of her freedom and her rights.

In Julia's story, we see an extreme use of colonial systems to disenfranchise and silence an Indigenous woman. But these forms of discrimination are not exclusively from the past; the very systems utilized since colonial times operate in today's society by labeling, marking, and dividing citizens in a hierarchy designed to protect only the privileged few belonging to the so-called dominant society. While in Mexico traditional knowledge and arts of indigenous women are recognized and celebrated, to be an Indigenous woman today is dangerous. In Mexico, the United States, Canada, and Latin America, thousands of Indigenous women are trafficked, raped, and murdered every year with impunity. In addition, everyday language works to further silence and exploit them, denying them their humanity and their rights because of their Indigenous identity.

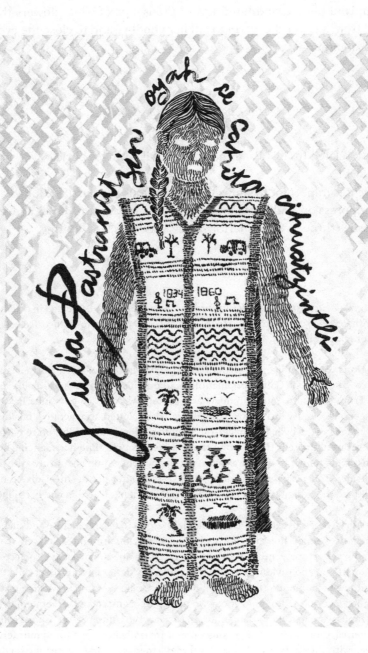

Julia Pastranatzin oyah se sanita cihuatzintli

1934 1860

JÚURIA PAXTRÁANA Imí Sinnalowwapo ju juria Paxtráana yorem jammulta ka juka itom yoremnokta nookay, entok tátabui nookta, jachin Yoorinokta, Franchuuteta, Rinwonokta, tülisi imë nookim táyay. En imë taawarimpotuk 40,000 yoremem jiabsa imi Sinnalowwapo entok Sonóorapo. Jántuk yamë betana yün jitta juëna nooki aayka, ka tüwa jioxteri. Inëlite juka Juuria Paxtraianga betana aayökamta tátayanake, jachisum a takawata jojoay, ka a jeentetuka bennasi. Jabbejan yoori süirkom weweetvametuk a nuksii ka seKána buiäraw bicha, wanáytuk a animaaltuka bennasi jabbe a bitbáaremta, tommipo a bibittoay. Mamaytuk mekka buiärampo a nünübvak ju yoori, bejja a juubiwlatoka, chë junne a čapo aman aay tommi yö baareka. Inëlituk a nënkisisimeka máay riikotuk. Ituk jammut máay simeta aamak jojoay ka jiaaleka. Bejja a muukilatuk junnetuk aay tommi yööy jua kounawa. Sime yorem jaamuchim kara emo jinehu béchibo i' Sime weyyey, buëytuk jitta jiösia yá'huchiam betana jioxteritaka junne ka bóokay. Jumë yoori riikom tokti Kaytasi am bitchay am yorem jaamuchimtuka

bechibo. En Kamti junëli jibba weyye, jume yoorim juka yorem jammulta bitchátek a buere aawnake, entok amemak joorem jibbam ania, buëytuk bompo jibba juka yáwrata jipure, tim jraa teewa waate nuxmiäarim; jachin wamë paxkom, itom jiaawi, itom eerim. Chë tüsisu wamë sotaarom yeihut kobba yota nesawëw yorem jaamuchim jibba jiookot jojoa. Imë taawarimmet wa yoremnokwame kaytapo bitbaawa, buëytuk wa yoori yoremtat kopteme lawti jachin junne a yaa baanake. Waate chë am susua, wanáy kaabe áme betana nonoka am jinëw bechibo.

TRADUCCIÓN AL CAHITA: ACADEMIA DE LENGUAS MAYO DEL ESTADO DE SINALOA

CAHITA

ZIINE 6 Julia Pastrana was an indigenous woman born in the northern Sierra Madre of Mexico, and a speaker of the language (she also was fluent in Spanish, French and English) The current CAHITA population is 40,000 living mainly in Sinaloa & Sonora. From the numerous pamphlets and posters we can see how Julia Pastrana's indigenous identity was utilized, manipulated, exploited, exaggerated, falsified, exalted and distorted by her manager (who was also her husband) to promote her exhibition to paying audiences. But ultimately it underlines her silencing and the impossibility for her to ever be a part of society by condemning her to always exist as an outsider. This perpetual "outsider" status -even after her death- isolated her & facilitated the exploitation of her body, the denial of her freedom and her rights.

In Julia's story we see an extreme use of colonial systems to disenfranchise and silence an indigenous woman. But these forms of discrimination are not exclusively from the past, the very systems utilized since colonial times, operate in current society today by labeling, marking and dividing citizens in a hierarchy designed to protect only the privileged few belonging to the "so-called" dominant society. In this Zine I highlight the current rich indigenous cultural diversity of our country (Mexico), and while we celebrate their traditional knowledge and arts, indigenous women today are victims of the most vicious and horrific crimes by the government and the military. But also, everyday language works to further silence, exploit them with impunity, denying them their humanity and their rights because of their indigenous identity.
To be an indigenous woman today is dangerous. In Mexico, the United States, Canada and latin America thousands of indigenous women and girls are trafficked, raped and murdered every year with impunity.

CAHITA

ZINE 6. Julia Pastrana fue una mujer indígena nacida en el norte de la Sierra Madre de México, quien además de hablar su lengua materna CAHITA, hablaba español, francés e inglés con fluidez. La población CAHITA en la actualidad es de 90,000, y viven principalmente en Sinaloa y Sonora.

De los numerosos panfletos y carteles podemos ver cómo la identidad indígena de Julia Pastrana fue utilizada, manipulada, explotada, exagerada, falsificada, exaltada y distorsionada por su representante (quien además era su esposo) para promover su explotación y exhibición ante un público que pagaba por verla. Pero sobretodo, denota su silenciamiento y la imposibilidad de que pudiese integrarse a la sociedad condenándola a una permanente existencia en los márgenes. Esta condición de perpetua exclusión, incluso después de su muerte la mantuvo aislada y facilitó la explotación de su cuerpo, la negación de su libertad y sus derechos.

En la historia de Julia, vemos el uso extremo de los sistemas coloniales que suprimen los derechos y silencian a las mujeres indígenas. Sin embargo, estas formas de discriminación no pertenecen exclusivamente al pasado, los mismos sistemas utilizados desde la colonia operan en la sociedad actual etiquetando, marcando y dividiendo a sus ciudadan@s, siguiendo una jerarquía diseñada para proteger a unos pocos privilegiados que pertenecen a la llamada sociedad dominante. En este zine, resalto la rica diversidad indígena de nuestro país (MEXICO), que mientras celebra sus tradiciones y conocimientos, a sus mujeres indígenas las somete a los crímenes más violentos y horribles cometidos por el gobierno y militares. Y de igual forma, el lenguaje cotidiano contribuye al silenciamiento y explotación, privándolas de su humanidad y sus derechos: el ser una mujer indígena hoy es peligroso. En México, los Estados Unidos, Canadá y América Latina, miles de mujeres y niñas son traficadas, violadas y asesinadas cada año con total impunidad.

CAHITA

Julia Pastranatzin oyah ce' cihuatsintli, omollacatlacatilih ipan Mictlampa Tetepeh Tonantzin ipan Mexihco, yehuatzin omotlahtoltiaya itlahtolnantzin CAHITA, yehuatzin noihqui omotlahtoltih Caxtilan, tlahtolli, Frances tlahtolli ihuan Ingles tlahtolli. Quin axcan meni macuilziguipilli CAHITA tlacameh, ihuan mochantilah ipan huey altepetl Sinaloa ihuan Sonora. Ipan miec ixnescayoa moxtli ihuan Ixpitlayoamoxtli Ahuelili tiquihtazgueh Julia Pastranatzin oguiteguihtih, oguitlahtolmacac, oitlacotic, oguitlahuelihtac, otecahcayauh, ihuan oguitlatiaya iteyacancatzin ahguin noihqui oahca inamictzin inic itlacotiliz ihuan oguimnextiliaya in tlacameh ihuan ipal oguitlaniaya tomin. Yehce omoteya quenin omocamaxacuaxa ihuan aic oguicauh mah mocalactih itech in tlacoyotl oguixnahuatih mah tlamach mah ye. Ica inin tlachihualiztli oguixtixtlatih ihuan ahmo, oguimahuiztilihueh Zetepan ihcuac omomiquilih oguitlatih ihuan oguitlacotic inacayo, oguitlatih illacoyoxxohcayo ihuan itlanahualizmachiuh. Ipan inemiliz Julia, tiquihtah quenin in huehcachaneh ahmo quimtlacaihtah ihuan ahmo quimmahuiztilah in macehualcihuatsitzin. Yehce, inin pinauhcayotli zan omochihuaya iyalhua, inin ahmo moplatlaloc

thuicpa queuh ihcuac oahcico in huehcachaneh ixguichca axcan guimahpilhuia, guiixmachcayotia ihuan guimxexeloah in macehualmeh, guitocah ce huehcapancayotl inic mopalehuia zan quezqui teicnelilloni tlacah tlein itechpohui ihuan monotza quenin: SOCIEDAD DOMINANTE. Ipan inin zine, nicnextia Ce macehualli nepapanyuhcatiliztli itech totlalnantzin Mexihco, tlein oc guilhuiguixtia inemiliz ihuan itlamatcayo, in macehualcihuameh ahmo quimmahuiztilah guincualantiah in tlahtoani ihuan yaocihuanimeh. Ihuan noihqui, in momoztla tlahtolli guichihua in camatzacualiztli ihuan tlacotiliztli, guintlahtolcotona itech tlacoyo ihuan itlanahualiztli machiliz: axcan in Yeja cihuamacehualmeh cenca atwl. Ipan Mexihco, Estados Unidos, Canadá ihuan América Latina, omotzonli ihuan mahtlacpohualli macehualmeh quimichteguih, guimquitzquiq ihuan quimicihah cehce xihuitl ipa nochi cencahuiliztli.

Ixneztica = ser notorio, manifiesto, evidente (to be notable), apparent, noticed
Ixneci = aparecer, hacerse ver, mostrarse (to appear, come into view, to show)

ERNESTINA ASCENSIO

DENUNCIÓ A SUS VIOLADORES ANTES DE MORIR

y 15 personas, entre familiares, autoridades comunitarias y médicos legistas, escucharon esta denuncia y dieron fe de los estragos que la violación tumultuaria dejó en el cuerpo de la anciana nahuatl, el PRESIDENTE FELIPE CALDERÓN negó la veracidad de esta denuncia, sin tener ningún informe médico o legista que fundamentara su versión de "MUERTE POR GASTRITIS"

"MUERTE POR GASTRITIS"

PRESIDENTE De La nación

COMO EN EL TIEMPO DE LAS MONARQUÍAS LA PALABRA DEL "SUPREMO" FUE SUFICIENTE PARA DESMENTIR EL CERTIFICADO DE DEFUNCIÓN del doctor JUAN PABLO MENDIZABAL, LAS NECROPCIAS FIRMADAS POR TRES MÉDICOS LEGISTAS, el dictamen del PROCURADOR ESTATAL de Justicia de Veracruz, MIGUEL MINO RODRÍGUEZ, y el PROPIO testimonio de la VÍCTIMA.

La misma impunidad y el mismo racismo encontraron las hermanas Méndez Sántiz, tres mujeres tzetzales que fueron violadas en un retén militar en Altamirano, Chiapas en marzo de 1994.

Delfina Flores Aguilar y Aurelia Méndez Ramírez, indígenas tlapanecas de Zopilotepec, Atlixtac de Álvarez, Guerrero, quienes fueron violadas por cinco soldados el 3 de diciembre de 1997; las 12 mujeres indígenas de la zona de Loxicha, Oaxaca que fueron violadas por efectivos del ejército mexicano en 1997; las indígenas nahuas, Victoriana Vázquez Sánchez y Francisca Santos Pablo, de Tlacoachixtlahuaca, abandonadas en abril de 1999;

Valentina Rosendo Cantú agredida sexualmente por ocho soldados del 41° Batallón de Infantería en Barranca Bejuco, Acatepec, Guerrero en febrero del 2002; Inés Fernández Ortega, violada en su casa por 11 soldados el 22 de marzo de 2002, en Barranca Tecuani, Ayutla de los Libres, Guerrero; las 23 mujeres agredidas sexualmente en Atenco por fuerzas de seguridad en mayo del 2006; las 13 mujeres de Castaños, Coahuila que el 11 de julio de 2006, fueron víctimas de una violación tumultuaria por parte de 20 soldados.

ERNESTINA ASCENCIO DENOUNCED HER RAPISTS BEFORE HER DEATH AND
FIFTEEN PEOPLE, AMONG THEM WERE HER RELATIVES, COMMUNITY AUTHORITIES AND
MEDICAL DOCTORS WHO LISTENED TO HER DENOUNCEMENT AND WITNESSED THE
THE DEVASTATION THAT THE TUMULTUOUS RAPE LEFT, ON THE BODY OF THE ELDERLY
INDIGENOUS WOMAN. PRESIDENT FELIPE CALDERON DENIED THE AUTHENTICITY
OF HER TESTIMONY WITHOUT PROVIDING ANY MEDICAL REPORT TO SUPPORT HIS
VERSION OF "DEATH DUE TO GASTRITIS". AS IN ANCIENT TIMES OF MONARCHIES,
THE WORD OF THE "SUPREME" WAS SUFFICIENT TO DENY THE DEATH CERTIFICATE
ISSUED BY Dr. JUAN PABLO MENDIZABAL, THE NECROPCIES SIGNED BY THREE
MEDICAL DOCTORS, THE EXPERT OPINION OF THE STATE ATTORNEY OF VERACRUZ
MIGUEL MINA RODRIGUEZ, AND THE TESTIMONY OF THE VICTIM.

THE SAME IMPUNITY AND RACISM WAS MET BY THE MÉNDEZ SÁNTIZ
SISTERS, THREE TZELTAL WOMEN WHO WERE RAPED AT A MILITARY
CHECKPOINT IN ALTAMIRANO, CHIAPAS, ON MARCH 1994; DELFINA
FLORES AGUILAR AND AURELIA MÉNDEZ RAMIREZ, TLAPANEC INDIGENOUS
WOMEN OF ZOPILOTEPEC, ATLIXTAC DE ALVAREZ, GUERRERO, WHO WERE
RAPED BY FIVE SOLDIERS ON THE 3rd OF DECEMBER 1997; THE TWELVE
INDIGENOUS WOMEN OF THE LOXICHA, OAXACA TERRITORY THAT WERE
RAPED BY MEMBERS OF THE MEXICAN ARMY IN 1997; THE NAHUA
INDIGENOUS WOMEN VICTORIANA VÁZQUEZ SÁNCHEZ AND FRANCISCA
SANTOS PABLO FROM TLACOACHIXTLAHUACA, GUERRERO, WHO WERE
INTERCEPTED AND RAPED BY SOLDIERS IN ABANDONED HOUSES ON
APRIL 1999; VALENTINA ROSENDO CANTÚ WHO WAS SEXUALLY
ASSAULTED BY EIGHT SOLDIERS OF THE 41st INFANTRY BATTALION
IN BARRANCA BEJUCO, ACATEPEC, GUERRERO ON FEBRUARY 2002;
INÉS FERNÁNDEZ ORTEGA, WHO WAS RAPED IN HER HOME BY
ELEVEN SOLDIERS ON THE 22nd OF MARCH 2002 IN BARRANCA
TECUANI, AYUTLA DE LOS LIBRES, GUERRERO; THE TWENTY THREE
WOMEN FROM CASTAÑOS, COAHUILA, THAT ON THE 11th OF JULY
2006 WERE VICTIMS OF GANG RAPE BY TWENTY SOLDIERS.

31

CONSENT AND FEMALE DESIRE IN INDIA

NISHA GHATAK

In him I swam, all broken with longing, in his robust blood I floated, drying on my tears.

—KAMALA DAS, *MY STORY*

Kamala Nalapat. Madhavikutty. Kamala Das. Kamala Surayya. Aami.

The many names of a vivacious, multifaceted woman who never shied away from speaking about her pain, her endless pursuit of love, and her belief that words will lead her to all the answers. Born on March 31, 1934, in the southern Indian state of Kerala, Kamala Das was witness to an India where the British still held the reins and contributed to atrocities like the Bengal famine of 1943, when around three million people lost their lives due to starvation. Her childhood was spent in the company of two indifferent parents, and she attended an English medium school run by the British. Her earliest memory of school life is ridden with traumatic experiences of racism she had witnessed because of the large population of white British students, who often called her dark-skinned younger brother "blackie."[1] Right before World War II, Kamala Das and her younger brother were sent to live with their grandparents in a village situated in Kerala. This, combined with her grandmother's stories about legends and Hindu mythology, opened up young Kamala's view of the rural life in her ancestral village. The years she spent with her

1. Das, *My Story*.

grandmother in Kerala also shaped her love for writing and poetry. In her autobiography *My Story* (1988) and its vernacular original in Malayalam, Kamala explores themes of childhood, love, desire, child marriage, hypocrisies surrounding the upper-caste matrilineal Malayalee families, homosexual encounters, sexual intimacy, and most importantly, marital rape. After moving around as a result of war and her mother's wish to travel home to Kerala, Kamala was coerced to abandon her education at the age of fifteen, when her father decided to marry her off to a family friend—a complete stranger to Kamala. While penning her memoir, Kamala focuses on the story of her unfortunate marriage to this stranger named Madhav Das. In her autobiography, Kamala recalls meeting the man at a social event as a child, when he quoted Aldous Huxley and spoke highly of poetry. This was all she knew about him when they first met. Like Kamala, for most women in India, an arranged marriage remains the norm. The opposite, or "love marriage," where the woman gets to marry a man of her choice, is a practice still considered uncouth in several Indian states.

LOCATING DESIRE AND THE ABSENCE OF CONSENT IN INDIA

Following her father's declaration, Kamala was forced to meet her fiancé in her mother's ancestral home. After a short exchange of words, Kamala recalls her future husband pushing her into a dark corner behind a door and crushing her breasts with his thick fingers.[2] In the chapter titled "An Arranged Marriage," Kamala delves deeper into the physical abuse she faced at the hands of her fiancé every time they met before the wedding—each time the bruises he left behind grew deeper and darker. Kamala juxtaposes this abuse against the plight of several young women who worked in her ancestral home and remained silent victims of repeated sexual assaults at the hands of men like her own husband. The silence of these women, who mostly belonged to the lower class and lower caste sections of the society, brings to focus the hypocrisies of the Indian social

2. Das, *My Story*.

system that belittles and dismisses their suffering. According to the 2018 reports published by National Family Health Survey and News18 India, 27 percent of women in India have experienced physical violence since the age of fifteen.[3] Furthermore alarming is the inability to comprehend the numbers pertaining to the women, especially in the rural areas, who are unable to come forward and lodge a complaint against their abuser—a fact repeatedly alluded to in Kamala's autobiography. Her poetry refers to the raw human sexuality and speaks of hidden desires that Indian female authors of her time had shuddered to write about. From the loneliness of a young girl to the despair of a woman who faces physical abuse at the hands of a husband, a man much older than her, Kamala's narrative is unequivocal in its expression of the woman in her. As we delve deeper into the narrative, we see Kamala taking charge of her own physical self— her body that had not been her own since she got married.

MARITAL RAPE IN DAS'S *MY STORY* (1988)

In her work, *Against Our Will: Men, Women, and Rape*, Susan Brown-miller devotes a chapter connecting rape to the exertion of power. She classifies rape as the most primeval example of subjugation. In the case of arranged marriages like that of Kamala's, the woman has little or no power to retaliate against any sexual advances made towards her by the husband, who is the primeval patriarch. In these cases, the wife takes the form of "property" that is rightfully "owned" by the husband as he exerts his right over her body. In several societies, the woman's body is thus never considered to be her own. Marriage becomes means for a male to acquire the female body.[4]

Kamala knew she would be the "victim of a young man's carnal hunger" and that societal pressures would lead her to procreate.[5] In February 1949, Kamala was married off to Madhav Das. She writes of the mango

3. Sheikh, "Every Third Woman in India Suffers Sexual, Physical Violence at Home."
4. Dietrich, review of *Against Our Will*, 71–73.
5. Das, *My Story*.

trees outside the Nalapat House in brown bloom and the flowering trees that hummed in the sun. Her father's face shone like the sun in the sky, and he made sure it was the most expensive wedding that the Nalapat House had seen. Kamala recalls how cheap she felt as a silent witness to all the preparations and glimmer surrounding the wedding. On her wedding night, while the rest of the household enjoyed a Kathakali[6] show on the porch, Madhav Das attempted to rape his young bride despite her repeated pleas. She remembers how he comforted her after she expressed her fear but continued his exploitation as the drumbeats of the Kathakali performance echoed through the night. Throughout the night, Kamala remembers being physically battered and bruised by her husband.

In Kamala's autobiography, we are introduced to her husband's brutality as well as emotional abuse and total disregard for a woman's consent in sexual relationships. Normalizing such a suffering at the hands of a known perpetrator is a violence that is heinous and seeks to question the very role of power in the given gender roles. While in the West, rape and all its variants are understood as mechanisms for the assertion of power, in countries like India, such an understanding is lax. This is a country where the majority stand against the independence of women, one that believes in controlling the women who, according to them, are carriers of socio-familial prestige. The fairer sex are worshipped within the walls of the Hindu temple and physically crushed in their own homes. When Kamala Das began writing feminist poems and published her autobiography amidst extreme familial protests, she was labelled a social misfit—a "mad woman" who dared to rave about the men in her life. Kamala's writing explores desire as twofold: The first desire explored is sexual desire, embedded deep within her writing; the second is the need to be wanted. Kamala's search for attention begins in her childhood with her parents and siblings, and later, extends on to her husband and the inconspicuous men who invoked love in her heart. In her writing, these desires give shape to Kamala Das, the woman. A polyphonic text, *My Story* digs deep into the many layers within Kamala's own character—from a daughter in a wealthy upper-caste family and a doting sister, to a middle-class wife, an author, a mother, and finally, a lover.

6. Kathakali is an ancient dance form from Kerala, usually used to narrate stories in Sanskrit from Hindu epics, like *The Ramayana* and *The Mahabharata*.

Yet, we remain appalled by the rarity of such writings in contemporary Indian literature. Nothing much has changed socially as divorce continues to be a taboo social choice in India. Kamala herself remained with her abusive husband until his death in the late 1990s, but her spirit burnt brighter than ever, and she refused to give up on her search for love until her last day in May 2009. Drawing on the fire of her strength, this essay draws to a close in Kamala's own words from her poem, "The Looking Glass."

"Getting a man to love you is easy
Only be honest about your wants as Woman."

BIBLIOGRAPHY

Brownmiller, Susan. *Against Our Will: Men, Women and Rape.* London: Penguin Books, 1976.

Das, Kamala. *My Story.* Kottayam: DC Books, 1988.

Dietrich, G. Review of *Against Our Will: Men, Women and Rape*, by Susan Brownmiller, *Manushi India*, IV (1979): 71–73.

Sheikh, S. "Every Third Woman in India Suffers Sexual, Physical Violence at Home," *News 18.* Updated February 8, 2018. https://www.news18.com/news/india/the-elephant-in-the-room-every-third-woman-in-india-faces-domestic-violence-1654193.html.

32

DEAR BLACK WOMAN

AMBER C. COLEMAN

A PLAYLIST

Survivor *Destiny's Child*
I Do *Cardi B (feat. SZA)*
Sorry *Beyoncé*
On My Mind *Jorja Smith & Preditah*
Special Affair *The Internet*
Rise Up *Andra Day*
I Wanna Dance with Somebody (Who Loves Me) *Whitney Houston*
U.N.I.T.Y. *Queen Latifah*
Didn't Cha Know *Erykah Badu*
I'm Every Woman *Chaka Khan*
Free Your Mind *En Vogue*
Truth Hurts *Lizzo*
CRZY *Kehlani*
Video (Main) *India.Arie*
Golden *Jill Scott*
I'll Take You There *The Staple Singers*
Un-thinkable (I'm Ready) *Alicia Keys*

River *Ibeyi*
Shea Butter Baby *Ari Lennox (& J. Cole)*
We Are Family *Sister Sledge*
Like a Star *Corinne Bailey Rae*
Level Up *Ciara*
Hot Girl *Megan Thee Stallion*
Without Me *Halsey*
While We're Young *Jhené Aiko*
Doo Wop (That Thing) *Lauryn Hill*
Almeda *Solange*
Wonder Woman *LION BABE*
Next to Me *Emeli Sandé*
Always Be My Baby *Mariah Carey*
Lemon *N.E.R.D & Rihanna*
Django Jane *Janelle Monáe*
Work It *Missy Elliott*
No Scrubs *TLC*
Don't Take It Personal (Just One of Dem Days) *Monica*
Moment 4 Life *Nicki Minaj (feat. Drake)*
Almost Doesn't Count *Brandy*
Let It Burn *Jazmine Sullivan*
Respect *Aretha Franklin*
Afrika *Amanda Black (feat. Adekunle Gold)*

https://open.spotify.com/playlist/6Ce7axBiCBGf2nJoeFUQpv?si=
37h8eCTcSoW9K1MgMg5Oeg

33

FOR RACHEL DOLEZAL WHO PERFORMS BLACK WOMANHOOD WHEN WHITE PRIVILEGE ISN'T ENUF

TYIESHA RADFORD SHORTS

Dear Rachel,
Or Nkechi Amare Diallo
I can't keep up with what you're calling yourself these days.
African American
Diasporic
Black . . .
All co-opted identities for a woman who hasn't quite been able to
negotiate the exchange rate of white tears for Black oppression.
Whatever you're calling yourself these days, I would not be doing
my due diligence
If I did not take the time to outline the terms of Black
womanhood.
You know, like a disclaimer of sorts
Before you sign on the dotted line and
Lose all of the privilege your remaining white womanhood
affords.

One.

Being a Black woman is more than box braids and self-tanning
 lotions.
Actually, it doesn't include self-tanning lotions at all
You cannot manufacture our melanin
Our Blackness is evident in our high cheekbones
Which we may or may not have inherited from a First Nation
 ancestor, and
Can be found in our two-toned crevices where the rejection from
 white feminism and the refusal from Black leadership meet
Our Blackness is the reason why we smell like cocoa butter, laven-
 der water, and heaven.
Heaven—before the fall of Lucifer
You know, back before he started trippin', thinking he was better
 than God.
Because, ain't that just how most men treat a Black woman?
Thinking they're superior, then running off and fucking shit up
 for everybody?
And even when our darker skin forsakes us for lighter pastures
You can still find it in the one drop that we passed on to massa's
 grandkids
As our collective inside joke against his claim to racial purity.
And to be clear
You will not be granted access to said inside jokes.

Two.

Being a Black woman does not automatically guarantee you
 access to Black men.
History has shown us this time and time again.
In fact, there will always be some chasm between Black love,
Be it romantic or platonic,
That your whiteness benefits from.
Know that should you choose to remain a white woman
Black men will not be off-limits to you.
You can sleep with as many or as few of them as you like
And still maintain your neutrality
When they are used for target practice in the

Street
Old Towne East alley
park gazebo
gated community
grocery store
passenger seat.
A neutrality that also, conveniently, allows you to be silent when
 your Black sisters disappear at epidemic rates.
Because, remember, hashtags don't go viral when we are killed.
Instead, voices are silenced
Tongues shoved deep into throats
Until all that remain are our
Tears and our
Moans and our
Knowing glances and our
Silent prayers to God hoping that She sees our trauma and fash-
 ions our daughters into swords.

Three.
Black women cannot be transracial.

Four.
No, seriously.
Transracial is some bullshit that you created to explore your fetish
 of Blackness while preserving the supremacy of whiteness.
Consider this, if race is no more than a social construct, tell me
 which midnight blue-black, Black woman has ever been able to
 claim whiteness and have her claim honored.
I'll wait.

Like if Auntie Maxine (no, you may not call her Auntie) woke up
white and demand that we see her as such, would you cape for
her?
Probably not.
You see, you are not carrying on the tradition of the numberless
 products of rape
who passed for white in order to survive

Who passed for white at the risk of exclusion and loneliness,
at the risk of chopping down entire family trees at the root so that
 the bloodied leaves could one day bear fruit.
You are more like a twenty-first-century minstrel
Bamboozling your way into pop culture
Blotting blackface when it suits you while simultaneously pushing
 actual
Black faces
Black voices
Black people
further beyond the margins.

Five.
Nobody gives a damn if you are a Black woman.
I mean this with all sincerity.
Those of us with the blessed curse of being both Black and
 woman know that
We are the literal and figurative mules of the world.
Know that sometimes you have to be an obeah woman
And Oshun yourself into yourself.
Know that we are both person and possession.
Both product and producer.
Both profitable and disposable.
We must let water run down straight backs
Watch parts of ourselves appear, dismembered and scattered in
 city dumpsters
Or reassembled on magazine covers, accenting white bodies.
We are thighs
Afros
Stretchmarks on ass.
We are lips
Tits
Milk—for our children and theirs.
But, most importantly, we are best seen and not heard
Which is good, because ain't nobody got time to listen to you,
Even when you tell them who you are.

PART 7

Speaking Intersectional Truths

34

TOWARD A POLITIC OF PREEMPTIVE CARE

TAHEREH AGHDASIFAR

WHILE THIS piece was written in 2016, now, in 2020, after the U.S. assassinated the commander of the Iranian Quds Force Qasem Soleimani in a targeted drone strike and the U.S. continues to increase devastating sanctions, the desires communicated in this text feel even more salient.

In the days after the mass shooting at the Pulse Nightclub in Orlando, many friends reached out to ask if I was okay. Some sent extra care because I am both brown (the kind associated with the shooter, not the kind who had been murdered) and queer. While I was grateful for the kindness, I was also surprised. I had never received so much support over a tragedy that is (relatively speaking) tangential to my actual life. I began thinking through the last few "tragedies" that affected me and realized how lonely those events felt. What if friends had offered the same kind of support when the U.S. imposed even more sanctions against Iran over their (legal) nuclear program? I wonder why no one sent condolences when the first Iranian, a fifteen-year-old boy suffering from hemophilia, died from the new sanctions because he could no longer access his life-sustaining medicine? Why had no one reached out when Iranians started lining up outside of pharmacies hoping chemotherapy drugs had finally arrived, but they never did? Why didn't those I am in community with

begin organizing against the sanctions? No one asked if I was okay. If my family was okay. If I needed the hugs, meals, comfort, or distractions that I received offers for after the Pulse tragedy.

This is not a criticism of those who have reached out to me and other folks in similar positions—I am deeply appreciative of the kindness that has been extended to me. This also is not a demand that we start closely following political developments everywhere in order to offer ourselves up to care for others as soon as anything happens. I do not need you to know the intricacies of Iranian politics to care for me, nor do I actually expect offers for immediate forms of care when things happen to/in Iran. I am instead questioning if we can reframe our approach to what we understand to be tragic, the kinds of lives we deem worthy of life, the parts of others we don't necessarily see in ourselves but should have reason to care for anyway.

As I strive to center the WOC feminist ethics of care spoken to in *This Bridge Called My Back*, I am curious how we can craft a queer feminist approach in our care for one another—how we prioritize particular ways of being and feeling in different communities, and what it means when parts of us may fall short or be made less visible in different spaces. When parts of us don't get seen, when parts of us learn to suffer alone, and what it means when no one notices that. What it means when all this care and love during the Pulse tragedy communicates to me (and I imagine others) that I am not feeling the right feelings; that my fear and sadness around what has happened / may happen to Iran, for example, is not as pressing as my expected emotional strife around the Pulse shooting and the racist panic which ensued. The love I have been offered around the tragic killings in Orlando is mediated by queerness, with racialization as an afterthought. However, the silence I have been met with around issues which impact my existence as a brown person from a working-class refugee family (without the queerness as relevant or present) demonstrate how other parts of me may not necessarily be worthy of care. While it's an unintentional consequence of care, it is also the only conclusion I can draw given the dearth of responses around events which have been more immediately devastating for my family and me.

There are parts of (all of) us that feel devastated by seemingly banal events, sometimes even more devastated than by national tragedies; there are parts of (some of) us that feel the impacts of quotidian racism

viscerally, violently, and invisibly; there are parts of (some of) us that are shattered by seemingly innocuous or barely news-worthy political developments. I am wondering where these racialized/illegible parts of me land for others. I wonder how those parts of me (and other QTPOC) impact the relationships white allies can have to us, how those parts of us alter the care that could lovingly and honestly be given to us. The level of care offered to me around Orlando has been from genuinely kind places, but from white folks, it has been through this lens of queerness, which feels like a nonconscious movement to alleviate white guilt through immediate and direct acts of kindness and giving to QTPOC. There is nothing wrong with this. Harnessing the energy of guilt and funneling it into direct action is a good thing.

The problem, instead, is twofold and long-term: that this kind of action falls dramatically short of what would actually shift the kinds of lives QTPOC lead, and that this urgent and response-oriented action along loose "community" lines or understandings does not take into account other kinds of tragedy that may also, or more greatly, impact the lives of QTPOC. What would it mean to begin movement from an intersectional position that understands that all parts of us are valuable—not simply the ones that may overlap with you? What would it mean if from that position we worked to provide care and encourage self-care around the various ways that U.S. imperialism / white supremacy can produce tragedy? What would it mean if care had meaning across scales, from offering a meal to organizing a demonstration to building and maintaining a radical coalitional transnational politics?

I am not arguing for less immediate forms of intimate care when it is needed and you can provide it but for a different framework altogether— one that demands a position that understands, appreciates, and deeply cares for the interconnectedness of our race, class, gender, ability, documentation, and sexuality, and how sometimes some parts of us are more vulnerable or more devalued than others (both within our "community" and outside of it). I am wondering how we might develop a broader sense of collectivity that is attuned to the ways that tragedy materializes and impacts lives that can be different than our own, rather than what we have to quickly assess and assume "must" be hurting others because of how it hurts (or induces guilt in) parts of ourselves. How can we forgo the alienation that knee-jerk politics and "care" can produce and instead

build forms of relationality on a daily basis that are genuinely open to how tragedies on various scales may manifest for those "like us" (queers, POC, etc.) but also those who have no overlap with us? How do we build forms of relationality that allow us to feel comfortable expressing what actually feels tragic for us, regardless of its legibility to others? Instead of further individualizing and monetizing pain, I am interested in a collective and coalitional politic that can care for parts of others that we cannot see, understand, or relate to—a feminist mode of care that does not rely on legibility within a liberal framework to necessitate care or love.

35

IN THE NAME OF DIVERSITY
—A SISTERS' CONVERSATION

SISTER SCHOLARS

Everywhere we see it
Missions, visions, goals, and curricula
Websites, brochures, newsletters, and advertisements
In the name of diversity
Dear Gloria, from 1979 until now in 2020
Dear Cherríe, we have not "turned our backs"
"Oppression suffered by women of color" abounds all around us
In the very air we breathe and all the spaces we occupy
Spaces in the academy
We can see it, feel it, smell and taste it
Oh yes, we hear it!
And we read it too!
In the "narrow" view of academe
Not the "expansive" view of our lives as academics
In the unacknowledged and undocumented emotional and physi-
 cal work of women of color
And our Brothers too
We are connected to you
To our Sisters of color around the world
Those with privilege like us

And those who have never known privilege
We see you
Your marginalization, your victimization
Your defenselessness,
Your womanliness, battered and scorned
Beaten and abused
We feel you!
We are not immune
We feel you and we see you and
We stand for and with you
On the shoulders of giants
Who went before us.

In the name of diversity
We acknowledge the unacknowledged
The unwritten work
The emotional work
The confidential work
The invisible LABOR
All in the name of diversity
It is not part of our "responsibilities"
It cannot be "evaluated"
There are no awards
None for service and excellence
None for teaching
Because that is what we are supposed to do
In the name of diversity
Service Others!
Damned if we do and damned if we don't
If awarded, then diminished or dismissed
Ethnic Journals, ill considered
Until a white male does
Writings about race, uncounted
Until a white woman does
Teach teach teach and bend over backwards to increase our
 teaching scores
Mentor mentor mentor until they graduate

The unwanted, students of color
The unwanted, language minoritized
The unwanted, internationals
Yet we toil and represent
Represent
Represent
In the name of diversity
Committee work
Represent
Service work
Represent
We stiffen our backs to bear
The assaults, hostility, and punishment
The aggressions untold
Be like us, we are told
Like a man
competitive
self-centered
domineering
power-hungry know-it-alls
Braggadocio
Not like us, crying and emotional
Collaborative and caring
Sharing, trying to do good for the greater good
Act like a man, a White man at that!
 "Go back home to where you came from"
 Not good enough
 Not a good fit
 Don't talk like us
 Don't look like us
 Don't think like us
Yet you need us
And we need you
With the reparations withheld for centuries
With the systemic, structural, and class horrors caving in
We will build bridges
We will mend fences

We will shoulder the load
Sing songs of hope
Live fulfilled lives
After you, Mitsuye Yamada
After you Audre Lorde
And you Harriet Tubman and Sojourner Truth
In the name of diversity
In the name of diversity
In the name of diversity
In the name of diversity
In the name of diversity
In the name of diversity
IN THE NAME OF DIVERSITY!!

36

OPEN LOVE LETTER TO MY YOUNGER SELF, A YOUNG BLACK BUTCH WORKING THROUGH HER SHIT

BRITTNEY EDMONDS

Dear Brittney,

I love you, and I think of you often. I am writing this because you some-times forget that you need others. You also sometimes forget yourself. I am writing this because you are a touchstone for yourself, and that is important. Your courage to love yourself will always be your greatest gift. Others will confuse this tenacity, your quiet intensity, for anger or self-absorption. You must mind them as you mind your former selves, with compassion.

Today I watched an epic film about a man alone in space. It was an alle-gory. It sent me on my own journey of contemplation. I thought deeply about how I arrived at the other end of this letter, about what I wanted to reach you, about the magic that would propel my heart and my will through space and time. What I want to share with you has nothing to do with triumph or overcoming, but the only way I know how to understand how I now stand with my back more perpendicular to the earth, with my shame finally cast off like a bad habit or an over-warm coat, is to think about you, how you are both me and someone else, how we have come to know each other through a magic this world refuses and therefore cannot contain.

For most of our life, we have had to warp ourselves to fit the limited confines of others' imaginations. Often, these people thought they were doing us favors, saving us from harm or grief, for they knew, as we would again and again find, that the cost to buck the belief of others is life and limb. They knew that even our own would not always love our flesh, our embodiment. What they did not know was how the limited imagination was a harm and source of grief itself, a failure to love. When Baldwin talked about white people and the evil they do in the name of whiteness, he said that their *innocence* is what most constitutes their crimes. There will be a period in your life where you will charge this verdict to everyone you know. You will damn them for their inability to recognize you as anything other than a problem, for your own inability to fit into categories that they can recognize and respect. This will be a painful and isolating period, to say the least.

During this time, you will have just graduated from college and taken your first steps toward realizing your long-held dreams. Your dreams will disappoint you. You will disappoint you. You will spend many years sitting in your apartment, licking your wounds. This will at times devolve into self-pity, cloying sentimentality that seeks to ape the angst of books and films, to make from the rubbish of your life the only kind of beauty that seems within reach. You will learn that beauty can be deceptive, this beauty and your own, your face attracting the wrong type and crowd, making demands on you and your movement in the world that have nothing to do with love. You will at first invest entirely in this beauty before divesting from it with vigor and vengeance.

But those times alone in your apartment will also teach you how to love yourself for no other reason than that you are alive. You will demand nothing of yourself and nothing of others, and for years, you will painstakingly revisit the ways in which you refused this basic charge, natural as breath, at your own expense. Your life will fall apart around you as you do so, and this, too, will be a lesson, about what you can live with and without, about how you survive, about how good it feels to relinquish control. These lessons come after, of course, so I write to you in part to give you the courage you have already exercised, though you will only, belatedly, recognize it as such. I write to you because you are never alone and because you are always full and because sometimes we need to hurt.

One of the most dissociative parts of this society is the belief that all its violence will somehow never occasion us pain. One of the most danger-ous parts of this society is the casual practice by which those in power slough off their pain onto those without power. And power can be a tricky word, operating along multiple axes and to multiple ends. Every-one wants their share, and you will grow to recognize in that desire itself a kind of violence that has no answer. You will resent those who cloak their desire in social niceties and the way of things, taking advantage of your social awkwardness. You will resent those who step on you and mischaracterize you and badger you in their race from the bottom. You will be surprised again and again by how others fear the bottom, how even if they do not desire the top, they will forsake nearly everyone and everything to escape its opposite.

You will find home there, with the undesirables, with those cast off and cast out. Most people will not understand this, will think you have willingly chosen failure or waywardness. But you will find love there—and freedom. Years later you will sit in another apartment, this time with a friend, and she will marvel at your self-possession. She will not see your pain, and you will not correct her when she asks, "Doesn't it ever get to you? Aren't you tired—I mean, do you ever feel not up to it, not want to reply to the vicious comment or the subconscious slight?" You and this friend will whisper across the room like co-conspirators. In the afternoon light, you will tell her slowly, admitting something you have only just come to know yourself, that of course you do not always say something, but that you never forget yourself. "The secret," you will say, "is to love yourself publicly, to let people know that you see nothing wrong or pathological with any part of yourself, so if there's a problem, it's not yours." You will not mention that this won't stop the slights, but you do tell her how clear your vision has become and how unsettling it is for those who would deny you to meet your gaze. You do tell her that loving yourself this way, your flaws and shortcomings, your past misdeeds and your future failures, frees you. Once free, it will be easier to see the willed unfreedom of others, how they hold you to standards and ideas in which they themselves do not believe, how the desire to be right or first contorts their wills and their hearts.

It's important that this pull toward freedom not only concern yourself. In the early years, I used my gaze to reflect back others' hypocrisy, to make them feel and experience their own hostility as I did. This was naïve. It led only to enemies—not to a better world. When I was young, I used to hate the idea that my being, simply for being minoritized, was expected to be exemplary. I still reject this idea, but with it, I reject the idea that my actions are in any way compensatory, that there is something to be compensated for, which is to say that others' barbarity, the very bricks of civilization, is not mine to answer for or to. You will learn this lesson and the compassion that accompanies it slowly.

The biggest changes will come when you begin to recognize the love in your life. It's a familiar enough story, but the people who stick around and love you *through* will change you, will utterly astonish you with their loyalty and care. Brittney, I write to you because for much of your life, you will not believe that you are able to make any difference that counts, your life only another drop in the bucket. That difference, believe it or not, extends from the simple charge, natural as breath, to love yourself, and to do so publicly.

Love yourself,
Brittney

37

FROM PAPERBACK TO PRAXIS

In Search of Filipina/x Feminisms in the Diaspora

MONICA ANNE BATAC, FRANCE CLARE STOHNER, AND KARLA VILLANUEVA DANAN

Three years ago, I googled "Filipina Feminism," and the book *Pinay Power* came up. . . . That was my entry point to Pinayism, peminism. . . . That book helped me change how I looked at Filipinas. . . . Growing up feeling like I was less than, that I was not capable, that I couldn't access these predominantly white spaces, I realized I was not the only one. There was a whole field of women waiting . . . they were out there.

—KARLA VILLANUEVA DANAN, ORAL INTERVIEW[1]

What we're really trying to do is carve out a space, create a place for Pinays in academia. And I think this is really the time to step up and say we're entitled and we want to claim this space.

—FRANCE CLARE STOHNER, ORAL INTERVIEW[2]

1. Karla Villanueva Danan participated in a Kapwa Calling podcast recording with Jacquie Gallos Aquines and Jillian Sudayan of Treaty 7 region, Calgary, Alberta. A partial recording of this discussion can be found at https://www.facebook.com/monicabatac/videos/10102108780898781/

2. Parts of this oral interview, along with other voices from the PINAY POWER II student collective, can be found in the Epic Youth Leadership Awards video on this initiative: https://www.youtube.com/watch?v=J2aLSmVG2Mw

Y EARNING TO be in community with other Filipina/x feminist schol-
ars, activists, practitioners, artists, and students, we recently took
up the task of co-imagining and co-organizing the academic and
community conference PINAY POWER II (PPII): Celebrating Peminisms
in the Diaspora, held in Tiohtià:ke/Montreal in April 2019. We write this
chapter to share our journeys prior to this conference and describe early
interventions from which this event emerged. We attempt to draw a
discursive map of the emergent forms of Filipina/x diasporic feminism
explored, practiced, and expressed at PPII by focusing on accessibility,
decolonization, and trans inclusion. We then gesture towards Filipina/x
feminist interventions yet to come.

———

Completing our degrees felt like we had defied the odds against us—the
sole Filipinas in our respective programs.[3] In our solitary attempts to heal
from ongoing violent and traumatizing classroom (and later, workplace)
experiences, we each turned to texts to find solace in this struggle. *This
Bridge Called My Back* provided us with a momentary reprieve from
our isolation, and we felt connected to women of color feminist writing.
Echoing Cherríe Moraga's reflection on faith, these writings helped us
"believ[e] that we have the power to actually transform our experience,
change our lives, save our lives."[4] They affirmed why we were angry and
exhausted, healing us enough to look toward feminism for hope and pos-
sibility: we can, *must* fight for our collective liberation.

And still, a longing remained.

Seeing so few students and scholars of color, we did not know of the
existing writing by Filipina/x/o professors until we searched for it ourselves.
Finding the anthology *Pinay Power: Theorizing the Filipina/American*

———

3. Many people will point to the work of Philip F. Kelly (York University) regard-
ing the rates of Filipino youth entering and completing Canadian post-secondary
education. Findings from the Filipino Youth Transitions in Canada Project taught
many Filipina/x/os of our generation that our individual challenges with school/
learning are indeed shared with youth across the country. We continue to initiate
and deepen community and school-based initiatives to support ourselves and the
college/university students to come.
4. Moraga, "La Jornada," xi.

Experience (2005) felt surreal, as it was the first text where we encountered a collection of Filipina scholarship. Editor Melinda Luisa de Jesús writes her dedication first "to my Pinay sisters throughout the diaspora."

Did this include us?

Where were we in these texts?

We began to wonder if collective Filipina feminist publications or anthologies had been developed from non-U.S. sites. In our search of the Canadian context, we found the university profiles of professors Nora Angeles, Glenda Bonifacio, and Ethel Tungohan. Intimidated but with curiosity, we read their works from afar, trying to imagine conversations and connections with them.

We were looking to explore our identities as Filipina/x while simultaneously deepening our feminist praxis. One solution was to enter community spaces. Initially drawn to community and academic spaces engaged with "social justice," we were taken aback by the intense, covert, and undiscussed lateral violence we received and witnessed once we became more involved. Here, feminist praxis was superficially touted but not embodied in practice, and further, young women and trans women were the frequent targets of misogynist aggression. To heal, we imagined a critical feminist and queer community wherein there would be a commitment to accountability, relationality, and decolonization.

EARLY INTERVENTIONS: CONVERSATIONS IN THE COMMUNITY

Seeking Filipina/x feminist connections, we (Monica and Karla) joined a Kapwa Calling podcast with Jacquie Gallos Aquines and Jillian Sudayan in February 2018. We absentmindedly put it out to the universe that we would like to work on a second edition of *Pinay Power*. We started exchanging ideas about gathering scholars and community members together. We were desperate for a safer space to gather, to connect with others in our (un)learning.

To assess the interest in a potential gathering, we hastily secured a booth at Pistahan, an annual festival at Nathan Phillips Square (Toronto, Ontario) organized by the Filipino Centre Toronto. It would take place

June 16–17, 2018. While Karla quickly created buttons and compact mirrors with playful Tagalog sayings, Monica created a T-shirt, "Peminista: Loud, Brown & Proud." We also curated a small mobile library of Filipina authors for this Pinay Power booth. Over those two days, we were visited by family, friends, and strangers alike. It was clear to us that feminism was unfamiliar. Students were enthusiastic and wide-eyed when we shared that we were trying to gather Filipina/x feminists together.

======

A daughter, no older than six years old, looked longingly at the colorful items on display and for sale. The child finally picked up a compact mirror, grinned, and proudly announced, "I want this one!"

Before we could respond, her mother quickly admonished her choice, "Do you know what that reads? Brown is Beautiful. Do you want to be Brown!?" Near tears, her daughter quickly put down that mirror, shaking her head profusely, apologetically. Monica tried to interject, repeating "Brown is Beautiful," without trying to overstep.

This was all too familiar.

We knew that internalized oppression and colonial mentality, and more specifically colorism and anti-Black racism, were present in our own lives and families. Hearing it mirrored so intensely by our kababayan was heartbreaking, and it validated the importance and urgency of this emergent work. Affirmed by radical mothers and politicized students, we were energized to figure out how to gather ourselves, our fellow Filipina/x feminists, together. And by continuing and expanding these conversations, we intentionally began to forge connections and deepen relationships with senior and early career Filipina/x feminist scholars, students, peers, artists, organizers, organizations, and allies, creating a shared purpose and vision for this gathering. As graduate students, we chose to anchor the organizing at McGill University, where Monica was studying for her PhD. We received interest from the Institute for Gender, Sexuality, and Feminist Studies (IGSF) where we could access resources, staff, and institutional supports to convene a community-engaged, student-led conference.

CONTOURS OF THE CONFERENCE

While we are unable to provide extended descriptions regarding the specifics of this conference organizing, here we point towards the contours of Filipina/x diasporic feminisms expressed at PINAY POWER II (PPII). We highlight organizing commitments and collectively held efforts to address accessibility, decolonization, and trans inclusion.

ACCESSIBILITY

The conference sought to be as accessible as possible, bearing in mind many Filipina/xs from all walks of life might attend. With no registration fee, we provided childcare, meals, snacks, and active listening services, and we covered invited speakers' fees, travel, and accommodations, thanks to funding secured with the Social Sciences and Humanities Research Council of Canada. Attendees and speakers utilized everyday language to engage with a diverse audience. All venue bookings were accessible for wheelchairs. Activities such as film screenings, community dinners, a comedy show, musical performances, a DJ demonstration, and an artist market provided opportunities for families, non-Filipinos, non-academics, and non-artists to access feminist thought, writing, cultural production, and praxis through accessible mediums. Jo SiMalaya Alcampo commented that future discussions should emphasize and prioritize disability justice.

DECOLONIAL PERSPECTIVES

The conference introduced discussions regarding what decolonization might look like within the Filipina/x/o community in conversation with Indigenous members locally and globally. Wanda Gabriel, Kaniekeha'ka, Kanehsatake, a professor of social work at McGill University welcomed participants to the territory on the first day and shared the Haudenosaunee Thanksgiving Address. Two members of the Center for Babaylan Studies, Jen Maramba and Jana Lynne Umipig, offered opening and

closing ceremonies to the group and created a communal altar. They discussed the complexities of re-membering ceremonial practices from and in diasporic contexts, on Indigenous lands. Three graduate students, Rebecca Goldschmidt, Nadenz "Nadine" Ortega, and Debra Andres Arellano, flew in from the occupied Kingdom of Hawai'i, where scholarly and activist discussions linking Filipina/x/o labor, migration, and settler colonialism are more advanced than in the Canadian context. It is no surprise then that all three speakers spoke on the Decolonization and Healing panel.

During the Pinays in Social Work panel, Kelly Botengan, a Toronto-based settlement worker and former live-in caregiver, stood up to comment on the importance of recognizing women who may not have all the official academic or professional qualifications but whose voices are integral to feminist discussions. She expressed her own discomfort with the collective identification of Filipina. As an Indigenous woman (Cordillera), she identifies strongly with her tribe. However, in the diaspora, such regional affiliations tend to be obscured. Similarly, incoming McGill Filipina professor Maria Hwang expressed that as someone born and raised in the Philippines, she did not identify as Pinay (a term originating from the U.S. diaspora) but Filipina.

Such instances reveal a collective effort towards decolonial ways of thinking and learning in community, where key learnings emerged through conversation, tended to Filipina/x/o complicity in Indigenous dispossession, and unsettled simplified understandings of conflated Filipina/x identifications.

SENSITIVITY TOWARDS TRANS INCLUSION

Beyond the desire to broaden transnational feminisms away from affiliations with and boundaries of nation states,[5] the conference also sought

5. Attempting to take a diasporic approach, we were clear about engaging beyond the Philippines-U.S. transnational binary. As Filipinas in the Canadian diaspora, we consistently felt eclipsed and compared to the U.S. articulations. Presenters and attendees, however, primarily came from North American institutions. We had a singular attendee from Hong Kong and the Philippines, respectively. See also Anna Lacsamana, "Identities, Nation, and Imperialism: Confronting Empire in

to query the articulations of Filipinas beyond hetero and cisgender normative scripts. The Transpinay panel was scheduled as a concurrent panel discussion on the first day. On Day 2 during a collective debrief session, where participants were invited to share, comment, and reflect on anything related to the conference, one attendee commented that the Transpinay panel should have been a keynote panel where all participants were to attend and listen.

We sat with this suggestion in silence, understanding the intent and motivation behind these words as a broader desire to hear from the trans women in the community. However well intentioned, it was not so simple. As organizers, we had been attentive to their needs, privacy, and comfort level. For many of the women on the panel, it was the first time they were agreeing to speak publicly, essentially "outing" themselves as trans. Several also shared previous traumatizing experiences in queer spaces and with other Filipino academics. As a result, they were generally hesitant to attend conferences, let alone share their lived experiences. Because of the existing personal relationships and established trust with some of the organizers, the women agreed to participate. Yet a keynote or plenary panel was too much pressure for their first speaking engagement, even with a Filipina/x feminist audience. We also had discussions about not fielding an open question and answer period to respect their boundaries. These women later shared that their talk served as an important space for them to share their own lived experiences with attendees receptive to listen and learn. It also created an opportunity for them to bond with each other.

PPII supported the expansion of "womanhood" in Filipina/x diasporic feminisms. Attentive to the coalitional politics and possibilities between women of color feminisms and queer of color critique, we explicitly support trans women in our community who experience simultaneous marginalization in queer and feminist spaces because of narrowly defined understandings of queerness and womanhood.

Filipina American Feminist Thought"; and Filomeno V. Aguilar Jr., "Is the Filipino Diaspora a Diaspora?"

GESTURING TOWARDS FILIPINA/X FEMINIST SOLIDARITIES

While some would describe the conference's beginnings as "serendipitous," such a description would oversimplify our journeys to this point, our individual and collective labor born out of literal and metaphorical longing. To echo Cherríe Moraga, this is "our refusal of the easy explanation to the conditions we live in."[6] Emphasizing this ongoing shared desire to be in community with our kin, we repeat the words of Genny Lim:[7]

> I look at them and wonder if
> They are a part of me
> I look in their eyes and wonder if
> They share my dreams

For some, those four days may have been a routine conference stop and added lines to the academic CV; for others, it served as a lifeline, a just-in-time intervention to save them from the isolation experienced in their everyday lives and in other scholarly and community spaces. PPII enabled us to meet each other where we were at, to literally find each other and cultivate new and renewed friendships and connections.

In the preface to the fourth edition of *This Bridge Called My Back*, Cherríe Moraga reminds us that these women of color feminist texts are like timestamps. The dream of an anthology with our voices within it no longer seems so out of reach. What began as a reaction to the isolation of Filipina/x graduate students soon became a tangible community gathering where we could express a collective commitment to feminism. We want to continue this organizing work within both academic and community spaces. And by writing to record our experiences, we hope that one day we can teach these texts to affirm that we are here and we are not alone.[8] Will we have to wait another decade and a half to convene this

6. Cherríe Moraga, "Entering the Lives of Others: Theory in the Flesh," 19.

7. Genny Lim, "Wonder Woman," 20.

8. For this manuscript, we thank the anonymous reviewers for their feedback. As well, maraming salamat to Chloe Rodriguez, Emilie Santos Tumale, Julia Baladad, Kari Tabag, Psalmae Tesalona, and Drs. Fritz Pino, Ilyan Ferrer, and Maria

many Filipina feminists and see the sprouts of PPII? Who might pick up the torch next? What does the sustainability of this feminist movement look like? In the aftermath, we sit with intentional hesitation and pause to reflect on the labor that is shared and collective and on what is our own individual responsibility and work.

BIBLIOGRAPHY

Aguilar Jr., Filomeno. V. "Is the Filipino Diaspora a Diaspora?" *Critical Asian Studies*, 47 no. 3 (2015): 440–461.

De Jesús, Melinda. L., ed. *Pinay Power: Peminist Critical Theory: Theorizing the Filipina/American Experience*. New York: Routledge, 2005.

Lacsamana, Anne. E. "Identities, Nation, and Imperialism: Confronting Empire in Filipina American Feminist Thought." In *Globalization and Third World Women: Exploitation, Coping, and Resistance*, edited by Ligaya Lindio-McGovern and Isidore Wallimann, 65–80. London: Routledge, 2016.

Lim, Genny. "Wonder Woman." In *This Bridge Called My Back: Writings by Radical Women of Color*, 4th ed., edited by Cherríe Moraga and Gloria Anzaldúa, 20. Albany, NY: SUNY Press, 2015.

Moraga, Cherríe. "Entering the Lives of Others: Theory in the Flesh." In *This Bridge Called My Back: Writings by Radical Women of Color*, 4th ed., edited by Cherríe Moraga and Gloria Anzaldúa, 19. Albany, NY: SUNY Press, 2015.

Moraga, Cherríe. "La Jornada: Preface, 1981." In *This Bridge Called My Back: Writings by Radical Women of Color*, 4th ed., edited by Cherríe Moraga and Gloria Anzaldúa, xxxv-xli. Albany, NY: SUNY Press, 2015.

Hwang for their feedback and engagements on earlier versions of this chapter, alongside their active participation in and witnessing of the conference itself.

38

"AIN'T I A WOMAN?"

Sojourner Truth in 1851 vs. a Black Sex-Trafficked Woman
Survivor in the Present

JACQUELYN C. A. MESHELEMIAH

SOJOURNER TRUTH, 1851 WOMEN'S CONVENTION, AKRON, OHIO

AIN'T I A WOMAN?

Well, children, where there is so much racket there must be something out of kilter. I think that 'twixt the Negroes of the South and the women at the North, all talking about **rights**, the white men will be in a fix pretty soon. But what's all this here talking about?

That man over there says that women need to be helped into carriages, and lifted over ditches, and to have the best place everywhere. Nobody ever helps me into carriages, or over mud-puddles, or gives me any best place! **And ain't I a woman?** Look at me! Look at my arm!

I have ploughed and planted, and gathered into barns, and no man could head me! And ain't I a woman? I could work as much and eat as much as a man—when I could get it—and **bear the lash** as well! And ain't I a woman?

I have borne thirteen children and seen most all **sold off to slavery**, and when I cried out with my mother's grief, none but Jesus heard me! And ain't I a woman?

Then they talk about this thing in the head; what's this they call it? [member of audience whispers, "intellect"] That's it, honey. What's that got to do **with women's rights or Negroes' rights**? If my cup won't hold but a pint, and yours holds a quart, wouldn't you be mean not to let me have my little half measure full?

Then that little man in black there, he says women can't have as much rights as men, 'cause **Christ wasn't a woman**! Where did your Christ come from? Where did your Christ come from? From God and a woman! Man had nothing to do with Him.

If the first woman God ever made was strong enough to turn the world upside down all alone, these **women together ought to be able to turn it back and get it right** side up again! And now they is asking to do it. The men better let them.

Obliged to you for hearing me, and now old **Sojourner** ain't got nothing more to say.

A BLACK SEX TRAFFICKED WOMAN SURVIVOR IN PRESENT DAY

AIN'T I A WOMAN?

Well, everyone, people are up in arms, so times must be changing. I think Black, trafficked women and anti-trafficking activists are all talking about **human rights** and some White people are indignant about it. Why are people angry about treating Black women like humans?

That judge downtown says that women need help for their addictions to opioids, to be taken to safe havens, and to live a life free from pimps. Nobody helped me to get over my addictions or gave me a place to live

or made sure I didn't go back to my pimp! **And ain't I a woman?** Look at me! Look at my body!

I have been beaten, raped, and abused in trap houses, and no woman has had it worse than me. And ain't I a woman? I could sleep and eat as much as a pimp—when I was able to—and bear a **beating by a john** as well! And ain't I a woman?

I gave birth to seven children and seen most of them **taken by Children Services**, and when I cried out as a mama, no one but God heard me! And ain't I a woman?

Then they talk about this thing . . . you know what I mean . . . whatchama-callit? (Someone yells out, "melanin.") That's it, sistah. What's that got to do **with women's rights or Black people's rights**? If my melanin is held against me and yours give you privilege, wouldn't it be selfish to not use your White privilege to help me?

That little Bible-toting, sexist man says that women can't have rights like men because **Jesus wasn't a woman**! Where did his Jesus come from? Where did our Jesus come from? Well, he came from God and a woman named Mary. Man had nothing to do with making Jesus.

If the first woman God ever made (Eve) was powerful enough to turn the world upside down by herself, **we survivors ought to be strong enough as a group** to make things right again! And survivors are asking to do it. Society better let us.

My name is **Zora**. Thank you for listening to my story.

39

A LOVE LETTER TO OURSELVES

Self-Love as a Revolutionary Act, Theories of the Flesh, and (In)Compatible Identities

LEANDRA HINOJOSA HERNÁNDEZ AND
SARAH DE LOS SANTOS UPTON

Queridxs,

We write this letter to you en solidaridad, to let you know that you are not alone as you process the relationships between your sexuality, identity, and cultural backgrounds. Like Anzaldúa, we understand that a letter is the only form through which we can express the intimacy and immediacy we long for.[1] *This Bridge Called My Back* helped us make sense of our identities and sexualities, and we are confident that *A Love Letter to This Bridge Called My Back* will do the same.

Leandra: I still remember the moment I first touched *This Bridge Called My Back: Writings by Radical Women of Color*. I was an undergraduate student enrolled in my first women's studies class—this is where I was first introduced to Anzaldúa's writings. She was the only Chicana author listed on our syllabus, and I clung to her writings for survival. By pure luck, one afternoon while at Half Price Books, I found the first editions of both *This Bridge Called My Back* and *Borderlands/La Frontera*, books that have traveled with me across duty stations, state lines, and country lines. Writings by Anzaldúa, Moraga, Levins Morales, and Quintanales

1. *Anzaldúa*, "Speaking in Tongues," 165–173.

helped me glue together the fragmented parts of my identity as a third-/ fifth-generation queer/pansexual, Chicana/Tejana feminist—identity categories and experiences that lacked terms, lexicons, and binding with which to join everything in my soul. As an adult, terms characterizing my sexuality have only recently graced my verbal utterances and writings, fragmented bits and pieces that find public homes when I feel safe.

I never quite knew how to navigate these conversations when I was younger. I remember very vividly the moment I realized sexuality was fluid and the accompanying internal conversations and logical hoops about what that meant for me as an individual: Straight? Gay? Lesbian? Bisexual? (Later pansexual?) How do I tell anyone about this? *Do* I tell anyone about this? Culturally, queer folks were always stigmatized, something I realized painfully through overhearing family conversations, watching novelas with family members, and observing general interactions as I grew up, particularly because I attended religious schools where sexuality was never discussed outside of a traditional heteronormative framework. Oftentimes, in my own state of nepantla, I felt as if I was straddling multiple borderlines, as if I had to choose one: my cultural background or identifying truthfully who I really am.

Sarah: La frontera taught me about fluidity. I grew up on the border of El Paso, Texas, and Ciudad Juárez, Chihuahu, and it was here that I learned what it meant to exist between two cultures, languages, and countries. This perpetual in-betweenness truly allowed me to not only "tolerate" ambiguity but to begin to embrace and even love this state of being. When I first read Anzaldúa as an undergraduate, she was the first person to give words to the concepts I already held sacred in my heart. I always considered myself straight, as no experiences growing up told me otherwise. Yet, when I found myself developing feelings for a woman for the first time, though it was confusing for me, my openness to the possibility was natural. While I identified as straight, the transition to seeing my sexuality as fluid was inherent to my experiences living in nepantla. The knowledge already lived in my body.

This is not to say that everyone else embraced this fluidity in the same way I did. There were painful moments of coming out, with tears and questions and accusations. There were moments of discomfort when others were upset that I did not fit neatly into their labels, frameworks, and ideas of who they thought I was or should be. There were long silences

and absences as I processed what this shift in identity meant not only to me but also to those around me. When I experienced racism in my first relationship with a woman, I felt further isolated and marginalized. However, when I turned to scholarship by other queer people of color, I felt seen and was comforted by this recognition.

———

This is a love letter to ourselves and to other queer folx who find themselves at the margins of seemingly incompatible and paradoxical cultural and sexual identities. As Chicana feminists who were born and raised in traditional Mexican, Catholic, heteronormative homes in Texas, our queer and pansexual identities were often stifled, stigmatized, and rebuked from close loved ones and family members. Furthermore, given that we are in partnerships with cisgender, heterosexual men, we have had to continuously justify our sexualities, our identities, and our relationships with heteronormative and LGBTQ+ friends, co-workers, fellow activists, and allies. Thus, in this short autoethnographic essay, we draw from existing literature on diverse and fragmented identities to trace the development of our sense-making of ourselves as third- and fifth-generation Mexican American, Chicana/Tejana feminists, and queer/pansexual, exploring how these identities impact our personal and professional lives.[2] Just as Andrade and Gutierrez-Perez draw on past experiences in "On the Specters of Coloniality" to offer consejos for future generations of estudiantes, we reflect on our coming-out process in order to share our stories with one another and with ustedes. We use these experiences to think through what we needed to hear in those moments so that we can offer these messages to ourselves, to one another, and to anyone reading our letter. As Hurtado notes, "Many women of color have to negotiate the external negative evaluations based on their group memberships—race, gender, class, sexuality—with their internal sense of self."[3] Drawing upon theories of love politics as a resistant act of self-care, theories of the flesh, women of color feminist writings on the fragmentation of selves and border concepts like nepantla and liminality, this essay is one of our first steps toward a further

2. The literature we have drawn from is listed in a bibliography.
3. Hurtado, "Theory in the Flesh: Toward an Endarkened Epistemology," 220.

development of theories of the sense-making and coming-out process as a
radical act of self-love and self-assertion.

Although you might hear phrases with negative connotations hurled
your way—"pinche joto" or "ay, malflora"—just know that you are not
navigating these spaces alone. It may seem as if your experiences, par-
ticularly navigating those moments of coming out, can be riddled with
endless self-questioning, doubt, and pain. However, we offer this love let-
ter to ourselves and ustedes that shows a glimpse of how coming out can
function as an act of self-love for those of us in the physical, cultural, and
sexual borderlands. As hooks explains in *All About Love: New Visions*,
"When we can see ourselves as we truly are and accept ourselves, we
build the necessary foundation for self-love."[4] Coming out, whether it be
to ourselves or others, allows us to know ourselves in deeper and more
meaningful ways, and creates opportunities for greater self-acceptance.
This love for ourselves and others allows us to reach heightened con-
sciousness, or conocimiento.[5]

We understand that the questions, accusations, and silences produce
arrebatamientos that we face together en solidaridad, but let this letter,
this book, and Anzaldúa's work and legacy, be a part of your Coyolxauh-
qui process. We have found support and strength as we share our stories
with one another and now with you, and we recognize the power and
potential in loving ourselves enough to live (and write) authentically. We
conclude with things we needed to hear que queremos compartir con
ustedes:

It's okay to take your time to figure things out. It's okay to be wherever
you are in your process. It's okay to take space from those who are unwill-
ing and unable to accept you for who you are. Your identity is messy
and complex, and that is beautiful. There is power and strength in your
ambiguity. You do not have to put up with homophobia and/or racism
in your romantic relationships, friendships, or within your family and
culture. Remember, you are not alone.

Con Cariño,
Leandra y Sarah

4. hooks, *All About Love.*
5. *Anzaldúa, Light in the Dark/Luz en lo oscuro.*

BIBLIOGRAPHY

Andrade, Luis. M., and Robert Gutierrez-Perez. "On the Specters of Coloniality: A Letter to Latina/o/x Students Journeying Through the Educational Pipeline." In *Latina/o/x Communication Studies: Theories, Methods, and Praxis*, edited by Leandra Hinojosa Hernández, Diana I. Bowen, Sarah De Los Santos Upton, and Amanda R. Martinez, 313–331. Lanham: Lexington Books, 2019.

Anzaldúa, Gloria. "Speaking in Tongues: A Letter to Third World Women Writers." In *This Bridge Called My Back: Writings by Radical Women of Color*, 4th ed., edited by Cherríe Moraga and Gloria Anzaldúa, 165–173. New York: Kitchen Table: Women of Color Press, 1981.

Anzaldúa, Gloria. *Borderlands/la frontera: The New Mestiza*. San Francisco, CA: Spinsters/Aunt Lute Books, 1987.

Anzaldúa, Gloria. *Light in the Dark/Luz en lo oscuro: Rewriting Identity, Spirituality, Reality*. Durham: Duke University Press, 2015.

De Los Santos Upton, Sarah. "Communicating *Nepantla*: An Anzaldúan Theory of Identity." In *This Bridge We Call Communication: Anzaldúan Approaches to Theory, Method, and Praxis*, edited by Leandra Hinojosa Hernández & Robert Gutierrez-Perez, 123–142. Lanham, MD: Lexington Books, 2019.

Gutierrez-Perez, Robert, and Leandra Hinojosa Hernández. "How to Read this Book: An Introduction for Everyone and No One." In *This Bridge We Call Communication: Anzaldúan Approaches to Theory, Method, and Praxis*, edited by Leandra Hinojosa Hernández & Robert Gutierrez-Perez. Lanham, MD: Lexington Books, 2019.

Hernández, Leandra Hinojosa. "'I Take Something from Both Worlds': An Anzaldúan Analysis of Mexican-American Women's Conceptualizations of Ethnic Identity." In *This Bridge We Call Communication: Anzaldúan Approaches to Theory, Method, and Praxis*, edited by Leandra Hinojosa Hernández and Robert Gutierrez-Perez. Lanham, MD: Lexington Books, 2019.

hooks, bell. *Sisters of the yam: Black women and self-recovery*, Vol. 66. South End Press, 1993.

hooks, bell. *All About Love: New Visions*. New York: Harper Collins, 2000.

Hurtado, Aída. "Theory in the Flesh: Toward an Endarkened Epistemology." *International Journal of Qualitative Studies in Education*, 16 no. 2 (2003): 215–225.

Lorde, Audre. *Sister Outsider*. Trumansburg, NY: The Crossing Press, 1984.

Moraga, Cherríe, and Gloria Anzaldúa. *This Bridge Called My Back: Writings by Radical Women of Color*. Watertown, MA: Persephone Press, 1981.

Moraga, Cherríe, and Gloria Anzaldúa. "Theory in the Flesh." In *This Bridge Called My Back: Writings by Radical Women of Color*, edited by Cherríe Moraga and Gloria Anzaldúa, 23. Watertown, MA: Persephone Press, 1981.

Moraga, Cherríe. *Loving in the War Years: Lo que nunca pasó por sus labios*. South End Press, 1983.

Nash, Jennifer. C. "Practicing Love: Black Feminism, Love-politics, and Post-intersectionality." *Meridians*, 11 no. 2 (2013): 1–24.

Pérez, Emma. "Sexuality and Discourse: Notes from a Chicana Survivor." In *Chicana Lesbians: The Girls Our Mothers Warned Us About*, edited by Carla Trujillo, 159–184. Berkeley, CA: Third Woman Press, 1991.

Pérez, Emma. *The Decolonial Imaginary: Writing Chicanas into History*. Bloomington, IN: Indiana University Press, 1999.

PART 8

Sense Making and
Embodied Knowledge

40

THIS BRIDGE

Intergenerational Story Archive, Re-rooting Solidarity

SUSY ZEPEDA

> We have come to realize that we are not alone in our struggles nor
> separate nor autonomous but that we . . . are connected and inter-
> dependent. We are each accountable for what is happening down
> the street, south of the border, or across the sea.
>
> —GLORIA ANZALDÚA

Dear Editors, Writers, Visionaries, Artists of *This Bridge Called My Back:
Writings by Radical Women of Color*:

As a working-class and detribalized, queer Xicana Indígena, I honor each
of you. Our spiritual *tias*, aunties. I am writing this during the global
pandemic and the Black Lives Matter revolution of 2020. I want to thank
you, each of you, for being brave, courageous, and openhearted in your
truth offerings. Your writing feels like an invitation to sit at the commu-
nity *maestra* circle, to touch traumas to heal while rewriting our sto-
ries. The collective vision you offered in *This Bridge* has given us, the
next generations, tools, *herramientas*, methodologies to see the complex
landscapes and layers of the world through the eyes of our ancestors, to
revive and remember the archives that give us life. *This Bridge* paved a
dynamic, interconnected road map to make visible the necessity of seeing
struggles as interlocked, particularly in the context of imperialist wars,
forced migration, Native genocide, disrespect of the Earth, enslavement,

imprisonment, detainment, and rampant fear and cycles of intergenerational trauma due to state-sanctioned and colonial violence.[1]

In *This Bridge* you ground solidarity through written word, *palabra, tlahtolli*—you show us that this praxis can be sacred, oppositional, and generative. You did not intend to articulate a harmonious or complete world but one that is always dreaming and imagining other worlds. Just, balanced, and harmonious worlds. *This Bridge* showed us the process of walking toward liberation through many paths. Narratives full of *enseñanzas*, teachings, that could be told around a ceremonial fire or with herbal tea at the "Kitchen Table."[2] Truth-telling of the most difficult kind. Unraveling the stories with shame, *tristesa*, and *susto* due to unjust systems rooted in white supremacist, patriarchal, colonial logics. This allows for the intergenerational remembering and healing to manifest *en circulo*. Ceremonial circles are often created to psychically unravel the cycles of violence and legacies of colonization, enslavement, genocide, and the dominance of patriarchy that live in our homes, bodies, and communities. *This Bridge* calls us into a circle in a good way and reminds us to go back to our circles, to unlearn in order to remember, and to feel worthy of being a part of the sacred space with humility and open hearts.

This Bridge offers the insight that we need to be in solidarity and meditation with each other. The innovation of the text is arguably rooted in teaching us how to be bridges through the praxis of creating possibilities of walking together in respectful ways across constructed barriers and borders. In one text live many interconnected histories. It puts flesh and bones to imagining by women of color rooted in U.S. Third World feminism.[3] Tensions, contradictions, and paradoxes are welcomed as they help us see our limitations and shadows and spaces to grow. Putting spirit work into words next to complicated narratives of racism, genocide, poverty, homophobia, patriarchy, protest, and war gives the reader, including next generations, permission to imagine a cosmically rooted critical existence and vision; to let go of the idea that we are in competition with each other

1. The Combahee River Collective, 2002.
2. Kitchen Table Press was in part created to re-publish *This Bridge* in 1983 to replace Persephone Press, the original 1981 press.
3. Sandoval, *Methodology of the Oppressed*.

and other beings on this earth; to rid ourselves of the colonial "divide and conquer mentality," the illusion of the American dream, and other destructive narratives that are maintained through current forms of racism that exist within the tenets of capitalism. The visionary sister warrior writers, now elders and ancestors, of *This Bridge* clearly show *we are relatives* who can actively practice solidarity and uplift struggles of liberation that are different from our own, through the articulation of poems, manifestos, essays, letters, and word prayers. We are distinct in walks, pathways, and histories, yet always interconnected. The goal is not unification or homogenization; instead, the vision is to honor differences that create possibilities for radical re-imaginings and ancestral rememberings. A deep wisdom that sheds light on possible tools for healing in this moment, in our lifetime. When people are aligned with this knowledge, compassion can grow exponentially, the greed, ego, or need to be dominant dwindles, the struggles that each person and community faces becomes clearer—particularly as we map the destructive patterns of the systems that perpetuate harm-based logics of eugenics (i.e. white supremacy, capitalism, and war).

The sister warriors featured in *This Bridge* and their communities taught us that knowledge and wisdom live within every being and sacred element, and that the circle must always be reciprocal and mutual yet critically aware of distinct geopolitical histories and hierarchies. Spiritual elder aunties, we are so grateful for you and continue to look to you for rooted, critical guidance in our current historical moment as we are witnessing the unraveling and unsustainability of global racist capitalism every time we lose a life to racist violence and this virus. It seems we need to re-root and learn how to listen again to ourselves, our elders, our earth. How do we put into practice the lessons of intergenerational oral storytelling as a form of protection and transformation? How can we be respectful of the origin stories? How do we grow our seeds of consciousness and liberation? What are the systems of creative knowledge that honor the wisdom of the earth? What conditions create the forgetting of ourselves as people of the earth? How do we unravel the violent programming of dominant narratives within our inner worlds and our collective minds, bodies, and spirits?

Siempre en mi corazón, in deep solidarity and love,
Susy

BIBLIOGRAPHY

Hanh, Thich Nhat. *Fear: Essential Wisdom for Getting Through the Storm*. Harper-Collins Publishers, 2012.

Moraga, Cherríe, and Gloria Anzaldúa, eds. *This Bridge Called My Back: Writings by Radical Women of Color*, 3rd ed. Berkeley: Third Woman Press, 2002.

Sandoval, Chela. *Methodology of the Oppressed*. Minneapolis: University of Minnesota Press, 2000.

Santa Cruz Feminist of Color Collective. "Building on 'the Edge of Each Other's Battles': A Feminist of Color Multidimensional Lens." *Hypatia*, 29 no. 1 (2014): 23–40.

41

EXCAVATING AND EMBRACING ANGER

An Abolitionist Practice Within

STEPHANIE CARIAGA

My body, like yours, tells a certain story. . . . It speaks in a clear, direct, and simple language, which is sensation. . . . Though it does not lie, somehow I have been taught to distrust it. My oppression and the subsequent trauma are rooted in this fundamental distrust.

And because of this experience of distrust, I am mad. Angry. Anger lives in my body like a ghost haunting a house. To understand my anger, I have to learn to understand my body, to return to it to ask the ghost to leave.

—LAMA ROD OWENS, *LOVE AND RAGE: THE PATH OF LIBERATION THROUGH ANGER*

I HAVE DEFINITELY learned to distrust my body's intuition. There is a child and mother in me who would rather avoid conflict than speak their angry truths. I am also a woman of color tired of censoring my politics and pedagogy to make them more palatable, tired of carrying generations of unprocessed anger that lingers in my body as multiresentments and has metastasized in my mother's body as disease.[1] The rising demands for racial, gender, and climate justice, combined with the isolation of a global pandemic, have beckoned me to no longer silence my anger but to let it sit with me.

1. To learn how the repression of anger can lead to disease and how feeling can lead to healing, see Gabor Maté, *When the Body Says No: Understanding the Stress-Disease Connection* (Hoboken, NJ: John Wiley & Sons, 2011).

When there is a clear call to abolish all forms of policing and prisons in this country, my deepest contribution in this moment is to practice solidarity right here through my body.[2] Audre Lorde calls us to do the "hard work of excavating honesty" from our anger,[3] while Cherríe Moraga and Gloria Anzaldúa summon us to listen to our embodied wisdom.[4] Today, I am inspired by the Movement for Black Lives' insistence on channeling the fertility of anger into collective transformation, but I cannot fully translate my awe into action unless I start with unraveling my own anger and its relative fears, contradictions, and longings.

EXCAVATING ANGER

During week twelve of sheltering at home, I felt a familiar rage. My son Lino was resisting shower time *again*. I felt a heat rise within, then a need to flee. Jaws clenched, I rushed toward the farthest bedroom in the house. I punched the door, slammed it shut. I was angry with my kids for not hearing me, at being stuck in this house, at not having my parents' home as a refuge anymore, angry with myself for being so fucking angry. I had nowhere satisfying to put this rage. I felt alone within this internal fire and desperately wanted something, someone to feel its impact with me. So I screamed and kicked the nearest wall. And to my surprise left a humongous hole.

My fire melted into shame. *What did you do?* a familiar voice interrogated. My mind raced through lies to cover it up. I even considered framing my own kids for the hole! When bedtime came, I finally told the ugly truth. Like a child bracing for punishment, I sunk my head into my shoulders and peered at my family. I burst into tears, apologizing for my

2. This realization became concrete when I participated in a speaking panel titled "Re-purposing our Pedagogies: Abolitionist Teaching in a Global Pandemic." One of the speakers, Carla Shalaby, emphasized that abolitionist teaching must dismantle the parts of ourselves that see students as disposable. On that panel and in this chapter, I focus on the emotional parts of ourselves that we deem disposable, namely our anger.

3. Lorde, *Sister Outsider*, 128.

4. Moraga and Anzaldúa, *This Bridge Called My Back*.

temper. My husband rubbed my back, joking that he was relieved it was me and not a ghost or pest. Lino hugged me as my daughter Laila teared up with me, both sensing the weight that had been lifted.

My family and I laugh when we tell this story, but I know this moment shifted some profound childhood wounds to the surface. Where does this potent rage come from, and why do I persistently police it? Why was I relieved that my family still loved me? Where have I been taught the lie that love is conditional upon having everything together and withheld when things fall apart?

The deeper I investigated, the more I recognized my wounds were present and old, personal and collective. I looked closer at my body's habit of turning away and tucking inwards. Underneath the anger is a fear of feeling and expressing too much. Underneath that fear is a young child with big feelings wishing someone would just turn toward her instead.

DISEMBODIMENT

I have always been sensitive to this turning away from emotion: being hurt when told as a child to "stop crying," noticing schooling's incapacity to hold the weight of young people's righteous feelings, enraged by white men and women's free reign to feel, express, and weaponize their emotions, while the emotions of marginalized bodies remain violently scrutinized. Owens calls this disembodiment, where the "psychic trauma of oppression posits itself in the body, . . . making it dangerous for us to sense our bodies."[5]

As a child, I would become overwhelmed by my dad's unexplained temper. Instead of learning to recognize and express my confusion and fear, I disembodied from those feelings and projected my concern towards others' comfort and safety. My mom reinforced this through her muted anger, which expressed itself as passive aggression instead. I eventually learned to focus solely on deciphering and feeling everyone else's feelings, underestimating their agency to meet their own needs while disappearing my own. But my anger keeps trying to relay a message: stop

5. Owens, *Love and Rage*, 85.

overriding your feelings for a semblance of belonging or false peace. It's okay to be seen in the chaos of anger.

I intuit that my anger is not just my own. When my Grandma Mary reunited with her husband in Hawai'i, thirteen years after being left in the Philippines pregnant with my father, it wasn't what she expected. Grandma discovered Grandpa Pete had found another lover. "*Agawid akon, anak*—It's time to go home," she would tell my dad, but they never returned. My dad remembers Grandma's emotional outbursts throughout his childhood and his overwhelming attempts at consoling her. I sense the heaviness of Dad's memories, but I'm also grateful for Grandma's temper. Their stories live in me when I kick a hole in the wall, declaring our bodies' refusal to keep holding on to unspoken heartbreaks. Our anger provides pathways to heal the losses of home and connection we've suffered under imperialist patriarchy, so we can rebuild home in our bodies now.

RECLAIMING EMBODIMENT

The deepest way I've learned to be in relationship with my body is through politicized somatics.[6] My friend Belia, a somatics practitioner, taught me a practice to get in touch with my anger. It starts with centering, a process of unlearning disembodiment and attuning to my body. I use my breath to anchor my feet into the earth, allow my spine to lengthen into a felt dignity, expand the edges of my body to take up as much space as I need. I breathe into my back, sensing my ancestors and inner child behind me, softening through the front of my chest, acknowledging the present before me. Different from meditation, I keep my eyes open to remember I'm not alone and allowed to connect with my environment.

From this centered place, Belia taught me to channel my anger by hitting pillows with a stick. The first time I hit a pile of pillows I notice how I

6. I draw from my training with generative somatics, a methodology of individual and collective transformation through the body. To learn more about the framework, practices, and real-life applications, see Staci Haine's book, *The Politics of Trauma: Somatics, Healing, and Social Justice*, North Atlantic Books, 2019.

hold my breath, anticipating backlash for my anger. I sense more pressure in the front of my feet, my torso lunging forward. In conflict, I often find myself in this forward-facing shape, ready to manage away discomfort. I hear it in my mom's heightened voice when she calls and tells me her leukemia is back, as we quickly figure out the best plan forward without pausing to check in about how heartbroken we feel.

Noticing the embodied feedback helps me re-center and hit the pillows again, this time remembering to breathe and be present in my heels and back. By the third time, I sense a slight expansion in my chest and a tender release. I choose not to run away. I stay in this moment, the pillows embracing my anger and the ground holding me. Anzaldúa says, "It's not on paper that you create but in your innards, in the gut and out of living tissue."[7] Through practice, my embodied narrative of anger slowly gets rewritten from fear and repression into new possibilities: power and pleasure.

RECEIVING INTIMACY

My journey through anger eventually leads me to grief, rooted in a longing for everyone to be seen exactly as they are and express exactly as they feel, myself included. Unexpectedly, I'm able to experience this kind of intimacy on a FaceTime call after my dad takes my mom to the hospital for her ten-day chemotherapy. My mom tells me later that he wasn't able to walk her into the hospital because of the pandemic protocols. As soon as I call my dad, he uncharacteristically breaks down. Throughout the pandemic and my mother's leukemia relapse, we have all been holding it together for my mom.

As my dad sobs uncontrollably, all I can say is, "I know, Dad. It's hard." "It's so hard, *nining*," he responds. I cry with him.

In that moment, I sense something heal in me, my inner child, perhaps my dad's inner child too. Even through a phone screen and the enforced distance of a global pandemic, I feel more connected with my dad than I've felt in a long time. By caring for my anger, I've become more open

7. Moraga and Anzaldúa, *This Bridge Called My Back*, 170.

to witnessing emotion without trying to fix it. I hope to soon experience this intimacy with my mom,[8] practice it with my children, institute it in schools. May we learn to love all the intricate, intergenerational parts of ourselves—including the anger, grief, and power—to never dispose of but instead to integrate the wisdom inside of them. This is my abolitionist practice, which starts from within.

BIBLIOGRAPHY

Lorde, Audre. *Sister outsider: Essays and speeches.* Crossing Press, 2012.
Owens, Lama Rod. *Love and Rage: The Path Towards Liberation Through Anger.* North Atlantic Books, 2020.
Moraga, Cherríe, and Gloria Anzaldúa, eds. *This Bridge Called My Back: Writings by Radical Women of Color,* 4th ed. Albany, NY: SUNY Press, 2015.

8. One month after I submitted my first draft of this chapter, my mother passed away from leukemia complications. As heartbreaking as this process was and continues to be, I did indeed experience moments of emotional intimacy with my mother and family. I am grateful for the opportunity to write this chapter and reflect on vulnerable moments of internal and intergenerational love, which has inadvertently prepared me for more raw emotions, pain, and healing that continue to come.

42

HOW TO MAKE COLLARD GREENS

OLIVIA RICHARDSON

D UE TO my experiences in a politicized body, I've found people tend to see more merit in my opinion when my work states it rather than when I voice it. That is, I have more agency as an artist than as a Black, cis-het, woman. In turn, my work is a vehicle that allows me to exploit the existing social structure that works against my voice. My goal is to educate my audience in an accessible form that can catalyze conversations that aid in a broader understanding of marginalized identity.

How to Make Collard Greens (2020) consists of my great granny's South Carolina "Low Country" collards recipe and my stream of consciousness. This work highlights the duality of being Black while simultaneously not always feeling Black enough. I nod to the use of oral tradition and the medicinal qualities cooking and soul food bring to the Black family and larger community. In this reflection, I try to find what parts of me are truly me and what parts are me trying to fit into my identity.

How To Make Collard Greens

Look for the biggest, greenest leaves.
Scrub the kitchen sink with Ajax and fill with cool water.
Submerge. Leave to soak.

There is always grit.
Why is there always grit?

The gas flame should be low.
Do I even like collards?
Throw in a ham hock, a chopped onion, and red pepper flakes.

Pat your collards dry.
Take a knife and cut the stems out all the way to the ridges.
"Only lazy cooks leave the stems on their spinach and greens."
Yes Granny.

Add your collards with salt, pepper, and a pinch of sugar;
They'll be bitter without.
Oreo echoes in my ears.
Mama's Gun, "Was that your voice or was that me?"

Place the lid and let it cook for a couple of hours.
Hang a collard leaf over the door to keep the evil spirits out.

Serve the collards but retain the pot liquor.
Serve to loved ones when under the weather.
You are what you eat springs to mind.
I want to be Black.

How to Make Collard Greens, 2020. Digital print, 9 x 15.5 in. (22.9 x 29.4 cm)

43

RECOGNIZE

KAIA ANGELICA LYONS

recognize verb
rec·og·nize | \ 're-kig-'nīz, -kəg- \
recognized; recognizing
Definition of *recognize*[1]

transitive verb

1. : to acknowledge formally: such as
 a. : to admit as being lord or sovereign
 Lana[2] *asked one of her employees to prepare a financial report for her to
 give to another department. The employee made it clear that he didn't
 think the report was necessary; in his opinion, the financial impact of
 the activity in question wasn't large enough to merit a report.*
 *We all know what it's like to be asked to do busywork, and no one likes
 having their time wasted. At the same time, every Black woman knows*

1. This Merriam-Webster definition has been condensed into five primary
parts.
2. Lana, like every woman whose story is told in this piece, is a Black woman.

what it's like to be questioned and second-guessed unnecessarily. This
was one of those times.
We might not know why Lana needed that report, and her employee
might not know either. But at the end of the day, he still prepared it
because he **recognized** *that Lana was his boss and he needed to follow*
instructions.

b. : to admit as being one entitled to be heard : give the floor to
There can be no disagreement that racism is prevalent, and if we all spent
our time fighting every microaggression inflicted upon us, we'd never
have time to do anything else. But when your organizations are failing
you and your friends aren't showing up for you, you have to make a
stand.

After a number of "riots" centered around police brutality broke out in St.
Louis, Sabrina decided to speak to different Greek chapters on her pre-
dominantly white college campus about racial tensions, her personal
experiences, and her peers' failings. When she received pushback from
her own sorority president, she felt defeated. But the president of a fra-
ternity on campus **recognized** *that what she had to say was important*
and that she should be listened to, and he invited her to come speak to
his chapter. He set up the room for her, gave her the floor, and held his
fraternity members accountable; Sabrina was able to speak freely, and
others were able to listen and learn.

2. : to acknowledge or take notice of in some definite way: such as
 a. : to acknowledge with a show of appreciation
Jacque was up at 5 a.m. working on a rough draft of a paper—one that
she would have to turn in later that day. She hadn't procrastinated;
she had spent her whole semester researching a different topic, only to
realize that the research she had executed would not support her thesis
as acutely as she'd like. So, the rough draft she was working on was a
completely new topic. Later that day, when Jacque had to present on
the progress of her (new) research to her class, she was, quite frankly,
exhausted. She felt like she was holding on by a thread, and she needed
someone to lift her up. That made it all the more beautiful when her
professor, who **recognized** *how much Jacque had to offer, said, "Trust*
your genius, and give your work some credit."

It was exactly what she needed to hear. It was her new mantra. And, eventually, it was an A+ on her paper.

3. **a** : to perceive to be something or someone previously known

Kaia had mastered the art of smiling at strangers. Specifically, she had mastered the art of smiling at strangers who weren't interested in getting to know her but were concerned with her presence. She knew how to say, yes, I belong here, yes, I am one of you, no I am not dangerous. All with a smile.

When she attended a predominantly white writer's conference, she grew accustomed to smiling this way. None of her peers seemed interested in her as a colleague; rather, they seemed to want proof that she actually belonged to the conference. Such treatment made her feel invisible. But one morning Claire, a woman of color she had met the night before, **recognized** *her when they passed in the hallway. Claire smiled at her and called her by name: "Hey, Kaia! How's it going, girl?" And the smile she gave Claire—just like the one Claire had given her—was real.*

 b : to perceive clearly: REALIZE

They **recognized** *the beauty in being Black women when*

- *another Black woman walked by her and said that her hair was a breath of fresh air*
- *she locked arms with her sisters at a protest and realized that she had found love and community, even in the midst of overwhelming grief*
- *she saw someone who looked like her living out her dream and realized that she could do it too*
- *the number of students in grade school who looked like her could be counted on one hand, and the yearbook photos of the Black children "stood out like blooming flowers on a budding tree"*
- *she realized after the 2016 election that others did not or would not acknowledge the beauty of Black women*
- *she's surrounded by her family, generations of Black women who make her feel at home*
- *she gave birth to her first child: a beautiful, Black baby girl.*

44

ENDARKENED PRELUDES TO WOMANHOOD

KENDRA JOHNSON

I REMEMBER THE precise moment I became a woman. I was nine years old. It was a sweltering day at summer camp, and my friends and I had gathered in the shade of a large tree to escape the heat. As was our custom during recess at school, we choreographed dance routines that were heavily influenced by the moves we had seen in music videos. When it was my turn to contribute an idea for the routine, I suggested a *slightly* promiscuous dance I had learned after staying up late to watch a late-night music video program that, as my mama would say, I had no business watching. The move was the *Back Breaker*, the grandmother to the dance style that would come to be known as *twerkin'*. To this day, I'm not sure why I decided to replicate the move I had seen performed by the scantily dressed women in the music video. I blame the heat. I bent my knees and arched my back the same way in which I had seen the dancers in the video. I opened my mouth and began to chant "aye, aye, aye"— everyone knows that no *real* dancing ever occurred without a few "ayes" and "heys" in the background—and shook my bottom with as much vigor as my nine-year-old self could muster. As my friends cheered me on, I danced harder and wilder and riskier. It was the kind of performance that only a child bent on impressing her friends could have given. What I remember most from that day were not the looks of admiration on each

of my friends' faces but rather the look of disgust bestowed upon me by my camp counselor, Mrs. C.

Mrs. C was a middle-aged Black woman. She was also a minister, deaconess, missionary, and praise dancer at her church, and she had very strong opinions on how girls should behave in public. Unbeknownst to me, Mrs. C had been watching my friend group and I choreograph our dance routine and had seen my moment of glory. She scolded me for being a "bad influence" on my friends. She then rounded up the group and lectured us about the ramifications of being young Black women who danced like *that* and our duty to *know better*. We were angry and confused. Not only had she ruined the fun, but also, she had seemingly ignored the group of White girls who, less than three yards away, had been doing splits and other tricks that left little to the imagination. For many years after the fateful encounter, I wondered if Mrs. C realized that she had denied my friend group and me the presumed innocence of being *young* by levying the moral expectations of being *women* against us. Our experience was neither unique nor was it the last time any of us would be subjected to a differential, occasionally punitive treatment within and across institutions because of our intersecting racial, gendered, and social class identities.

The day after my early foray with twerkin', and many times after that, I got "the talk" from my parents. The talk was their way of reminding me that I was Black and because I was Black I could not "do everything those White people do." Outside of our family home, a large number of historical and contemporary examples have suggested that Black girls within the United States have historically been excluded from notions of girlhood innocence;[1] in fact, the denial of adolescent purity for Black children has roots in chattel slavery. "Black boys and girls were often put to work as young as two and three years old. Subjected to much of the same dehumanization suffered by Black adults, Black children were rarely perceived as being worthy of playtime and were severely punished for exhibiting normal childlike behaviors."[2] So, at an early age, I learned

1. Epstein, Blake, and González. *Girlhood interrupted: The Erasure of Black Girls' Childhood.*

2. Epstein, Blake, and González. *Girlhood interrupted: The Erasure of Black Girls' Childhood*, 4.

to reconcile my interlaced identities of being a Black woman-child as I became more aware of how they influenced society's perceptions of me. I knew that if I was not careful, any action that defied Eurocentric standards of femininity and docility would render me maladjusted or resistant.[3] Despite my best efforts to be careful, I recognized that being part of a lineage of people who had not been afforded the presumed innocence of adolescence or the consideration of personhood would mean continually and fastidiously defining myself from the vantage point of an anomaly. Most of the early lessons I learned about what it meant to be a Black woman in America were taught to me in ways that emphasized all the things I could not do because the intersections of my racial and gendered identities maintained my exclusion from notions of humanity.

Not being allowed to do "everything those White people do," or being afforded the same societal protections and social capital forced me to negotiate my gendered and racial group memberships both against and alongside other groups; however, even though the metaphysical paradox of being a Black woman in America has remained a complex system of (un)becoming that has been fraught with frustration,[4] I am thankful for people like my parents and Mrs. C and my eternal sister-friends who have helped me define myself for myself so as to not be crunched into people's fantasies of me and eaten alive. Both my personal encounters with gendered racism and racial sexism and those that I have shared with other Black girls and women have caused me to develop a distinctive style of living and leading that is rooted in the West African ideology of *Sankofa*. Sankofa emphasizes the importance of using the knowledge gleaned from past experiences to inform the present and prepare for the future. I feel both compelled and honored to use my individual experiences as a catalyst for the radical (re)conceptualizing, centering, and celebration of Black girls and womxn, as a collective.

3. Fordham and Ogbu, "Black students' school success," 366–372; Annamma et al., "Black Girls and School Discipline," 211–242; Lindsay-Dennis, "Black Feminist-womanist Research Paradigm," 506–520; Smith-Evans and George, *Unlocking opportunity for African American girls*.
 4. Lorde, *Sister Outsider*.

BIBLIOGRAPHY

Annamma, Subini Ancy, Yolanda Anyon, Nicole M. Joseph, Jordan Farrar, Eldridge Greer, Barbara Downing, John Simmons. "Black Girls and School Discipline: The Complexities of Being Overrepresented and Understudied," *Urban Education*, 54, no. 2 (2019). 211–242.

Epstein, Rebecca, Jamila J. Blake, and Thalia González. *Girlhood interrupted: The Erasure of Black Girls' Childhood*. Washington, DC: Georgetown Law Center on Poverty and Inequality, 2017.

Fordham, Signithia, and John Ogbu. "Black students' school success: Coping with the 'burden of "acting white."'" In *The Structure of Schooling: Readings in the Sociology of Education*, edited by Richard Arum, Irenee R. Beattie, and Karly Ford, 366–372. California: Sage, 1986.

Lindsay-Dennis, LaShawnda. "Black Feminist-womanist Research Paradigm: Toward a Culturally Relevant Research Model Focused on African American Girls," *Journal of Black Studies*, 46, no. 5 (2015): 506–520.

Lorde, Audre. *Sister Outsider: Essays and Speeches*. Toronto: Crossing Press, 1984.

Phinney, Jean S. "Stages of Ethnic Identity Development in Minority Group Adolescents," *The Journal of Early Adolescence*, 9, no. 1–2 (1989): 34–49.

Smith-Evans, Leticia, and Janel George, *Unlocking opportunity for African American girls: A call to action for educational equity*. New York: National Women's Law Center, 2014.

45

THE BLACK WOMAN COALITION

LISA WHITTINGTON

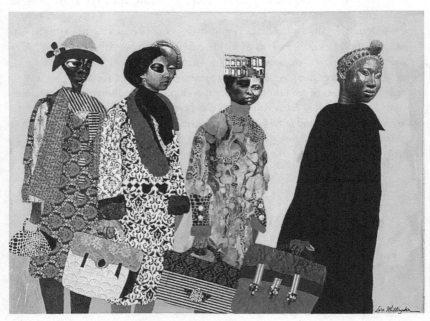

The Black Woman Coalition, 2020, Mixed media, 36 x 48 in. (91.4 x 122 cm)

The Black Women Coalition is a 36 x 48 mixed-media artwork executed on canvas. In 2020, Black women in America were active on the front lines of the election and stepped up and voted for Joe Biden. The actions of Black women changed the course of the United States, which was headed toward fascism. This artwork honors the work of Black women in the 2020 United States election.

PART 9

Justice and Healing in Times of Crisis

46

TO HEALING HERIDAS CON CORAZÓNES OF GENERATIONS

A Testimonio

GABRIELA ARREDONDO

IT CHASED me as I walked out of the house to leave—an unearthly wail, a woman's voice, my abuelita. It pierced my soul and forced me to run back inside for one more despedida. But when I got to her bedside, 'Uelita was peacefully asleep. That was the last time I saw my Abuelita Tencha alive.

'Uelita fought against the cruelties of the rinches, marched herself to San Antonio and Austin to fight Texas's segregated and racist school system, liberated her emaciated and war-ravaged nephew from a military hospital in Louisiana, taught many children and adults in her community to read and write in Spanish and English, sold handmade quilts and tamales to make ends meet, and became the linchpin in a vast multi-generational border familia.

'Uelita's abrazos were enveloping: her bosom was warm and ample, her hair smelled like rose water, her laugh was contagious. Her kitchen was always warm, full of activity, filled with familia, amigos, vecinos . . . todos juntos, platicando, chismiando, regañando, testimoniando, charlando. No one used the front door; everyone knew the back door was the real entrance to her home. The screen door opened right into her cocina. There was rarely a set mealtime as 'Uelita was always ready to feed anyone who dropped in her legendary tamales, machaca, pozole,

frijoles, juevos y chorizo, and her handmade tortillas (los de harina pero tambien los de maíz). She made tortillas almost daily.

That last time, though, 'Uelita's kitchen was dark even though the sun shone outside. 'Uelita had been scorched, her chest ravaged with third-degree radiation burns, her breast removed entirely. As we sat together at the table, she opened her light cotton bata and showed me what the brujerias de los médicos had wrought upon her.

The U.S. medical system failed 'Uelita. We failed her too. She did not get mammograms during most of her life, and it never occurred to us to encourage her to get them. Even Medicare would have paid for them, and we could have helped her with the co-pays. Pero, como me dijo ese dia, she didn't think viejitas could get breast cancer, and medical doctors never informed her. We know from extensive research that despite advancements in treatments, "the mortality rate of breast cancer is still higher among Black, Hispanic, and Native American women than among White women."[1] We know too, that like my 'Uelita, women of color regularly face lack of access to early detection and screening, are diagnosed at more advanced stages of disease, and have uneven access to frustratingly unaffordable treatments. Racism and discrimination are embedded in our medical system.

Our medical system is failing us again. We are in the midst of a global pandemic, batallando el COVID-19, and people of color are being especially hard-hit. As with many other diseases in this country, there is growing evidence that long-standing inequities in our health and social systems are putting people of color at higher risk for getting sick and dying from COVID-19. Researchers are finding that racial disparities in death rates of those with COVID-19 are "due to these compounding, elevated risks from our systems of housing, the labor force, health care systems, and policy responses—are the result of *systemic racism*."[2] As of July 2020, for example, Blacks constitute 6% of the population of California but are 9% of the deaths from COVID-19; Latinos are 39% of the California population but represent 56% of confirmed cases of COVID-19 and 46% of the deaths from el COVID.[3]

1. Clement G. Yedjou et al., "Assessing the Racial and Ethnic Disparities in Breast Cancer Mortality in the United States," 486.
2. "The Color of Coronavirus: COVID-19 Deaths by Race and Ethnicity in the U.S."
3. "COVID-19 Is Affecting Black, Indigenous, Latinx, and Other People of Color the Most."

The job losses during this pandemic also starkly reveal racial and gender inequities. From February 2020 to May 2020, 11.5 million women lost their jobs vs. 9.0 million men. Researchers are finding that women have been concentrated in highly impacted jobs where physical distancing is nearly impossible and working remotely is not an option, including health services, retail, K–12 education, and leisure/hospitality.[4] Evidence is mounting that mujeres are disproportionately losing their jobs during this pandemic, more than women or men of any other group in the U.S., particularly as "Hispanic" women are concentrated in these highly impacted jobs.[5] Mujeres in these jobs are less likely to be able to work remotely.

In addition, workers with a college education are most likely to be able to keep their jobs by working remotely: between February 2020 and May 2020, 6% of workers with a college degree lost their jobs but 21% of workers without a high school diploma lost their jobs.[6] Here too the COVID-19 pandemic is laying bare the impact of uneven educational opportunities and systemic discrimination.

Research is also showing that on average a person with an advanced degree earned 3.7 times as much as an average high school dropout. As of 2018, 30% of Latinas have earned a college degree—a huge advancement since 2000 but still far short of our potential. Even with educational attainment, wage gaps across race and gender remain painfully real: as of 2019 for every dollar earned by a non-Hispanic White man in the U.S., an Asian American woman makes ninety cents, a Non-Hispanic White woman makes seventy-nine cents, an African American woman makes

4. Gonzalez-Barrera and Lopez, "Before COVID-19, Many Latinos Worried About Their Place in America and Had Experienced Discrimination."

5. Gonzalez-Barrera and Lopez, "Before COVID-19, Many Latinos." The trends in employment among Hispanic workers are echoed in a Pew Research Center survey conducted April 29–May 5 in which Hispanic adults were more likely than American adults overall to say they have taken a pay cut or lost their job because of the coronavirus outbreak. Ruth Igielnik, "Majority of Americans Who Lost a Job or Wages due to COVID-19 Concerned States will Reopen too quickly," *Pew Research Center*, May 15, 2020. https://www.pewresearch.org/fact-tank/2020/05/15/majority-of-americans-who-lost-a-job-or-wages-due-to-covid-19-concerned-states-will-reopen-too-quickly/.

6. Kochhar, "Hispanic Women, Immigrants, Young Adults, Those with Less Education Hit Hardest by COVID-19 Job Losses." See also, "Fast Facts: Degrees Conferred by Race and Sex," *National Center for Education Statistics*. Accessed 2020. https://nces.ed.gov/fastfacts/display.asp?id=72.

sixty-two cents, a Native American woman makes fifty-eight cents, and a Latina makes fifty-four cents for the same job.[7]

So, what can we do about systemic racism, about the disparities in our healthcare and educational systems, in so many parts of our lives? Sitting in her kitchen, my 'Uelita asked me the same question: "Pues, que puedo hacer?" After that radical mastectomy (no supe que me iban a quitar todo) and continued radiation treatments from a doctor she did not know, she finally agreed to travel to a specialist we all had confidence in, but by then she had endured too much radiation; her heart and her lungs were too damaged. She decided against further surgery, knowing she would last no more than a few weeks. Mi 'Uelita died within weeks of returning home.

The cancer caused her death, but our medical system killed her. 'Uelita's unbearable pain drove her to a doctor who sent her home undiagnosed, with painkillers. By the time the pain became excruciating, her cancer was so dangerously advanced that her prognosis was poor.

Thirteen years after she died, 'Uelita's voice came back to me as I tried to process what the doctor was telling me about what was growing in my own body. Through the roaring in my ears, I heard my 'Uelita, "Pues, que puedo hacer?" In that moment, our bodies bridged the distance and connected through time. Like her, I fought. My own third-degree radiation burns took a year to stop bleeding, but they stopped. Because of her commitment to education, mi familia made many sacrifices so I could attain as much education as possible. Yo sí supe que me iban a quitar todo. Because of her fights, I survived.

Now I navigate this global pandemic that seems to be spread through breathing, navigate it with damaged lungs and heart, but presente. So, what can we do? We know what we need to do. The walls of moms, of veterans, of BLM protesters of all stripes and walks of life have made it impossible for us to pretend we don't know. We need to work toward removing the barriers of discrimination and racism, to improve access to quality health care and promote health equity—make insurance available and affordable, ensure transportation to medical facilities, create childcare programs and policies that support our ability to take time

7. "Quantifying America's Gender Wage Gap by Race/Ethnicity," National Partnership for Women & Families Fact Sheet, 2019.

off work to care for ourselves and each other. We need to reaffirm our commitments to bridging our differences, to recognizing the humanity in each other, and to resisting the polarization of our current toxic politics. COVID-19 is disproportionately affecting people of color because we have not made the systemic and personal the changes that must be made.

We must learn from our pasts and understand that our bodies are connected through time and across space. For me, my 'uelita and her 'uelita before her provide an unwavering strength, support through a collectivity of mujeres that heals as it bridges time. Yes, we are in the midst of a global pandemic that is laying bare long-standing racial and gendered inequalities, structural racism and sexism, and fundamentally broken institutions.

To move forward, we need to draw from the strengths of generations, to be guided con corazónes hinchados con amor and kindness as we expect more from each other and stand up against injustice.

BIBLIOGRAPHY

"COVID-19 Is Affecting Black, Indigenous, Latinx, and Other People of Color the Most," *The COVID Tracking Project*, accessed July 2020. https://covidtracking .com/race.

Gonzalez-Barrera, Ana, and Mark Hugo Lopez. "Before COVID-19, Many Latinos Worried About Their Place in America and had Experienced Discrimination," *Pew Research Center*, July 22, 2020. https://www.pewresearch.org/fact-tank/2020/07/ 22/before-covid-19-many-latinos-worried-about-their-place-in-america-and-had -experienced-discrimination/.

Kochhar, Rakesh. "Hispanic Women, Immigrants, Young Adults, Those with Less Education Hit Hardest by COVID-19 Job Losses," *Pew Research Center*, June 9, 2020. https://www.pewresearch.org/fact-tank/2020/06/09/hispanic-women -immigrants-young-adults-those-with-less-education-hit-hardest-by-covid-19 -job-losses/.

"The Color of Coronavirus: COVID-19 Deaths by Race and Ethnicity in the U.S.," *AMP Research Lab*, March 5, 2021. https://www.apmresearchlab.org/covid/deaths -by-race#counts.

Yedjou, Clement G., Paul B. Tchounwou, Marinelle Payton, Lucio Miele, Duber D. Fonseca, Leroy Lowe, and Richard A. Alo. "Assessing the Racial and Ethnic Disparities in Breast Cancer Mortality in the United States." *International Journal of Environmental Research and Public Health*, 14, no. 5 (May 5, 2017): 486. doi:10.3390/ijerph14050486.

47

HASTA ENCONTRARLOS / UNTIL WE FIND THEM

GIA DEL PINO

INSPIRED BY my work with the Colibrí Center for Human Rights and their mission—"promote healing and change by working with families of disappeared migrants to identify and honor those who have lost their lives on the U.S.-Mexico border"—I've learned about a specific and unique grief experienced by families who live with prolonged uncertainty over what happened to their missing loved ones. It is a concept created by Pauline Boss called "ambiguous loss." I wanted to highlight this aspect of working with immigrants and migrant families in "Hasta Encontrarlos / Until We Find Them."

Anzaldúa's bilingual and Spanish poetry served as inspiration for "Hasta Encontrarlos / Until We Find Them," a series of vignettes that profile four fictional missing migrants as described by their mothers and wives. Like real profiles that groups create in their dedicated search for missing and disappeared migrants, these vignettes include messages like those from migrants' families that are shared on social media in hopes that people can help find their family members. The biological information included are details that forensic anthropologists and police officials often request.

HASTA ENCONTRARLOS

(Dedicado a todas las familias que buscan a sus seres queridos que desaparecieron cruzando la frontera.)

Yo soy Francisco Miguel Rodriguez Bermudes
Desaparecido el 21 de marzo de 2020
En Sasabe, Arizona, Estados Unidos

Edad: 30 años
Estatura: 1.54 Mts.
Complexion: robusta
Tez: morena clara
Ojos: café claro
Cabello: corto con pelo negro

¿Alguien puede ayudarme a encontrar a mi hijo? El coyote lo abandonó y lo dejó atrás mientras intentaba cruzar el desierto de Sonora. Se fue con un rosario de madera alrededor del cuello y en su zapato tenía un papelito guardado con el número de teléfono de su esposa y su contacto en los Estados Unidos. Por favor, comparta este mensaje por todas partes. Que Dios les bendiga.

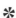

Yo soy Jairo Javier Rodriguez Ibarra
Desaparecido el 15 de abril de 2018
En Tijuana, Baja California, MX

Edad: 36 años
Estatura: 1.65 Mts.
Complexion: delgado
Tez: moreno claro
Ojos: café oscuro
Cabello: negro lacio

Señas particulares: una pequeña cicatriz sobre las cejas, un lunar marrón claro en la pierna derecha por encima de la rodilla, un tatuaje de tinta azul en el antebrazo derecho con el nombre de su hija, "Andrea"

Ayúdenme por favor a localizar a mi esposo, Jairo Javier, quien desapareció hace dos años. Iba de Rosarito a Tijuana y desde ese día no escuché ni supe nada de él. Hoy le pido a Dios que nos ayude a encontrarlo y a poner fin a nuestro sufrimiento. Le echamos de menos. Sus hijos extrañan desesperadamente a su padre. Por favor ore por nosotros y comparta este mensaje. Todavía tengo fe en que volverá con nosotros vivos. Amén.

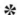

Yo soy Nelson Martin Torres Sanchez
Desaparecido el 15 de abril de 2018
En Nuevo Laredo, Tamaulipas, MX

Edad: 18 años
Estatura: 1.78 Mts.
Complexion: regular
Tez: cremita
Ojos: café
Cabello: negro

Señas particulares: tatuaje en el brazo de la "Santa Muerte" y tornillos en la tibia izquierda por una lesión de fútbol.

Mi querido hijo, Nelson, te espero todos los días con el corazón roto. Ayer olí tus camisetas sólo para sentirme cerca de ti. Hueles aún persiste incluso después de dos años. El tiempo ha pasado volando, pero me detiene en seco. La verdad es que mi vida terminó el día que desapareciste. La mujer que ves aquí está muerta. Te necesito mi hijo, mi vida, mi corazón. Dios, por favor, solo quiero saber qué le pasó a mi hijo. Por favor, Dios, dame una señal de si está vivo o muerto. Si está muerto, tráiganlo de vuelta a mí para que pueda darle un entierro adecuado o simplemente déme la felicidad de abrazarlo y volver a verlo. Necesito saber qué le sucedió para poder llevarlo a casa a descansar y descansar de este sufrimiento e impotencia diarios. Amén.

✳

Yo soy Luis Enrique Hernández Alvarado
Edad: 30 anos
Estatura: 1.70 Mts.
Complexion: mediana
Tez: moreno
Ojos: grandes, café claro
Cabello: negro lacio

Desapareció el 10 de febrero de 2005 en Nogales, Arizona, Estados Unidos, en camino para reunirse con su hija en Tucson, AZ, para celebrar su quinceañera. Sus restos fueron identificados el 26 de septiembre de 2018.
Mi querido hijo, lo que daría por abrazarte por última vez. Te extraño todos los días, tanto que me duele el corazón y mi alma está cansada. El único consuelo que tengo es saber que nos reuniremos nuevamente en el cielo. Pensé que saber me traería algo de paz. Pero no importa cuánto lo intente, mi vida nunca ha sido la misma desde el día en que desapareció. Y no importa cuánto tiempo haya pasado, una madre nunca olvida a su hijo. Tu recuerdo vive para siempre en mi corazón y alma. Que descanses en paz, Luis Enrique, mi hijo, mi vida.

UNTIL WE FIND THEM

(Dedicated to all the families searching for their loved ones who disappeared during their migration journey.)

I am Francisco Miguel Rodriguez Bermudez
Disappeared on March 21, 2020
In Sasabe, Arizona, United States

Age: 30 years
Height: 4'7"
Build: robust
Skin complexion: light brown
Eyes: light brown
Hair: short black hair

Can anyone please help me find my son? The coyote left him behind while he was attempting to cross the Sonoran desert. He left wearing a wooden rosary around his neck, and in his shoe he had a piece of paper with his wife's phone number and his contact in the U.S. Please share this message far and wide. May God bless you.

I am Jairo Javier Rodriguez Ibarra
Disappeared on April 15, 2018
In Tijuana, Baja California, Mexico

Age: 36 years
Height: 5'4"
Build: slim
Skin complexion: light brown
Eyes: dark brown
Hair: straight black

Special characteristics: a small scar above the eyebrows, light brown mole on his right leg above knee, blue ink tattoo on his right forearm with his daughter's name, "Andrea."

Please help me locate my husband, Jairo Javier, who went missing two years ago. He was going from Rosarito to Tijuana, and from that day I haven't heard or known anything about him. Today I ask God to please help us find him and to end our suffering. We miss him. His children desperately miss their father. Please pray for us and share this message. I still have faith he will come back to us alive. Amen.

I am Nelson Martin Torres Sanchez
Disappeared on April 15, 2018
In Nuevo Laredo, Tamaulipas, Mexico

Age: 18 years
Height: 5'8"

Build: regular
Skin complexion: cream
Eyes: brown
Hair: black

Special characteristics: tattoo on his arm of the "Santa Muerte" and screws in his left tibia from a soccer injury.

My dear son, Nelson, I wait for you everyday with a broken heart. Yesterday I smelled your T-shirts just to feel close to you. Your smell still lingers even after two years. Time has flown by, yet it stops me in my tracks. The truth is my life ended the day you disappeared. The woman you see here is dead inside. I need you my son, my life, my heart. God, please, I only want to know what happened to my son. Please God, give me a sign whether he is alive or actually dead. If he is dead, please bring him back to me so that I can give him a proper burial or just give me the happiness of hugging and seeing him again. I need to know what happened to him so I can bring him home to rest and so I can rest from this daily suffering and impotence. Amen.

✳

I am Luis Enrique Hernández Alvarado
Age: 30 years
Height: 5'5"
Built: medium
Skin complexion: brown
Eyes: large, light brown
Hair: straight black

He disappeared on February 10, 2005, in Nogales, Arizona, United States, on his way to reunite with his daughter in Tucson, AZ to celebrate her quinceañera. His remains were identified on September 26, 2018.

My beloved son, what I would give to hug you one last time. I miss you everyday so much so my heart aches and my soul is tired. The only consolation I have is knowing that we will reunite again in heaven. I thought knowing would bring me some peace. But no matter how hard I try, my life has never been the same since the day you went missing.

And no matter how much time has passed, a mother never forgets her child. Your memory forever lives within my heart and soul. May you rest in peace, Luis Enrique, my son, my life.

48

EL NUEVO MUNDO

JOHANNA CASTILLO

"**Y**OU DON'T look Dominican!!!" is what I get when I am outside the island. When I am inside, I get variations of the question "mami chula y de dónde tú ere?" in a very particular tone. How is a Dominican supposed to look? Or in my case how is a Dominican queer woman with an afro, who is also a transmuting flower, a whole mango and a data center supposed to look, dress, or think?

Since I can remember, I've had to confront imposed definitions of my identity in the circumstances and spaces I've found myself in. Being in a school that my family couldn't afford, made me think that I needed more money to be able to fit in; being part of my family's religion made me think that I was supposed to be saved por el "Dios que todo lo ve"; going every Saturday to straighten my curls made me think I had to straighten my hair to feel comfortable in my body; experiencing the submissive behavior of the women closest to me around macho men made me think that I was supposed to be only pretty and calladita, porque "calladita me veo más bonita"; seeing how women had to present themselves to survive a Dominican workplace made me think I have to wear a suit and tacones and straighten my hair to get a job; deciding to cut all my hair off made me think my womanhood was my hair and also that being called

a lesbian was an insult; being constantly harassed in the streets made me think I have to camouflage myself to hide in plain sight como si na e na; observing how my body reacts when I want to express disagreement made me think my voice was an accessory; feeling guilty when setting healthy boundaries with people made me think I have to be available 24/7 to others; experiencing the way art institutions use words as a decorative dressing made me think that my words don't necessarily have to match my actions; attending a design school that constantly touts their dedication to sustainability, while brazenly discarding their student's bodies of work made me think that the institutional image and lip service is more important than the work itself. Sadly, the list can go on.

Every place I go, the institution and subjects work hard to define what I am or should be. On one hand, it is a constant reminder of the toxic normalization (and unconsciousness) of the racist, misogynist, post-colonial, heteronormative, patriarchal, capitalistic patterns that continue

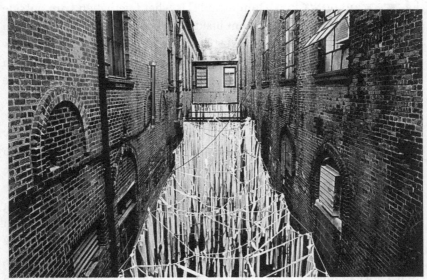

El Nuevo Mundo II (New York), 2019. Recycled textiles, 96 x 14 x 15 ft. (2.7 x 4.3 x 4.6 m). Site-specific interactive installation. Photography by Johanna Castillo. Brick Alley, Garner Arts Center, Garnerville, NY (Site-specific immersive sound, *Limbos Sensoriales*, 2:56, in collaboration with Marcos Moore, Mael Martínez, Fernando Moore, y Germán Castellanos).

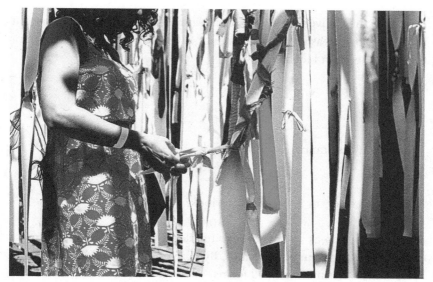

El Nuevo Mundo II (New York), 2019. Recycled textiles, 96 x 14 x 15 ft. (2.7 x 4.3 x 4.6 m). Site-specific interactive installation activated by participants. Photography by Federico Fernández. Brick Alley, Garner Arts Center, Garnerville, NY

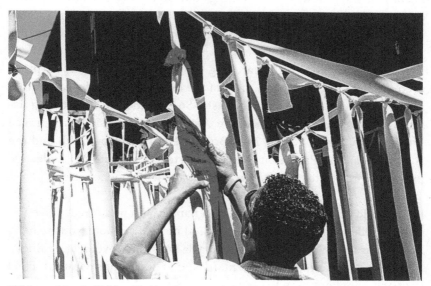

El Nuevo Mundo II (New York), 2019. Recycled textiles, 96 x 14 x 15 ft. (2.7 x 4.3 x 4.6 m). Site specific interactive installation activated by participants. Photography by Federico Fernández. Brick Alley, Garner Arts Center, Garnerville, NY

repeating themselves around and within me, and on the other hand it pushes me to ask, as an act of resistance What do I want? How do I want to live? Where am I local?

Local
Safe space
Healing
And non-resistance

How does a space of non-resistance look?

El Nuevo Mundo as a collaborative textile installation started as an act of non-resistance (un corito sano). By being here, now. Allowing space of no-mind. No time. No fixed forms. In fact it started as a thing with no name (_____) An exploration and a hidden longing to (re)connect with my-naked-healed-unknotted-self, others and nature. The first intuitive installation happened in the patio of Pocoapoco Residency in Oaxaca (2019). It was the first thing I did after living in a non-stop-machine-mode for over 3 years in New York while working around human connections, circular systems, hyperconsumption and textile waste.

In Oaxaca, I found myself searching for textile waste. To my surprise, even though I did find some, most of the local ateliers and weavers told me they did not produce much waste. So I decided to mix it with listones to honor their material culture. Alongside other residents (Garance Franke-Ruta, Sarah Bengle, Mila Broomberg, Lisa Nebenzahl) and the students from La Paz Montessori we started to activate our collective presence through textiles, knots, the sun and a big pochote tree.

[[[Un nudo azul, tu, yo y el árbol. Una hamaca, un nudo rojo, tu, yo y el cielo. A yellow knot, us jumping, you sit, I move, I am here, you are here. Sound. Las voces. Tu frecuencia, la mía, la nuestra. Movement. Stillness. Purple knots. Tres nudos, nos sentamos. Dos nudos, nos paramos. Final knot and I am knot here]]]

Continuación
Change

The past is the present. The present is the present. The future is
the present

Time is a funny zing.

[[[What are the possibilities of creation when I am knot haunted by an
othering-external-unconscious-limited-linear-extractive-western-ma-
cho man-binary-global-local-online-exotic-desirable-trauma gaze? (I
don't know, this word just keeps growing) What are the possibilities
of creation when I allow life to flow through me without any words
attached? What are the possibilities of being here when I allow my body,
my mind and my soul to become the space I am constantly looking for
outside?]]] [[[Flower gaze?]]]

The second iteration (El Nuevo Mundo II) was a lovely invitation by Gar-
ner Arts Center which once was a Textile Mill to create an interactive
textile installation. The recycled material given to me for this installation
was all white and it was my first time working with monochromatic tex-
tiles consciously. I remember I was like, How am I going to create a space
of connection with all this whiteness? Imagine you want to cook some-
thing delicious you learned from your abuelita and you only have salt.

El sazón es importante.

Y el tiempo también.

Cosas ricas hechas a fuego lento. Unas habichuelas bien hechas. Un
arrocito bien puesto. Pal de fritos crujienticos. [[[Y el chorrito de miel
que empieza a llover sobre ti con el primer bocado]]]

Cosas importantes.

I asked the curator if they had some colored scraps around. The journey
for different shades and tones of color, patterns and texture became a
serious request. Very serious.

[[[If I know what I like

I will ask for it
Inner-outer sun
Inner-outer moon
The subtle power
of my womb]]]

((("Welcome to the New World. You are about to explore nothingness, with nothingness, plus nothingness. You're about to [aguacate!!!] drop your mask at the door to explore and connect. You are about to walk over [te compramos todo...] a new territory, [... lo que sea viejo] to build a new territory...))) (Excerpt of the immersive sound of the piece).

What is chosen for me, what am I choosing?

[[[Colors were found. Colors were given. Colors were sent. Colors were shipped. Colors traveled. Colors took the bus. Colors are dancing. Colors are singing. Colors are showing up. Colors are here.]]

El sazón es importante.

Participants were encouraged to intervene // activate // decolonize // add sazón to the white canvas with colored textiles. While experiencing the piece, one participant (Suzanne) said "this feels like a human car wash" and then another one (Raymi) said: "a human car wash that cleans your soul." [[[was I becoming the piece?]]]

Ok.

When I submitted this love letter in 2019, I was still thinking I had to create a new world outside myself. I was solely focusing on the outside system. La forevel externa lucha. My everyday life felt like a fight. I realized I was making inclusive and safe spaces for others as an artist, but what was I doing for me as a human being? En el 2020 I had no other option than to look inside myself. It was the first time I started to see myself como el sistema contra el que luchaba. Even though at the moment I started El Nuevo Mundo III with the question Cómo se imaginan el nuevo mundo

// no normalidad? as an Instagram story (ENM III @laconectora), deep down I knew that I had a lot of inner healing to do.

How can I transform cycles of trauma into cycles of healing?

El Nuevo Mundo adapts to the mental, spiritual, and physical space I find myself in. As much as it is an ever evolving dimension to reclaim space, time and energy to heal, to love, to dream and play, it's also a space for collective exchange, healing and care.

A space of presence for nature to flow through me-us.

Yo soy flor y tú también.

ACKNOWLEDGMENTS

El Nuevo Mundo II (New York, 2019): Curated by Jonathan Shorr. Supported by Garner Arts Center and President Robin Rosenberg. Installation created with the collaboration of Marcos Moore, Raymi Guzmán, Kaara Mary, Mael Martínez, Germán Castellanos, Fernando Moore, Miguel Florimón, Federico Fernández, Michelle Almonte, Nicolette Maio and, Morgan Zelmer. Special thanks to Aida Marcelino, Lisa Nebenzahl, Ana María López, Gloria Ivanna, Kris Burns, Jamie Kimak, Yto Barrada, and Fabscraps for the recycled colored textiles.Text revised by Vanessa López and Paola Segura. Thank you to the participants that added a love knot to the piece.

49

¡NO MÁS BABOSADAS!

Realigning Central American Femme Subjectivity in Our Narratives

CHELA E. HERNANDEZ

To My Fellow Central American Writers,

When I began writing this letter, our diaspora was reeling from the effects of the beginning of the heightened sociopolitical climate from our motherlands to the United States. That particular sociopolitical climate consisted of the reminders of coups and stolen elections that rose to neofascist regimes that were swayed by the U.S. imperialist government. What I did not know when I first jotted this letter down in late 2019 was how the world as we knew it would change in ways we were not prepared for. As we continue to reel from the short-term and long-term effects of the coronavirus pandemic, it is more imperative to reclaim our narratives and heal as we amplify our voices and write in ways we have yet to imagine. Every time we turn on the news, we see the trauma our siblings have suffered crossing the borders to the United States. We have endless think pieces and roundtables with prominent Latinx writers and scholars who attempt to homogenize our diverse perspectives into a monolith. Latinidad attempts to identify our experiences as a universe of sameness through a supposed familiar tie to Latin America.

Furthermore, as we embark on the new decade, the mainstream media seems to imply that we have to be in agonizing pain to be heard. Whether the pain comes from the water and food shortages of El Salvador or the assassinations of prominent activists and defenders like Berta Cáceres, I am here to tell you that regardless of what the Trump administration says or what archaic academic institutions tell us, we are here, and we have enough power in our writing to exist. By reclaiming our narrative through our writing, we can create stories without necessarily looking for the approval of academic institutions that try to undermine our humanity. For so long, our work has been rearranged, appropriated, and exploited by white academic scholars who know little of our experiences yet yearn to reap the benefits of our traumas. We are much more than the scraps that white academics attempt to paint us as. We have to stop looking at the academic institution to praise our work.

Therefore, I encourage you to write stories that encompass a canvas of our words and experiences in ways that white academics cannot replicate— even if they attempt to screenshot the words on their computers. We must type stories that also reach our mothers, grandmothers, aunts, and community motherly figures who second-guess themselves before finding the space to express their strength in their narratives. We can use writing to transcend the trauma our culture has endured. It is a sad reality that most of the work in which the mainstream attempts to define us is nothing but mere trauma. While recognizing our trauma is necessary, we cannot heal if we rely on our trauma to survive. I write to you to create a work that transcends what the mainstream assumes we are.

It is like the saying goes, *to heal, you cannot recover in the same place.* It may seem difficult to get out, especially when living in this society tells us that we are not enough. I am here to remind you that as Central Americans we are more than enough. We have enough to write our stories. We have enough to explore narratives and visions we have yet to jot down in our notebooks. We certainly more than enough to retrace these stories, away from the reach of the American hegemonic society that imposes to break us daily. It may not seem like it now, but if we waited for the right time or confidence to jot down our thoughts, we would never see our stories shine beyond the retina laptop displays that luminate our rooms.

258 CHELA E. HERNANDEZ

We all have voices to create the narratives we know we can preserve; we only need to seize these opportunities, even when times are bleak. I am here to remind you that the opportunity is now. The white, capitalist, heteronormative, patriarchy continues to run rampant in our lives, but it has also brought us closer to reclaiming our roots. I think of the great Central American writers and thinkers who are already creating work. I think of *Central American Art and Beauty*, a group of social media pages, and their creator Zaira Miluska who reminds us of the beauty that already resides in our motherlands. We are already here; it is time for us to use our tools to create more reminders of our greatness. I have the uttermost faith that we can do this. Whatever you do, remember to do it from the heart. Create the stories with the pain that dwells in you. Create the narratives with the hope that follows you wherever you go. Create the pieces you are more capable to write than you can already imagine.

I will support you, and the community at large will embrace your work. It may seem bleak given how even Latinidad is largely Mexican hegemonic. Nevertheless, we are still here and can still recover. While I get that the intentions of Latinidad are to unify our experiences and struggles into a common thread, any attempts to homogenize our experiences only erase and ignore the anti-Black, anti-Indigenous, and anti-queer rhetoric that has continued from the fragments of the caste system Spanish colonizers imposed on our ancestors. That is, I do not wish to continue the notions of Latinidad because the concept of Latinidad perpetrates white supremacist, heteronormative patriarchy. Our experiences are far too broad and unique to try to dumb down to a binary of boxes that only academics in universities can relate to. Rather, we should inspire to create an intersectional Latinx feminine subjectivity that acknowledges multifaceted experiences and narratives to amplify in our archives. Instead of centering cisgender women writers, we must foreground femme, non-binary individuals and transgender women as storytellers.

Additionally, our writing must recognize and ensure that Central American writers from all nations in our region are represented, not just those with ties directly to El Salvador and Guatemala. We must also create stories that reject a womanhood that thrives off Eurocentric ideals of repressing our authentic selves in order to be a soft-spoken and

respectable womxn. Instead, write stories that thrive off our experiences and emotions in ways are neither "respectable" nor soft. Our stories should not be written solely in English and Spanish nor should our womxnhood be defined by narrow Eurocentric appearances that erase African, Asian, and Indigenous Central Americans. Write down the pieces that allow our African, Asian, Indigenous and queer Central Americans to appear in their all their unique experiences and perspectives.

Write words that scream the strength of your ancestors and your family cheering you on to continue. Make stories that relish in your unapologetic queerness. Essentially, write narratives that embody yourself to the fullest. I hope you find the fire inside you to dare to jot down all your desires that you can be proud of, both for your present and your future. I will be rooting for you.

¡Échale ganas!

BIBLIOGRAPHY

Anzaldúa, Gloria. *Borderlands/La Frontera: The New Mestiza*. 4th ed., Aunt Lute Books, 2012.

Frazier-Carroll, Micha, "Roxane Gay: 'If I was waiting for confidence to write, I'd still be waiting,'" *gal-dem*, January 15, 2019. https://gal-dem.com/roxane-gay/.

Martinez, David Tomas. "'The Cinnamon Tsunami is Here': A Latin@ Writer's Roundtable," *Gulf Coast: A Journal of Literature and Fine Arts*, 25 no. 2 (Summer/Fall 2013).

Miluska, Zaira. "Central American Art & Beauty." *Facebook*, www.facebook.com/CentAmBeauty/.

Moraga, Cherríe, and Gloria Anzaldúa. *This Bridge Called My Back: Writings by Radical Women of Color*. Latham: Kitchen Table/Women of Color, 1981.

Romano, Joseph. "You Cannot Heal in the Same Environment That Made You Sick," *Medium*, July 15, 2018. medium.com/@LiveTREW/you-cannot-heal-in-the-same-environment-that-made-you-sick-f6ea0f756c42.

Takahashi, Tess L. "The Imaginary Archive: Current Practice." *Camera Obscura*, 22nd ed., 66 ser. 3 (2007): 179–184.

50

SAY HER NAME

ASHLEY CROOKS-ALLEN

When I heard about #SayHerName,
I immediately wanted to write
I'm a spoken word artist
This is what I do.

I'm a researcher who studies Black Lives Matter
This is what I do.

I know when we say Black Lives Matter people hear "police bru-
tality against Black men"
and not "state-sanctioned violence against Black people"
I know Black women are doing the work
That they are founding the movement
That they are writing love letters that change the world
And that it's so common even among Black women to think that
 this movement
that they're doing the work for,
that was founded by them, isn't about them, just men.
This is what I do!

But somehow I did not know what to write
The men are "missing,"
And the women write them poems
But who writes the poems for the women?
I did not know how to write this poem
There was no template, no draft.

Did I write Black women a thank you note?
A love letter?
Did I write a call to action on their behalf?
Did I write about the grief that hit when I was stopped by the
 police
and my parents weren't even mad I was speeding
Just grateful I didn't end up a hashtag?

So I looked through all my Black Lives Matter poems
and found only bits and pieces here and there
Mere whispers of women
I did not know what to do
I did not know what to write
I did not know what to say
So I said her name

Sandra Bland
I probably should've said something when they said she commit-
 ted suicide in jail
Thinking they could toss Sandy out in the same trash bag they
 hung her from

When they were still killing our babies in their sleep and walking
away scot-free in 2015
Aiyana Stanley Jones

When they turned our mental illness into a death sentence
Tanisha Anderson

When they came into our homes to serve traffic stop warrants but
left with our sister's life
Korryn Gaines

When they decided that we were living too loud for them so they
stopped you from breathing
Rekia Boyd

When we called them for help but they arrived ready to play a
lethal game of Rock Paper Scissors Shoot!
Charleena Lyle and unborn baby Lyle

What is a name really but a way to call someone into a space
Alive or dead, they are with us
If you've ever been to positive Black girl Instagram
there's a high chance that you've had someone encourage you to
 "speak it into existence"
So let's speak them into existence
in this world where there is so little room for us
We must take up as much space as we can

Hold Black women a seat at the table
Not with your coat or purse
Put their name in it to say they are here
To say they matter

See I'm sure we've said Black Lives Matter a million times
But do you know who first wrote that love letter to black people?
Did you write her a love letter back?
Did you address it to
Alicia Garza?

When our organizers were having their homes surrounded by
police
Calling her a terrorist
Did you remember to you call her
Patrisse Cullors?

When my sister was working to ensure that all our people of the
African diaspora knew their lives mattered too, did you remem-
ber to say her name?
Opal Tometi

Please
Don't just wait until their lives have been stolen
Hold them even now before their names
are all we have left to hold

PART 10

Remembering This Bridge

Love Letters

51

BRIDGE WORK AHEAD

Women of Color Liberatory Pedagogies, Then and Now

MEL MICHELLE LEWIS

Dear Beloved *This Bridge*,

I write this love letter to illuminate, celebrate, and offer gratitude for your liberatory pedagogies. With a deep reverence and affection for you, *This Bridge Called My Back*, I also share my own transformative experiences and the opportunities I have had to teach the text in Gender and Sexuality Studies and Ethnic Studies college courses over the last ten years. I begin by placing you on my altar, lighting the candles, frankincense, and sage, pouring water, arranging stones, feathers, icons, insects, and images. Your pages are ritual, a ceremony of saying.

I write this love letter on the first day of 2020, looking back and envisioning feminist futures. For myself and for today's students, who sometimes struggle to claim their feminism, I've found that using your passionate pages as the central course text ignites intellectual inquiry, political fury, and personal revelation in students who "catch fire," as Cherríe Moraga names it, as we examine the articulations of political vision and theory in the flesh found within.[1] You, *This Bridge*, are a model for intellectual, political, and personal revolution. My own revolution was rooted in the Combahee River Collective's "Black Feminist Statement." They write, "As Black feminists and lesbians, we know that we have a very definitive

1. Moraga, "Catching Fire," xv.

revolutionary task to perform and we are ready for the lifetime of work and struggle before us."[2] This is my daily call to action, personally and pedagogically.

The feminist classroom constitutes a point of encounter for many college students at a formative stage in their personal and intellectual development. The deeply personal and radically political intersectional, multi-modal, and transdisciplinary formula you offer as a text makes you a mentor, a healer, a friend, a lover, a comrade, and a teacher. As a Women's Studies major in the late 1990s, negotiating my Black, queer, and feminist awakenings, I found you to be all of these things.

Through Gloria Anzaldúa's essay, "La Prieta," I began to dwell in my disorderly body, reassessed my relationship with my conservative and Catholic, Creole mother, embraced my queer longings, and interrogated familial colorism and the colorblind aspirations that shaped my coastal Alabama youth in the affirmative action years. Anzaldúa writes, "But it's taken over thirty years to unlearn the belief instilled in me that white is better than brown—something that some people of color *never* will unlearn. And it is only now that the hatred of myself, which I spent the greater part of my adolescence cultivating, is turning to love."[3] Black and queer, I needed Anzaldúa to love and teach me in order that I might learn to love myself. She did.

CHANGE

By transforming the negative perceptions we have of ourselves, we change systems of oppression in interpersonal contexts—within the family, the community—which in turn alters larger institutional systems.
—*Gloria Anzaldúa, "Counsels from the Firing . . . Past, Present, Future"*

2. Combahee River Collective, "Black Feminist Statement," in *This Bridge Called My Back: Writings by Radical Women of Color*, 4th ed., ed. Cherríe Moraga and Gloria Anzaldúa, 218 (Albany, NY: SUNY Press, 2015).

3. Anzaldúa, "La prieta," 202.

As *This Bridge Called My Back* is not written in stone, neither is our political vision. It is subject to change.

—*Cherríe Moraga, "Refugees of a World on Fire"*

Perhaps one of the most significant offerings within you, *This Bridge*, is the way in which change is engaged. Readers can trace these changes across the editions of the text and, by extension, across feminist space-time, from 1981 to 2015, and now in 2020. As we continue to read the works within with new eyes, you offer students the opportunity to delve deeply into the personal and political lives of Third World women, then and now. The farther away we get from the 1981 first edition (and the older I get in my own bones), I recognize students are both gently reassured and disturbingly alarmed by me and the *This Bridge* aunties (and ancestors) as feminists of color. Students interrogate us: "Who are Third World women and women of color? What are the lesbian languages spoken here?" Immersed in a 2020 QTPOC intersectional politic and lexicon, students feel both represented in the text, and recognize the changes in terminology and framing. Yet they often lament that the experiences, critiques of power, and calls for change have remained the same.

In her essay "I Don't Understand Those Who Have Turned Away from Me," Chrystos writes, "It occurred to me that no amount of education was going to improve my lot in life if I did not also change my attitude about society."[4] Although she left school following this revelation, I invite students in the classroom to consider what it is that they must change. What do you, *This Bridge*, require of them? Nellie Wong's "In Search of the Self As Hero: Confetti of Voices on New Year's Night," asks students to examine, "Who am I?," developing a reflexivity that inevitably inspires, and often requires, change.[5]

4. Chrystos, "I Don't Understand Those Who Have Turned Away from Me," 68.
5. Wong, "In Search of the Self As Hero," 177.

THEORY IN THE FLESH

A theory of the flesh means one where the physical realities of our lives—our skin color, the land or concrete we grew up on, our sexual longings—all fuse to create a politic born out of necessity.
—*Gloria Anzaldúa and Cherríe Moraga, "Entering the Lives of Others: Theory in the Flesh"*

The danger lies in ranking the oppressions. *The danger lies in failing to acknowledge the specificity of the oppression.* The danger lies in attempting to deal with oppression purely from a theoretical base.
 —*Cherríe Moraga, "La Güera"*

When reading you, *This Bridge*, students have commented that they had little to no knowledge of feminisms that emerged from theory in the flesh, as well as feminisms that were produced by Black feminists, Third World women, Indigenous feminists, and gay, lesbian, and queer folx of color feminists. For all of their engagements with and critiques of "white feminism" and even "intersectionality" itself, a material and spiritual centering of physical, racial, sexual, and political theory as lived through bodies, identities, and communities often remains unexamined. It is a disarming revelation to some that QTPOC folx have feminist grandparents! Grandfolx articulating grand visions. No one ever told them, until you did.

Teaching you, *This Bridge*, Gloria Anzaldúa, Cherríe Moraga, Chrystos, Nellie Wong, Norma Alarcón, Audre Lorde, Pat Parker, and others all express their feminisms, in their own words. This is deeply transformative for students who identify as QTPOC folx, grappling with feminist theory and praxis themselves. Many of these students could write a well-cited fierce undergraduate thesis on the deficiencies and violence of "white feminism" but have not imagined using personal narrative and poetry to articulate and embody their own theory in the flesh. This is what I call "the bridge work ahead" for the political writer/artist/maker, and it is perhaps the thing I love most deeply about you as a text.

WRITERS

> The political writer, then, is the ultimate optimist, believing people are capable of change and using words as one way to try and penetrate the privatism of our lives . . . however, I am feeling more discouraged than optimistic.
>
> —*Cherríe Moraga, "Refugees of a World on Fire"*

> Most of the women appearing in this book are first-generation writers. Some of us do not see ourselves as writers but pull the pen across the page anyway or speak with the power of poets.
>
> —*Gloria Anzaldúa and Cherríe Moraga, Introduction*

What would it mean for every student to have the opportunity to learn to write by learning that they are already writers. This is one of your lessons, *This Bridge*. Many students are paralyzed by fear. The ruler to the knuckles of this generation is the extraction of their own voice and stories from their leaning. The earnest question, "Can we / how do we use 'I' in our essay?" unravels me each time students inquire. Write a formulaic thesis or a pristine paragraph in another class, y'all. In my class, your examples of fierce yet vulnerable poetics and prose are centered as a tender methodology and labor of love.

Read *This Bridge*
Write what you need to say
Learn how you need to say it
Let it leap from your soul and from the souls of your ancestors
Say what you have never had a chance to say
Find what needs to be said more than anything that you have never said
Complete the assignment
This is the bridge work ahead

Mel Michelle Lewis
January 2020

BIBLIOGRAPHY

Anzaldúa, Gloria, and Cherríe Moraga, "Introduction 1981." In *This Bridge Called My Back: Writings by Radical Women of Color*, 2nd ed., edited by Cherríe Moraga and Gloria Anzaldúa, xxii-xxvi. Brooklyn, NY: Kitchen Table Press, 1983.

Anzaldúa, Gloria. "La prieta." In *This Bridge Called My Back: Writings by Radical Women of Color*, edited by Cherríe Moraga and Gloria Anzaldúa, 198–209. Watertown, MA: Persephone Press, 1981.

Anzaldúa, Gloria. "Counsels from the Firing . . . Past, Present, Future: Foreword to the Third Edition," In *This Bridge Called My Back: Writings by Radical Women of Color*, 4th, ed., edited by Cherríe Moraga and Gloria Anzaldúa, 261–266. Albany, NY: SUNY Press, 2015.

Chrystos. "I Don't Understand Those Who Have Turned Away from Me." In *This Bridge Called My Back: Writings by Radical Women of Color*, 2nd ed., edited by Cherríe Moraga and Gloria Anzaldúa, 68–70. Brooklyn, NY: Kitchen Table Press, 1983.

Moraga, Cherríe. "Catching Fire," In *This Bridge Called My Back: Writings by Radical Women of Color*, 4th ed., edited by Cherríe Moraga and Gloria Anzaldúa, xv-xxvi. Albany, NY: SUNY Press, 2015.

Moraga, Cherríe. "Foreword: Refugees of a World on Fire." In *This Bridge Called My Back: Writings by Radical Women of Color*, 4th ed., edited by Cherríe Moraga and Gloria Anzaldúa, 255–260. Albany, NY: SUNY Press, 2015.

Moraga, Cherríe, and Gloria Anzaldúa. "Entering the Lives of Others: Theory in the Flesh." In *This Bridge Called My Back: Writings by Radical Women of Color*, 2nd ed., edited by Cherríe Moraga and Gloria Anzaldúa, 24. Brooklyn, NY: Kitchen Table Press, 1983.

Wong, Nellie. "In Search of the Self As Hero: Confetti of Voices." In *This Bridge Called My Back: Writings by Radical Women of Color*, 2nd ed., edited by Cherríe Moraga and Gloria Anzaldúa, 177–181. Brooklyn, NY: Kitchen Table Press, 1983.

52

MY BLACK IS BEAUTIFUL

GERTRUDE SWAN

I SEE YOU SHININ'

On days like these
When swaddles of cotton cover the day sky
And light shines a matted white rather than neon yellow
I am reminded that even the sun has to fight to be seen on some days
Some people prefer warmth from blankets, temperatures are more
Comfortable when they can be controlled
White lights don't burn like yellow rays do
Plants don't grow from white lights
What needs life doesn't need shade
Even when celestial hands stretch cotton swabs to resemble white silk
this summer afternoon
The silk appears to me a sterile lab coat, rather than a bride's gown
So pretty, very expensive
Used, then tucked away after the occasion
It's made accessible in artificial blends
But money can't buy me love
The best things in life are free, free like the sun's woven strains of yellow
wool

She fights to be seen on some days, despite accessibility
Days like this, with streams of white silk, fitted sheets over the afternoon sky
The sun shines through anyhow
I see her fibers caress a leaf to the left of me, and it burst of life
I see her grace the feather of a bird across the yard with a refined, yet durable textile
I feel her touch me, though my back is turned
I see that all things are noticed when looked for, even on days like these
I notice her, because we are one in the same
Burning some, giving life to others
She fights the world, but not me
The clouds and its precipitation from Earth's nature try to hide her
Umbrella to skyscraper man-made shields
She, always the victor
Funny, it seems when you realize the world worships her beauty in orbit
But battles with itself on the inside, plots to simulate power
Rejects warmth for comfort, runs to darkness then wonders why it barely survives
I see you shining anyhow
Laughing at their ignorance, shaking your head at their loss of identity
I feel your power
Always the victor
She may have to fight the world, but not me

DECEPTION

They treat us as if we are beasts of the night
They do not tell us we are the universe they have denied the sun
We are convinced to marvel at the Milky Way, its sparkling White stars
Its planets and moons of radiant colors
We are taught we are not bright enough, we do not shine
Only that which gleams can succeed, only that which dazzles can possess power
But in all the universe, the universe itself

Is Black
A deep, ebullient abyss holds the galaxies and all traces of existence
Our great-great-great-grandfathers built mansions in which they could not sleep
Our great-great-grandmothers cooked food for those who rationed scraps to malnourished children
The bountiful bosoms of our matriarchs flooded with milk denied to their own offspring
If Massa's newborn cried hungry
Our great-great-grandfathers lay tracks for locomotive cabins in which they could not ride
Our great-grandmothers cleaned toilets for those who forbade her to contaminate it
Potty-trained toddlers with soft, dove-like skin who loved them, their privilege uncorrupted and dormant
While the ravens from their wombs soiled diapers and sucked on wooden spoons
Some decades later, science has proven civilization began in Africa
Ancient holy texts from Jews, and expanded by Christians, report
Jesus's hair grew toward the heavens and felt like the wool of sheep, like mine
It only flows down like water, when it is forced with pressurized heat or manipulated by toxins
Due to folk tales of praised White beauty, then idolized among people my shade, sometimes a bit lighter
And always darker
The darker the skin, the more foreign the hair implanted from Brazil, India, or China
The devout, peaceful Christians say, "It don't matter what color Jesus skin was, or the texture of his hair
The blood He shed on the cross was red, the same color that flows through us all"
But I wonder, if I could travel through time and behold the blessed countenance of My Savior
Marvel all eternity in his brown eyes, the same ones Western civilization would stain blue
If I touched his hair, of curled spindle, bounded lock, or boxed cornrow

His skin the cocoa-brown color of my brilliant father
Or the caramel toffee, butter pecan of my genius brother
Or the almond joy of my everlasting love
And His image kept its origin
Would my cocoa-brown father be three years without a stable occupation?
Would my caramel toffee, butter pecan brother have to attend a gifted school to receive an education worthy of his intelligence?
Would my almond joy love and I fear our fruit would be stopped by police and arrive at The Valley
of Death, instead of back home to us as intended?
Or, would our son be shot down in infamy? Or destined to life in a penitentiary?
Could the doubting Thomases of the world see the Jesus in my race
If he, and those like him, would see Him in us with their eyes
Rather than imagine it in their hearts, should they choose to do so
If my father, brother, and lover looked like The King, Himself
Instead of one of the Wise Men bearing frankincense, and myrrh of the Nativity scene
Could the men, women, and children of my race be contained then?
Would our honor be too great to shame? To tamper with?
Would gangsta leans be sacrilegious to behold?
Would "Hands-up, Don't shoot" be a gesture of worship, instead of a prayer and shield?
What if Mary looked like me, instead of Eve?
Would the virtue of my sistah be maintained?
Would the media freely portray her naked, and deceitful?
Could she await Joseph's betrothal?
Rather than snared by the serpent's stain?
Could Tamar's injustice be committed? Would she remain abducted in silence, without reproach?
Mary watched her son die, and was comforted
I watched the mothers of Trayvon Martin, Eric Brown, and Laquan McDonald weep without consolation
Or justice, or peace
Would a Black woman's tears be holy water
And not the gall which lay in the pail of that Woman at the Well?
The Blacks, We remain thirsty

It is not because we do not drink
It is because we are drained
The reservoirs depleted, it is too laborious to replenish so quickly
That which is constantly manipulated, incessantly misconstrued
No wonder some of us have become those beasts
Angry, independent from the tribe
Cannibalistic and competing
Struggling to survive, licking our wounds
Numb to fleeting joy, and glorifying pain
We have forgotten
Black is not only the color of the night, of the beasts, of the darkness, of
fear
It is not only the color of the end
Black is the beginning—uterus of the dawn, womb of the horizon
The abyss bringeth light
The universe itself is Black—the color of creation
It holds the galaxies and all traces of existence
It shall not be moved, it shall not be broken
Not even with lies, deficiency, degradation, or misuse

PARADISE

When my feet touch pavement and brick
One foot after the other on black slaps of concrete or red-stained sand
and clay
I wonder why they ain't made of gold
When I see slanted eyes and wide noses
Silk streams of straight hair
And wavy strains of a black sea
I hear rolled Rs of the Americas
Lisps idolized by Castilian royalty
Mother tongues I do not know,
The universal language of laughter all around me
Lovely ladies draped in head coverings, shades of ebony to ivory
Two girls walk block to block, showering compliments

In hope of striking up conversation about Mormon bible study
Fresh Nikes sit outside an interfaith meditation room, lights bright inside
after dark all summer
Physical imperfections worn perfectly
Troubled minds from dark pasts paint masterpieces on street walls
Rustic hands lay mosaic tiled floors
I think this is what the Kingdom of God will look like in Christ's coming
This is the world as The Holy One intended
This land mirrors the home of my soul

53

A DECLARATION OF GRATITUDE FOR THE TONGUES WE SPEAK

FABIANE RAMOS

THERE'S ALWAYS a sense of wonder when I walk into libraries. Treasures waiting to be found—words, ideas, imagination printed on books—a magical place. There's the smell of old, dust gathering on shelves. Yet the layer of dust covers the possibility of new. Words are printed, they happened in the past, but the new awaits with every opening of a book and new reading of wor(l)ds. Each reading, each body that engages with pages creates something new. A new understanding, interpretation, reconfiguration.

Storm clouds were forming rapidly. The sky was purple and pink. Trees were moving frantically, pushed by the strong gust of winds. The rain came pouring down with all its might. Heavy clouds—powerful wind—torrential rain. The weather was my mirror that day.

I ran into the library to escape the storm. Immediately forgetting the downpour, I was immersed into the usual sense of wonder that books and ideas provoke. Excitement tingled my body.

These were difficult days. I felt disconnected from writing and the types of knowledge I believed were the norm in the academic context. Trying

to frame research and writing into the theories I had been reading felt contrived and rigid. It was the first year of my doctoral studies in Education. I felt obedient and domesticated as I saw myself reproducing the social and intellectual roles I thought I had to perform . . .

The lovely daughter
agreeable female
carrying the smile
and perfectly placed mascara
reading the "right" books
the good student
sitting up straight
with my legs elegantly crossed . . . [1]

Heavy clouds, wind, and torrential rain were my every day.

Rationality dismembered from heart.

Prescriptive universality of aesthetics and logic.

My introduction to academia was breaking me into tiny bits—dividing complexity into totalizing and qualifiable units. It was fossilising my thought and sense of self into disconnected fragments.

Despite numbness and blurred vision, I could feel creativity and poetics simmering under the surface of my skin. They wanted to be released, shared with the world. I wanted to be connected. I felt split.

I walked slowly through the library, browsing shelves, searching for treasure. And there it was, the red book with yellow writing on the cover. It was worn out, full of dust. I shook the dust off, took a deep breath. I opened it and met her *Speaking in Tongues:* [2]

She *spoke in tongues* about writing

1. Ramos, *Opening-up Entangled Conversations*, 41
2. Anzaldúa, "Speaking in tongues," 165–174.

About theory
In tongues to me
Tongues with so much meaning
Tongues that gifted me with language and courage
She warned:
Writing can be a monster
it can tie you down
restrict, control
stump on you
eat you up
spit you out
But remember:
Writing is alchemy
Architect of creativity
Writing is a healer
Sense maker
Record keeper of our existence
Designer of our own stories
Creator of selfhood
Soul maker
Writing is an act of intimacy
Into the depths of knowings
Connector of one to all that is

Theory is embodied
Writing is the materiality of theory on paper.[3]

In that very moment, with the red book sitting on my lap, eyes glued onto the pages, I knew that life would never be the same again.

I met her in the library, on a stormy day.

Her words encouraged me to open my pores and let it all out, to open up to the beauty of writing. She showed me that it could be done. She taught

3. Gloria Anzaldúa and Cherríe Moraga, *This Bridge Called My Back: Writings by Radical Women of Color* (Watertown, MA: Persephone Press, 1981).

me it was possible to embody academic writing that is creative, poetic, and full of layered knowledges.

Writing can be a bridge between material and ephemeral—between the multiple ways of knowing and being that exist within each of us.

She encouraged me to come to writing, through the body, through the spirit. She gently showed me the poetic as a political act—an act of defiance to norms and expectations in the hegemonic academic machine.

I came into a new existence that day.

I closed my eyes in order to see and in the process, started to create and expand selfhood. I already knew this in my bones, but I had no words, vocabulary, language to articulate what my bones already knew from time immemorial. She gifted me with language, with tongues through which I could speak and create. All parts were welcomed—no longer fragmented and severed into pieces.

A love story was born that day. From that instant of love at first sight, letters of love came to life, words of love, love that makes words, words in love, loving words.

I left the library carrying a warm smile and *This Bridge* close to my chest. I held it tight as I walked back to the office. The rain had stopped, clouds were clearing, the sun started to shine through.

———

Dear Gloria,

You talked during an interview about being born to perform a service and reaching people with ideas, to reach a great number of people.[4] Querida Gloria, you have done this and continue to do so. You reached me in the

4. Anzaldúa, *Interviews/Entrevistas*, 35.

deepest ways. And now through the words I write on paper, whisper in people's ears, shout to the wind—your work continues.

With gratitude in my heart, I can now *speak in tongues*, create bridges, and perform translations. Never ignoring structural oppressions and injustices, I choose to connect with the various wor(l)ds of my existence. In some of these wor(l)ds, I'm at the center, in some I'm at the margins. Sometimes the bridge is semi-built, sometimes it's completely destroyed, sometimes there are mighty walls where bridges should exist. Yet I choose to proceed. I walk with caution. I understand the dangers, but I choose voice over silence.

I arrange the voice I choose to speak, the words I select to share. This selection and assembly of meaning via words is an expression of personal power and creative fire. Even when the configuration of structural power might not seem to move—I still choose to speak my truth. Even when my words might be nothing more than incomprehensible noise to some ears—I choose to speak because I choose to exist. I choose not simply to exist but to create a record of this existence despite the walls erected along the way.

Stormy doctoral days are over. I wrote a thesis *speaking in tongues*. Through pain, tears, embodied agony of uncertainty, you walked with me. Other generous souls also held my hand along the way. You and they whispered love into my ears. Love that became energy moving my fingers on the keyboard until the final word was on paper.

Stormy days in academia are however never far off, and sometimes clouds form so very quickly that running for cover is a challenge. But now I have a strong umbrella made of intellect-love-creativity, fire-body-spirit coalitions. She keeps me safe. With umbrella in hand, I dig deep to connect with the muse within. With umbrella in hand, I keep walking, reconfiguring and speaking her-my-our-your voice . . .

Love,
Fabi

BIBLIOGRAPHY

Anzaldúa, Gloria. "Speaking in Tongues: A Letter to Third World Women Writers." In *This Bridge Called My Back: Writings by Radical Women of Color*. Edited by Gloria Anzaldúa and Cherríe Moraga, 165–174. Watertown, MA: Persephone Press, 1981.

Anzaldúa, Gloria. *Interviews/Entrevistas*. Edited by A. Keating. Oxfordshire: Routledge, 2000.

Ramos, Fabiane. *Opening-up Entangled Conversations: Engaging with the Stories of Refugee-Background Students in Australia*. The University of Queensland, School of Education, 2018.

54

COMING INTO MY FEMINISTA WAYS WITH *THIS BRIDGE CALLED MY BACK*

JUDITH FLORES CARMONA

Dear Gloria and Cherríe:

I write you to thank you for the wisdom you imparted to this first-generation student and scholar. When I was asked to write this letter, I was flooded with memories about you and your work. I met you, Gloria and Cherríe at the celebration of the twentieth anniversary of *This Bridge Called My Back*. The year was 2002, and one of my now best friends, Ellen, and I headed for the UC Berkeley campus from California State University, Monterey Bay. Ellen and I talked about this life-changing experience over the phone. This is her recollection and mine.

ELLEN: It was almost twenty years ago—the twentieth anniversary of *This Bridge Called My Back: Writings by Radical Women of Color*, and we were driving from Monterey to Berkeley to attend the celebration of the publishing of the new edition. Our beloved professor Rina Benmayor was joining some of her co-authors to read from the newly published *Telling to Live: Latina Feminist Testimonios* anthology. We'd just graduated together with our BAs, and we were excited to be meeting and hearing from radical women of color scholars who helped raise our consciousness and inspired us.

You, a Mexicana, and Bethtina, an African American woman, both in your twenties, and me, a middle-aged Latina of Puerto Rican descent.

JUDITH: I recall reading *Borderlands/La Frontera* as a college sophomore. I was struck by the resemblance of what I read in those pages and my own life. People wrote about Mexicanos—and, not in negative ways. It was powerful to read critiques of the machismo and also of the power of our words. Then I read *This Bridge*, and I felt empowered to author my own herstory. Tell to live. Writing is healing.

ELLEN: I'm in my sixties now. I don't remember what was said at the celebration, but I remember being mesmerized, feeling like my heart would fly out of my chest. I remember you and I holding hands and crying as someone—I think it was Aurora Levins Morales—read a piece from the new anthology. We thought we'd meet everyone at the restaurant after the event, but we couldn't stop talking about what we heard, what we witnessed, what we felt. Then Bethtina suggested we go back to the hotel instead because our conversation was important. We needed to talk with each other. I think we each felt raw. I know I did. And we wanted to share that vulnerability with each other. We wanted to really listen to each other and share our truths. That moment was too precious to lose.

JUDITH: We experienced precisely what this love letter asks that we write/ share about—our sisterhood, our coalition building, our exploration of our intersecting identities and how we came into our feminista ways.

ELLEN: I remember you (Judith) sitting on a bed in the hotel room. Bethtina insisted on sitting on the floor. I was on the other bed. We talked for many hours. How long was it? I think it was most of the night. It is still visceral. I treasured our friendship. I didn't want to lose that. We talked about feminism. What kind of feminists were we? It was more than a label.

JUDITH: It was such a deep, profound, impactful, and yet painful conversation. Feminist—what did it mean then—what does it mean now? Feminista—it's more meaningful for me in Spanish.

ELLEN: Why was I crying? Why was that label, that identity, so important to me? How could I listen well to you, Judith, and not lose myself? As a light-skinned Latina, struggling to regain my heri-

tage language, as an assimilated Latina, what was I not seeing or understanding? I remember Bethtina was more quiet. What was she thinking? Why didn't we ask her? She watched us, you and me, as we struggled to listen and speak our truths. Maybe she felt we needed this; needed to work this out between us.

JUDITH: Now we are both professors. One at a Hispanic-Serving Institution and another at a Predominantly White Institution (PWI).

ELLEN: You are doing powerful social justice work in your research and teaching, and you're moving swiftly up the academic ladder. I teach service learning at a PWI, and as I get closer to retirement, I'm still struggling to come to terms with the internalized whiteness injected into me during the formative years of my life. Now we talk and get together when we can. Did we ever resolve our differences in regard to feminism? I don't know. But I know that we will never forget that weekend. The twentieth anniversary of *This Bridge*— when we confronted our differences in painful and powerful ways. And I know we still love each other.

———

As we hung up the phone, I realized that this letter is a love letter about a close friendship that was possible because of the *Bridge* that you, Gloria and Cherríe, built for us women of color. You made it possible for us to blur the boundaries that kept us apart. The twentieth anniversary reunion served as a healing space that moved us toward a sisterhood grounded in solidarity—toward transformation.

BIBLIOGRAPHY

Anzaldúa, Gloria. E. *Borderlands/La frontera: The New Mestiza*. San Francisco, CA: Aunt Lute Books, 1987.

Latina Feminist Group. *Telling to Live: Latina Feminist Testimonios*. Durham, NC: Duke University Press, 2001.

Moraga, Cherríe, and Gloria Anzaldúa, eds. *This Bridge Called My Back: Writings by Radical Women of Color*. Brooklyn, NY: Kitchen Table: Women of Color Press, 1981.

55

WA GAGO

An International Student's Love Letter to
This Bridge Called My Back

KHOLOFELO THELEDI

TODAY I walked to the university I attend to ask my department if they have any grants or scholarships I can apply for. In addition to other advice, it was suggested that I donate plasma in order to pay the exorbitant fees the university charges students. As I reflected on this advice, I thought about how odd it is that we—international students and domestic minoritized students—leave our relations and our favorite tuck shops and places of worship, forsaking the land where our ancestors dwell in pursuit of what we are told is education and a better life. But, instead, we enter these halls that suffocate us and attempt to bury us over and over again. These spaces and the people who inhabit them remind us—indirectly of course—that we are a problem. Their libraries, curricula, architecture, message boards, language codes, research questions, cafeteria food, memorials, symbols, stipends, autocorrect, and even their landscaping, choke us until we feel like we can no longer breathe. "Even their gazes colonize" as Toni Morrison once said. And when the smothering feels unbearable, we skip classes and meals until we can catch our breath, just so that we can return to push through another day, another semester, another year. "Stress is, indeed, too benign a term," wouldn't

you agree, hermanas?[1] What is the cost of continuously subjecting our-selves and our siblings to the education systems in the so-called Western world?

I write as an African/Black woman from the Global South currently attending a predominantly white institution (PWI) in what is now called the United States of America. The university, like many U.S. institutions, is located on unceded Indigenous peoples' land. Several times a week, I attend graduate seminars where we ask important questions about decol-onization and the meaning of subjectivity. During these seminars I some-times check out and contemplate the implications of my presence as an international student for Indigenous peoples' and U.S. Black peoples' trek toward tokollo (liberation). While I grapple with my intrusive presence, I sit in classes where I also experience colonial violence and its effects on my body. On those days, I go to my apartment, retrieve my copy of *This Bridge Called My Back,* and read it while lying down on my brown couch enveloped by a string of Christmas lights I hung up to alleviate my homesickness. I allow the words of Third World poets, theorists, writ-ers, and artists to seep into my bones and penetrate my spirit to quiet the anger I felt earlier in seminar when a White student said the reason a Black scholar's work was published in an esteemed academic journal is because it "filled the diversity box." Or when another student stated their application to a graduate program was denied in favor of Black students' but that they felt okay about it because they view it "as a form of reparations." I let out a deep "mhm" as I highlight Mitsuye Yamada's words: "Part of being visible is refusing to separate the actors from their actions, and demanding that they be responsible for them."[2] As I read, I vow not to allow myself to be one of the "modern medusas" Gloria Anz-aldúa describes, women of color whose "throats [are] cut, silenced into a mere hissing."[3] I underline these words, "We do not experience racism, whether directed at ourselves or others, theoretically," when I remem-ber the heart palpitations and choking I felt in my throat when I spoke up against these students' ignorant comments.[4] Every microaggression,

1. Moraga, "Catching Fire," xxiii.
2. Yamada, "Invisibility Is an Unnatural Disaster," 35
3. Anzaldúa, "La Prieta," 206.
4. Yamada, "And When You Leave, Take Your Pictures with You," 58.

every rejection, and every tokenizing gesture is as real and as palpable as the taste of blood in your mouth when a 5'8" male punches you in the face in the street because you refused to give him your cell phone number. (Or, more accurately, because you dared to be Black, female, and free).

This Bridge Called My Back dabbed my tears and simmered my rage many times when I was a first-year PhD student at a PWI. I believe it will continue to do so for other minoritized folk. It brings me khomotso le mahlogonolo (comfort and blessings) and gives me permission to trust the theory that LIVES inside my flesh. I reread the essays and caution myself not to let them "adopt me as their cause" because I am foreign, not to "adapt to their expectations and their language" because they refuse to acknowledge and learn mine, and never to be "reduced to [a] purveyor of resource lists" because it helps them acquire tenure, while we empty their trash cans under the cover of night and fight for adjunct positions in the summertime.[5] Reading and repeating the Black feminists' affirmation that "Black women are inherently valuable" out loud empowers me to write and to articulate my vision for the future.[6]

The authors and artists of *This Bridge* pull out a chair and remind me that it is not that I lack imagination, rather it is language (their language) that fails me.[7] So, I imagine in my many tongues.

When I imagine a just and liberated feminist world:

Ke bona basetsana ba raloka kgathi le diketo ko strateng (I see young girls playing games in the street) well past the sun has set because nothing in the darkness sees them as prey

Ba bolela Sepedi le Xitsonga le Spitori (they speak Sepedi and Xitsonga and a language spoken in Pretoria)

Meriri ya ba bangwe o lohilwe ka wool, ba bangwe ka tlhale, and still others ba lohile ka matsogo (their hair is braided with wool, others with thread, and others are braided by hand)

5. Anzaldúa, *This Bridge Called My Back*, 166.
6. Combahee River Collective. "A Black Feminist Statement," 212.
7. Cherríe Moraga cited in Anzaldúa, "Speaking in Tongues," 164.

They play and learn in their own communities;

They do not leave their relations, their land, and the homes their foremothers built in search of thuto le bophelo (learning and life/safety/opportunity) mošwamawatle (across the waters) in the lands of men who slit their ancestors' throats and threw their emaciated bodies into the Deep

Instead

Their spaces and places of learning are constructed and decorated ka setsô (culture/tradition) by their own mothers and fathers and sisters and brothers

And they theorize in their own tongues

And when they grow old and sleep evades, they will join the sleepless woman in *Paradise*[8] for a walk in the moonlight.

As I lie on my couch, rereading the letter written to me by my dear sis Anzaldúa on 21 mayo 1980, ke tsepisa go lokola lentswe le le leng kamo gare ga ka (I promise to free the voice inside of me). I hope that as you read this, bokgaitsedi (sisters), le utlwa lerato le tebogo (you feel deep love and gratitude) from me, a Third World PhD student gasping for air at a PWI.

BIBLIOGRAPHY

Anzaldúa, Gloria. "La Prieta." In *This Bridge Called My Back: Writings by Radical Women of Color*, edited by Cherríe Moraga and Gloria Anzaldúa, 206. 4th ed. Albany: SUNY Press, 2015.

Anzaldúa, Gloria. "Speaking in Tongues: A Letter to Third World Women Writers." In *This Bridge Called My Back: Writings by Radical Women of Color*, edited by Cherríe Moraga and Gloria Anzaldúa, 164. 4th ed. Albany: SUNY Press, 2015.

8. This is a reference to Toni Morrison's book *Paradise* (New York: Alfred A. Knopf, 1998).

Combahee River Collective. "A Black Feminist Statement." In *This Bridge Called My Back: Writings by Radical Women of Color*, edited by Cherríe Moraga and Gloria Anzaldúa, 212. 4th ed. Albany: SUNY Press, 2015.

Moraga, Cherríe. "Catching Fire: Preface to the Fourth Edition." In *This Bridge Called My Back: Writings by Radical Women of Color*, edited by Cherríe Moraga and Gloria Anzaldúa, xxiii. 4th ed. Albany: SUNY Press, 2015.

Yamada, Mitsuye. "Invisibility Is an Unnatural Disaster: Reflections from an Asian American Woman." In *This Bridge Called My Back: Writings by Radical Women of Color*, edited by Cherríe Moraga and Gloria Anzaldúa, 35. 4th ed. Albany: SUNY Press, 2015.

Yamada, Mitsuye. "And When You Leave, Take Your Pictures with You: Racism in the Women's Movement." In *This Bridge Called My Back: Writings by Radical Women of Color*, edited by Cherríe Moraga and Gloria Anzaldúa, 58. 4th ed. Albany: SUNY Press, 2015.

POSTSCRIPT

Meditations and Musings

GLORIA J. WILSON, JONI B. ACUFF, AND
AMELIA M. KRAEHE

AMY gloria, at the onset of *A Love Letter to This Bridge Called My Back*, we used your term "aesthetic pronouncements" in the call for submissions we circulated. Contributors responded to the invitation in surprising ways.

GLORIA Ah, yes. What stands out to me is that we have a powerful collection of aesthetic and intergenerational pronouncements. Many of them gesture toward ancestral lineages and have done so through visually and poetically gestures. One such example is a submission by contributor Olivia Richardson, who is a printmaker. She created lovely work that includes a recipe for collard greens. Collard greens!! I hollered "YESSSS" when I saw that one, partly because I grew up in Alabama, and collard greens signal a very specific tradition of cooking in Deep South (USA) Black kitchens. Which reminds me, Olivia's work is in direct conversation with writer and culinary artist Khaliah D. Pitts's powerful poem, *we work / we sweat*. Gives me chills to make these connections. Khaliah's and Olivia's work reminds us that these traditions are often shared through mothers, sisters, aunts, grandmothers and so on. It represents the stories that might be found in an archive of gastronomic delights, with geographic specificity. It signals a

host of Black/Brown family traditions and ancestral memories that should be documented but are often overlooked.

JONI I think that's because internalized white supremacy, patriarchy, and even classism can make a person of color believe that something is wrong with them if they do things that feel natural to them, things that have carried over from ancestral memory. Watching the performance of whiteness can make a person of color question their very existence. So, when you find other people of color who do similar things as you, the things that you once questioned because of Whiteness, you find peace. You find affirmation. You may not know these people, but you *know* these people. So, for example, that collard greens recipe offered by Olivia Richardson, you *know* the granny who she refers to in the piece. That is *your* granny. Even more, *you* are that granny, yesterday, today, and tomorrow.

I think that's one of the most significant things that I felt like this series of contributors offered . . . connections. They describe feeling the same way I feel about this book. Regardless of where they are from, there are some connections amongst us that only women of color can have with one another. It just warmed me to read about and see myself in all of these "bodies of culture," in the words of Resmaa Menakem.

BRIDGE AS BODY

AMY There were a lot of contributors who interpreted the call for submissions in an artistic, poetic manner. It was interesting to see the range of ways people approached *This Bridge*, too. It stood out to me that it was not simply that they had read and understood what the work was about. They had a *relationship* with the original book. And then, and in some ways because of those relationships, I think we ended up with a wide range of styles of writing and topics that people wanted to talk about. There are writings that feel embodied in a way that transports me to another place and time. They offer an *experience*. There's a piece written by a contributor from Hawai'i, and while reading it I felt as though I were riding on that country road with the author as she raged and revealed injus-

tice. Though I didn't have any cultural connection with where she was writing from, I nonetheless was transported. I think much of the writing takes you somewhere, and in that sense, it is bridge-work. It taps into the body in a way that perhaps other texts don't or do not intend to. There were artworks, photographs, and visual renderings that were inspiring as well.

What if we think about this collection and the original book *This Bridge Called My Back* as part of a movement—and maybe not just part of a movement, but a movement unto itself. Most movements have imagery and their own iconography. Artwork is integral to movements because it helps convey messages and also inspires and compels in ways that traditional texts, lectures, and speeches might not be able to. I'm excited to see some of the work in the book possibly help move us and move the conversation to another level and maybe toward another generation of readers.

GLORIA And it would be interesting to think about what it means to be working toward a Third World feminist consciousness. What are the ways to articulate that? "Third World" signals something very specific. Some of the original authors in *This Bridge* were writing about that, but does that concept mean the same thing now, and what might be another articulation of that given the movement in time?

Some of the contributions to this collection are articulated in different languages, which may have seemed quite comfortable for the authors. Some readers may experience dissonance, though. They may be thinking, "Why isn't this in English?" It makes me happy that these authors have contributed to *A Love Letter* in their own languages. So maybe it is not legible or easy to understand for some people. There may be discomfort that comes with that, and that is okay.

BRIDGE AS LANGUAGE

AMY I think that's really important. Cherríe Moraga and Gloria Anzaldúa helped pioneer that way of communicating, writing, and theorizing, and in doing so, they insisted on a different kind of

imagination. Consciously or unconsciously, we write toward an audience, and they showed how to imagine our readers as more than a whitestream audience, those readers who are comfortable and well trained within white patriarchal institutions. There is a tendency to be assimilated even as we write, even as we give voice to our experiences. There is a constant need to resist assimilation because there's a whole apparatus of cultural production and publishing oriented toward U.S. white male hegemony, from the voices of leadership all the way to the critical audiences to which it caters. So writing in multiple languages is a form of liberation. It is an act of creative resistance. It is a way of being authentic to oneself and being whole.

Language is a thread of continuity between *This Bridge* and *A Love Letter to This Bridge*. As Joni was saying, language contains culturally rooted reference points. So different people can write in the same language and still not be participating in the same discourse. That is critical as a way to continually decenter so that we never get so comfortable that we occupy the center, even without knowing. In this collection, readers will encounter chapters that have unconventional formats that initially may be disorienting for some people and require a shift in expectations or shift in the amount of work that they are willing to do to engage with the creator of the work. I think that relational dynamic is an important part of personal and collective liberatory struggles for justice, dignity, and wholeness and is encapsulated through this collection.

BRIDGE AS ARCHIVE

GLORIA I think about this collection as a historical archive. Each chapter reflects, in some way, what is happening both in and outside of U.S. borders and each with its own aesthetic form. What's exciting is that what is being produced and offered through these forms each offer a distinct perspective, some of which point toward hegemonic forms of everyday violences and others which turn away from that. This archive represents full-throated theory in the flesh responses!

AMY A lot of the chapters we received in response to the call for *A Love Letter* get into the nuances of negotiating power from a very particular social location, geographic location, and cultural background. Although this is not a book that puts forward answers per se, in some cases, there are insights that can become tools that are translatable and adaptable to other contexts. There are gems to be found in each piece. I hope readers will find things that they can use in their lives and that they will come back to the collection again and again, as we have with *This Bridge*, to find new relationships and meaning within the book that will be generative, healing, and empowering at different times in different circumstances of their lives.

STATES OF PRECARIOUSNESS

JONI It's been forty years since the first edition of *This Bridge* was published. There are so many events that have impacted the lives of women of color in the U.S. Today, folks are using newer technologies like social media to share these stories. The voices of women of color are buttressed like never before. For example, both the "#SayHerName" and the "#MeToo" movements originated online, on social media, in an effort to magnify the voices, humanity, and lived experiences of women of color. These movements work to disrupt the violence and sustained dehumanization of women of color. Women of color, and specifically Black women, have struggled to hold and own space, safe space, in the world. There has been a perpetual struggle for Black women to have their humanity recognized in ways that help them thrive beyond the white imagination. I think that *A Love Letter*, working in tandem with these social movements, in the same historical context, places a spotlight on these very struggles and possibly strengthens their reach.

GLORIA Agreed, Joni. The editors of the original text made a point to contextualize the moments that they were living in. So, each edition serves as an archive of what was happening, locally, nationally, globally, twenty years ago, what was happening thirty years ago.

We think with those versions of the text and know that we continue to live in times when the health and well-being of women, and specifically women of color, and LQBTQ people is at particular risk and how certain forms of citizenship are being questioned.

In *A Love Letter*, our current events are archived. The coronavirus has ravaged communities up and down the country (North America) and has disproportionately impacted communities of color, exposing flaws in our health-care system. When it comes to access to health care, reproductive health-care services, and workplace support, women of color have been underserved and undersupported. These flaws have been compounded by failures we see elsewhere: the denial of climate change by global leaders, including the forty-fifth U.S. president and thirty-eighth Brazilian president; the dangerous rhetoric that encourages fear and anger as a means to incite racial, ethnic and religious divisions; panic about immigration and fear of losing a "dominant" culture to these racial, ethnic and religious minorities. Both of these presidents ran campaigns centered on the themes of law and order; these are central to fascist politics.

Recent U.S. protests have led to widespread exposure of state-sanctioned violence, which is not new to Black Americans. Amidst anti-Black violence of the state and amidst the protests in support of Black lives, I think with those whose work aligns with the intersections of racialized sexual and state violence, like Christina Sharpe and others like Jallicia Jolly, who recently highlighted, in *Ms.* magazine, about Black women being murdered, violated and maimed. This on-going state violence gave birth to the #SayHerName hashtag: on June 6, 2020, nineteen-year-old BLM organizer Oluwatoyin Salau was kidnapped one hour after tweeting about being sexually assaulted, and she was found dead on June 13; on March 13, 2020, twenty-six-year-old Breonna Taylor, an emergency medical technician, was shot and killed as she slept in her home in Louisville, Kentucky; on June 9 of 2021, twenty-five-year-old Riah Milton, a Black trans woman, was found murdered in Cincinnati; nine months before that, on October 12, 2019, Fort Worth police shot Atatiana Jefferson in her home as she played video games with her eight-year-old nephew, who witnessed the fatal shooting. Receiving even

less coverage is the epidemic of violence against Native American women and girls.

And, in thinking of this state of precariousness, it's difficult to think of what we're living through right now. We could not have imagined a year ago living through this pandemic and what that has meant for the lives of people and who it has affected disproportionately. What has been scary to think about is the fact that it's not just happening in the U.S., thinking hemispherically and through my mother's stories of what's happening in the Philippines and how this pandemic has emboldened state-sanctioned violence upon working-class peoples who attempt to organize and rally for government assistance. President Duterte gives "shoot to kill" orders amidst the pandemic: to shoot persons protesting during the pandemic and those who leave their homes during quarantine. This has mostly affected those struggling with basic needs and who protest lack of government support for these needs.

On the flip side, I am reminded that women of color, and particularly Black women, have been fighting and practicing radical acts of care for centuries, but when strategies to submerge these stories exist (much like the banning of Anzaldúa's *Borderlands/La Frontera* from being implemented in school curricula) girls and women are refused direct access to these texts. It's almost like we have to search for them. You know?

BEING MOVED AND BECOMING MOVEMENTS

AMY This first twenty years of the twenty-first century have grown in the intensity of anti-democratic forces across the globe. It's frightening, despair-inducing, and depressing. It is what the news media and social media feed us constantly. I feel more empowered when I look at who is pushing back. Who are the people leading the movements that push back against oppressive forces and insist on democratic processes and social arrangements? A commonality I see across many, if not most, of the resistance movements right now is that they are initiated by women of color. It is somewhat

remarkable. The atrocities are global and connected. For instance, leading in the struggle against far-right forces in Brazil are women. Here in the U.S. there has been a lot of media coverage of the yellow-shirted "wall of moms" in Portland supporting Black Lives Matter protests. The strategy of women walking together comes from women of color. India's Women's Wall in 2019 was made up of five million women. Imagine it—a sea of dark-skinned women forming a human chain. Of course, Black Lives Matter was started and is still led by Black women outraged by the relentless assault on Black life. This year has seen racial reckonings with anti-Blackness in movement spaces across the world. It has also meant revisioning histories. For instance, there is growing acknowledgment that Black and Latinx trans women led the Stonewall rebellion that sparked the gay rights movement in the U.S. And so, returning to Joni's point about technology, we can learn from and be inspired by the images we see in the news and social media. Third World feminist-conscious women of color are very often the ones on the front lines. Their creative forms of resistance are theories in the flesh. I think that should not be overlooked as though it were a small detail of history.

GLORIA Yes. These dialogues are timeless. Amy and I were talking the other day about how institutions take up what they consider to be on-trend topics such as race, but if you trace back far enough, women have always been rising up and pushing back in dissent. They really have. The governor of Arkansas has recently introduced legislation to defund *The 1619 Project*, in other words, to prohibit the use of federal funds to teach *The 1619 Project* in K–12 schools and districts. It reminds me of other attempts to ban certain knowledges from K–12 curricula. Living in Tuscon, Arizona, makes me think about prior gestures to ban Mexican American Studies from the Tucson Unified School District. I believe a judge ruled this as unconstitutional—thankfully—yet Gloria Anzaldúa's text, *Borderlands/La Frontera* still shows up on "banned books" lists. There's nothing inherently dangerous about that book, and its knowledge has been withheld from many who might find a sense of liberation in and through Anzaldúa's words. Again, I return to *theory in the flesh*. The banning of *Borderlands* works strategically

to delegitimize a certain type of lived experience. So, in this sense, I think about voices of women of color across time which have been submerged, buried and therefore disappeared from history. I question, How many other "unknown" women have practiced dissent in various forms and in refusal to imposed social and material conditions of their lives? We are living proof of the radical efforts those women! I mean, we wouldn't be able to exercise our own voices in material forms such a *A Love Letter* were it not for their resistance. If it weren't for their fight.

AMY And that fight often begins around the kitchen table before it's on the street or in the legislature.

CONTRIBUTORS

Joni Boyd Acuff is a Black, neurodiverse, cisgender female who was born and cared for in Starkville, Mississippi, USA. She is the daughter of Sharon and Maurice Boyd, sister of Freda, Trese and Reggie, wife of Jason Acuff, and the mother of three Black children, Jata, Jaysin, and Jaxin. Currently, Acuff teaches undergraduate and graduate students in the Arts Administration, Education, and Policy Department at The Ohio State University, Columbus, Ohio. Her work aims to identify and explicitly name the role that art and visual cultural play in mediating race, what it looks like, how it is performed, and how it is re-created to sustain contemporary power structures that are guided by the racial caste system in the United States. Acuff has authored a wealth of scholarship that lends pedagogical strategies to art educators who are seeking to place lenses like critical multiculturalism, critical race theory, Black feminist theory, and Afrofuturism at the crux of their teaching practices.

Tahereh Aghdasifar earned a BA in Middle Eastern Studies and an MA in Women's Studies from Georgia State University and her PhD in Cultural Studies from Emory University. She is an assistant professor of Women's Studies at California State University, Dominguez Hills and director of the Society for Radical Geography, Spatial Theory, and Everyday Life.

Sama Alshaibi's photographs and videos portray the social and gendered impacts of war and migration through her own body. Alshaibi's sculptural installations evoke the disappearance of the body and act as counter-memorials to war and displacement. Alshaibi's monograph, *Sand Rushes In*, was published by Aperture, NYC. Alshaibi was awarded the 2021 Guggenheim Fellowship in Photography, 2019 Artpace International Artist Residency, and 2017 Visual Arts Grant from the Arab Fund for Art and Culture (Beirut). Alshaibi has exhibited in 20 solo exhibitions and over 150 group exhibitions, including State of The Art 2020 (Crystal Bridges Museum of Art), Cairo International Biennale (Egypt, 2019), Ayyam Gallery (Dubai, 2019), Pen + Brush (NYC, 2019), Marta Herford Museum (Germany, 2017), and Herbert F. Johnson Museum of Art (NY, 2017). Born in Basra, Iraq, in 1973 to a Palestinian mother and Iraqi father, she now lives in Tucson, Arizona, where she is a professor of Photography, Video, and Imaging at the University of Arizona.

Gabriela Arredondo is department chair and associate professor of Latin American and Latina/o Studies at the University of California, Santa Cruz. She received her PhD in History from The University of Chicago. She is the author of *Mexican Chicago: Race, Identity and Nation* (Illinois, 2008), co-editor of *Chicana Feminisms: A Critical Reader* (Duke, 2003), and has published several articles, including "Cartographies of Americanisms: Possibilities for Transnational Identities, Chicago, 1916–1939," in *Geographies of Latinidad: Mapping Latina/o Studies Into the Twenty-First Century*; "Of Breasts and Baldness: My Life with Cancer," in *Speaking From the Body*; and "Lived Regionalities: Mujeridad in Chicago, 1920–1940," in *Mapping Memories and Migrations: Locating Boricua and Chicana Histories*. Dr. Arredondo is appointed a Distinguished Lecturer by the Organization of American Historians (2010–2023), was a fellow at Stanford University's Center for the Study of Race and Ethnicity (2007–2008), and received a UCSC Golden Apple Teaching Award (2010). Her research and teaching interests range from comparative Latina/o histories and Chicana Feminisms to migration histories and critical race formations in the Américas.

Michelle Bae-Dimitriadis is an art educator and artist, raised in South Korea, and she immigrated to Los Angeles, CA in the early 1990s. Refusing

cultural homogenization and social harmony by the autocratic, military government of South Korea, she has embarked on a new journey encountering a new terrain of social and cultural imperatives with racialized gender differences. She earned a PhD in Art Education at the University of Illinois, Urbana-Champaign and is currently an assistant professor of Art Education, Women, Gender, and Sexuality Studies, and Asian Studies at Pennsylvania State University. Her research interest revolves around refugee / immigrant youth art, media activism, community art practice, land-based art inquiry, and critical race feminist studies in art education. Her research has been published in peer-reviewed journal articles, book chapters, and books in the field of (art) education, women and gender studies, and cultural studies. She was a guest editor of the journal volume special issue on "Girls from Outer Space: Emerging Girl Subjectivities and Reterritorializing Girlhood" in the *Journal of Cultural Studies <–> Critical Methodologies*.

Born in Mexico City, **Laura Anderson Barbata** is a transdisciplinary artist currently based in Brooklyn and Mexico City. Since 1992 she has initiated long-term projects and collaborations in the Venezuelan Amazon, Trinidad and Tobago, Mexico, Norway, and the United States, which address issues of social justice and the environment. Her work often combines performance, procession, dance, music, textile arts, costuming, papermaking, zines, and protest. Recipient of Anonymous Was a Woman Award, and grants from FONCA Mexico. Her work is in various private and public collections, including the Metropolitan Museum of Art, New York; el Museo de Arte Moderno, México D.F.; and Thyssen-Bornemisza Art Contemporary.

Monica Anne Batac (she/they/siya/niya) was born in Tkaronto (Toronto, North York, Canada), a second-generation Filipinx in the Canadian diaspora. Her mother was born and raised in Tondo, Manila, her father in Masantol, Pampanga. Monica is a queer Filipina writer, teacher, community organizer, and PhD candidate at the McGill School of Social Work (Montreal, Quebec). In her interdisciplinary research and community practice, Batac focuses on improving local, provincial, and national community-based interventions for Filipinos across the life course. In 2018, she was awarded the prestigious Vanier Canada Graduate Scholar-

ship from the Social Sciences and Humanities Research Council of Canada. She leads various scholarly and community-building activities for Filipinx emerging and established scholars and social work practitioners at McGill, including the conference, PINAY POWER II (April 2019) that celebrated Filipina/x feminisms in the diaspora, and Filipino-Canadian Futures at Concordia University (September 2019).

Stephanie Cariaga is a mother, partner, daughter, sister, and more, who centers wholeness, healing, and intimacy in all of her work. She draws her cultural intuition from her Filipina lineage, including the ancestors, the water, and the land across the diaspora. She has served the wider Los Angeles community for over thirteen years as a high school and middle school literacy teacher, founding member of the People's Education Movement, and now an assistant professor in teacher education at California State University, Dominguez Hills. At the University of California, Los Angeles, Stephanie completed her award-winning dissertation titled "Pedagogies of Wholeness: Cultivating Critical Literacies with Students of Color in an Embodied English Classroom." She has also published in *The Urban Review* and *Rethinking Schools*. Drawing from radical feminist epistemology, her teaching and research examines the intersections between trauma and healing-informed pedagogies, critical literacy, and critical teacher sustainability. All of her work is inspired by her best teachers, daughter Laila and son Catalino.

Judith Flores Carmona is the daughter of Josefina and Vicente (RIP). She is a first-generation student and scholar. At New Mexico State University, Dr. Flores Carmona is an associate professor, faculty fellow for the Honors College and interim director of Chicano Programs. Her research interests include critical pedagogy, Chicana/Latina feminist theory, critical race feminism, social justice education, and testimonio methodology and pedagogy. Her work has appeared in *Equity and Excellence in Education*, the *Journal of Latino/Latin American Studies*, the *Journal of Latinos and Education*, and in *Chicana/Latina Studies: The Journal of Mujeres Activas en Letras y Cambio Social*. She has two co-edited books, *Chicana/Latina Testimonios as Pedagogical, Methodological, and Activist Approaches to Social Justice* (Routledge) with Dolores Delgado Bernal and Rebeca Burciaga and *Crafting Critical Stories: Toward Pedagogies*

and Methodologies of Collaboration, Inclusion & Voice (Peter Lang) with Kristen Luschen. She co-authored *Un-Standardizing Curriculum: Multicultural Teaching in the Standards-Based Classroom (2nd Edition)* with Christine Sleeter (Teachers College Press).

Charlene A. Carruthers is a Black, queer feminist community organizer and writer. As the founding national director of Black Youth Project 100, she has worked alongside hundreds of young Black activists dedicated to creating justice and freedom for all Black people. Charlene is the founder and executive director of the Chicago Center for Leadership and Transformation. Passionate about telling more complete stories about the Black Radical Tradition, Charlene provides critical analysis, political education, and leadership development training for activists across the globe and has served as a featured speaker at Wellesley College, Shaw University, Princeton University, Northwestern University, and her alma mater Illinois Wesleyan University. She is author of the best-selling book *Unapologetic: A Black, Queer and Feminist Mandate for Radical Movements*. Charlene was born and raised on the South Side of Chicago where she currently resides. In her free time, Charlene loves to cook and believes the best way to learn about people is through their food.

Johanna Castillo is a Dominican human being, a connector, and a love catalyst. She uses textiles, portals, research, and art as a means to heal; to unlearn; to (re) humanize; to decolonize; to (re) connect with her ancestral wisdom; to create fluid-intuition based frameworks, healthy circularities, and non-binary systems of thought, as an ever-evolving knot that reflects on her lived and desired experiences. She is the founder of Trepelito, a brand eco-system focused on human connections, radical love, and repair. Her work has been activated in spaces such as Centro Cultural Eduardo Léon Jimenes, Dominican Republic; Goodman Gallery, online; Central Park, New York; Union Square Park, New York; Espacio Morillo, Oaxaca; Garner Arts Center, Garnerville, New York; 313 Butler Gallery, Brooklyn; New York Academy of Art, New York; The Invisible Dog Art Center, Brooklyn; Theresa Lang Center, New York; Parsons School of Design, New York.

Vivian Fumiko Chin was born and raised in the San Francisco Bay Area, in the East Bay to be more precise. She is the granddaughter of a woman

who had bound feet and was married at sixteen and a woman who left Japan as a picture bride. Her mother was born in Alameda, California, and was interned at Heart Mountain, Wyoming. Her father landed in the United States from China as part of a military operation that was left incomplete because of the ending of World War II, or so the story goes. Vivian gave birth on the floor of a shack to her son who is now 6'2" and grown. After this planned home birth, a social worker named Becky visited and accused her of selling formula and diapers for drugs. Now she is living off-grid with unstable internet at the end of a dirt road.

Amber C. Coleman is originally from Columbus, Georgia. She received her Bachelor's degree in Art and French from Mercer University in 2014 and then her Master of Art Education from the University of Georgia in 2018. She is currently a PhD student and graduate assistant in Art and Visual Culture Education at the University of Arizona. From her work as an artist, educator, and researcher, she has realized the power in looking at her own experiences and the experiences of the groups to which she identifies, and she is motivated to make connections between Black feminism, art, and museum education. This work is important to her as it also impacts her field where Black women's voices are often underrepresented, misrepresented, or erased. Her work hopes to give voice and space to Black women and their experiences through art, as she believes that it is a natural conduit for expression.

Keya Crenshaw, a native of Columbus, Ohio, attended The Ohio State University where she received her BA in 2006 with honors and double majors in Women's Studies and Film Studies. Keya has previously held positions at The Ohio State University in the Office of International Affairs, at the Kirwan Institute for the Study of Race and Ethnicity, Americans for the Arts, the Brooklyn Arts Council, and the *Columbus Post* newspaper. Founder of Black Chick Media, LLC, Keya acts as a film festival consultant, digital media maven, and writer. As a creative entrepreneur and actor, Keya is a member of numerous organizations, including the League of Professional Theatre Women (New York City), the So and So Arts Club (London), and PAST Productions Columbus. As a Bayou, Creole, Catholic Black woman in Amerikkka, Keya understands firsthand the pain of a new love language, the power of ancestral recall, and the healing to be found in owning your truth.

Ashley Crooks-Allen is a PhD candidate in Sociology at the University of Georgia, where they focus on Black immigrant identity and social movements. Their dissertation is tentatively titled, "Mestizaje Undone: A Qualitative Social Media Analysis of Afro-Latinx Identity and Social Movements." This work will take a qualitative approach to understanding how Afro-Latinx people use social media to make identity claims in relation to the Black Lives Matter movement. Their master's research focused on Afro-Caribbean identity and experiences with the Black Lives Matter Movement in Georgia. They also completed a certificate in Women's and Gender Studies. They graduated from Emory University with a major in Creative writing and a minor in Sociology and were a Mellon Mays Undergraduate Fellow. They are from Irvington, New Jersey, and are of Afro–Costa Rican descent. In conjunction with academia, they also devote time to spoken word poetry and activism.

Karla Villanueva Danan (she/they/siya) is an interdisciplinary storyteller. Karla strives to tell the stories of her own experience as a second-generation settler of Philippine descent and to intentionally both create and hold space for others to do the same. Born and raised in Mohkínstsis (colonially known as Calgary, Alberta) and now living in Tkaronto (colonially known as Toronto, Ontario), she completed her undergraduate studies in International Relations and French at the University of Calgary. Karla has worked and volunteered with various not-for-profit agencies supporting feminist, women-focused social services; settlement and immigration; and community mental health. As an artist, Karla wrote, directed, and produced her first short film, *Jezebel*, in 2018 as a love letter to her mother and the complexity of growing up as Pinay in the diaspora.

Sarah De Los Santos Upton (PhD, University of New Mexico) is an assistant professor in the Department of Communication at the University of Texas at El Paso. Her research and teaching explore nepantla identity, borderland pedagogy, and reproductive justice. She is the co-author of *Challenging Reproductive Control and Gendered Violence in the Américas: Intersectionality, Power, and Struggles for Rights*, winner of the NCA Feminist and Women's Studies Division's 2018 Bonnie Ritter Book Award. She is also the co-editor of *Latino/a Communication Studies: Theories, Methods, and Practice*. Her research is published in the journals *Departures in Critical Qualitative Research*, *Women's Studies in*

Communication, Development in Practice, Action Research, and *Frontiers in Communication,* as well as various edited volumes.

Gia Del Pino moved to Tucson, Arizona, in August 2019 to continue her passion of working for immigrant rights and justice along the U.S.-Mexico border. Prior to the move, she was the co-founder and lead organizer of a grassroots, immigrant-led organization called Madres Sin Fronteras in Gainesville, Florida. Madres Sin Fronteras was created in 2017 in response to the new U.S. government administration's hard-line anti-immigrant platform. Together they worked tirelessly to create a set of strategic plans to ensure justice and protections for affected communities and vulnerable families. Gia is the proud daughter of immigrants who grew up in a predominantly immigrant community in Miami, Florida. She has an MFA in Art and Technology from the University of Florida and is currently pursuing her PhD in Art and Visual Culture Education at the University of Arizona.

Tanya Diaz-Kozlowski uses she/ella pronouns and is an assistant professor in women's studies at Clark College. She has taught and developed courses on Chicana Feminisms; Latinx Popular Culture; Introduction to Latina/o Studies; Introduction to Women's, Gender, and Sexuality Studies; Queer and Transgender Theory; Gender, Sex, and Power; and Whiteness in a Multicultural Society. She is a teacher, scholar, and writer who is grounded in her use of testimonio pedagogy and U.S. women of color feminisms and is committed to culturally relevant teaching. She earned her doctorate in Education Policy, Organization and Leadership with minors in Latina/o Studies and Gender and Women's Studies from the University of Illinois at Urbana-Champaign in 2015. Dr. Diaz-Kozlowski enjoys riding her motorcycle, spoiling her dog Francisco, and hiking and is an Aries sun, Aquarius moon, Capricorn rising.

Lan Duong is a first-generation Vietnamese American refugee, writer, and scholar. She has come to feminist language through her poetry and scholarship. Currently she is an associate professor in Cinema and Media Studies at the University of Southern California. She is the author of *Treacherous Subjects: Gender, Culture, and Trans-Vietnamese Feminism* (Temple University Press, 2012). Her second book project, *Transnational*

Vietnamese Cinemas and the Archives of Memory, examines Vietnamese cinema from its inception to the present day. She has co-edited the anthology *Southeast Asian Women in the Diaspora: Troubling Borders in Literature and Art* (University of Washington Press, 2013). Her poetry has appeared in *Watermark: Vietnamese American Poetry and Prose* (Asian American Writers Workshop, 1998), *Bold Words: Asian American Writing to Span the Centuries* (Rutgers University, 2001), and *Tilting the Continent: Southeast Asian American Writing* (New Rivers Press, 2000).

Brittney Michelle Edmonds is an Assistant Professor of Afro-American Studies at the University of Wisconsin, Madison. She is a scholar of twentieth- and twenty-first-century African American literature and culture, specializing in the study of Black critical humor after 1975. Her writing has appeared or is forthcoming in *MELUS: Multi-Ethnic Literature of the United States, South: A Scholarly Journal, The Journal of Feminist Scholarship, The Encyclopedia of African-American Culture,* and *Auburn Avenue.* With historian Jennifer D. Jones, she co-founded the Black Queer Sexuality Studies Collective at Princeton University.

Dionne Custer Edwards is a writer, arts educator, and the director of Learning and Public Practice at the Wexner Center for the Arts, where she manages an expansive portfolio of public programming including Pages, a yearlong collaborative writing program she created that pairs artists with educators to facilitate arts integration and arts experiences for high school students. Pages also publishes an annual anthology of student writing and art created during the program. As a writer, Dionne's work has appeared in *Alternating Current Press, 3Elements Review, Columbus Alive, Flock, Gordon Square Review, Grist, Storm Cellar, The Seventh Wave, Tahoma Literary Review, Entropy Magazine,* and others. She was named a finalist for the 2019 Tupelo Press Berkshire Prize and recently received a Community Arts Partnership Award from the Greater Columbus Arts Council. She has graduate and undergraduate degrees from Antioch University and the Ohio State University. Find her online at lifeandwrite.com.

Saba Fatima is an Associate Professor of Philosophy at Southern Illinois University Edwardsville and the host of *She Speaks: Academic Musli-*

mahs, a podcast that interviews Muslim women in academia. She writes about social and political issues faced by Muslim Americans in journals such as *Social Theory and Practice, Hypatia, Journal of Muslim Minority Affairs,* and *Social Philosophy Today.* Her research interests include virtue ethics; non-ideal theory; social and political within prescriptive Islam; Muslim/Muslim-American issues within a framework of feminist & race theory; and medical humanities. You can learn more about her at sites.google.com/view/sabafatimaphd.

Liliana Conlisk Gallegos (aka Machete) is a first-generation Xicana, transfronteriza de la region entre Tijuana y San Ysidro, perpetual border crosser, and native foreigner par excellence. This experience living on the border inspires her specialization in the decolonization of current academic perceptions of knowledge. Anti-colonialista, indigenista, co-conspiradora con mis hermana/o/xs indocumentados y LGBTQ. Sin miedo a decir la verdad because many sacrifice so much for that to even be possible. Uses humor as power source. She is an Optimus Prime Trauma Transformer; experimenter with art, virtual reality, multimedia; performer of research; translator of and filter for supremacist formats in order to curate interactive research performances for community healing. One of such performances is The Art of Dreaming which showcases live data in the form of art made by students and community members around the topic of being undocumented and the complex interplay between forms of trauma, resistance, and survival.

Dr. Nisha Ghatak is a tutor in the School of Cultures, Languages & Linguistics at the University of Auckland, New Zealand. As a recent doctoral graduate, she is passionate about women's autobiographic writing from non-Western paradigms and is currently working on a research project on Indigenous women's writing from New Zealand.

Raquel Hernandez Guerrero is a Xicana womanist and embraces a journey of re-Indigenization/regeneration. Inspired by liberation theology, she views the role of spirit in struggle as crucial in dismantling structures of oppression. She holds a Bachelors in Anthropology and Masters in Humanities, both from the University of Colorado at Denver where she focused her studies on *danza Azteca* and Mexica cosmovision. As

a practicing *danzante,* she continues to discover sacred movement and sacred space-making in the world around her. As a mother, she came to possess a spiritually embodied understanding of the ritual of becoming a life-giver and of continuing the ceremony of mothering. She is currently a full-time PhD student in the Comparative Ethnic Studies Program at the University of Colorado at Boulder studying decolonial theory. For her upcoming dissertation, she plans to uncover Xicanx understandings of the maternal divine in decolonizing mothering and engendering healing from intergenerational trauma for Xicana mothers.

Chela E. Hernandez was born and raised in Los Angeles, California, the third of four children. Growing up, her mother, Gloria Elena, made sure that she was aware that El Salvador is the motherland. She also made sure that her daughter Chela realized the strength in her voice and opinion regardless of what others thought of her. Hernandez attended University of California, Riverside where she got a Bachelor of Arts in History and Women and Studies and San Francisco State University with a Master of Arts in Women and Gender Studies. She does her very best to be involved in her community by participating in numerous Central American organizations that help serve the interest of the people. She currently writes in her spare time as a way to heal and to remind herself of her power.

Leandra Hinojosa Hernández (PhD, Texas A&M University) is assistant professor in the Department of Communication at Utah Valley University. She is a co-author of *Challenging Reproductive Control and Gendered Violence in the Américas* (Lexington, 2019) and co-editor of the following books: *This Bridge We Call Communication: Anzaldúan Approaches to Theory, Method, and Praxis* (Lexington, 2019); *Military Spouses with Graduate Degrees: Interdisciplinary Approaches to Thriving amidst Uncertainty* (Lexington, 2019); and *Latina/o/x Communication Studies: Theories, Methods, and Practice* (Lexington, 2019). Leandra has published peer-reviewed scholarly journal articles in outlets such as *Women's Studies in Communication, Communication Research, Frontiers in Communication, Journal of Media and Religion,* and *Health Communication.*

Kendra Johnson is a self-proclaimed big-bodied feminist and champion for urban schools and education. Kendra's background in elementary

education, school reform, and teacher development informs her work as an educator, researcher, and learner. Her research focus is expansive and includes interrogating the intersections of fatphobia and the strong Black woman schema in teacher preparation; and using theater-based practices in teacher education to support pre-service teachers' development of critical consciousness. Kendra earned her BA in Journalism and Communications from Hampton University. She also has her MEd in Educational Studies from Johns Hopkins University. Kendra is currently working on her PhD in Curriculum, Culture, and Change at Virginia Commonwealth University.

elizabeth jones // emj is a Creole, Jamaican painter, writer, farmer, and beetle queen, born in 1995 and raised in the Bay Area on Muwekma Ohlone lands. Their interest lies in building connectedness through food, farming, dance, song, and visual arts. Through their experiences healing from and living with chronic illnesses, they have learned that quality, nutritious food can be effectively used as preventative and restorative medicine. They believe it is important not only to create broader access to nutritious food but to have systems in place for sharing knowledge of how to grow, prepare, and use food. Elizabeth also values art as a vehicle for healing. Art is a tool for telling the stories of our past, observing our patterns in the present, and imagining a future where we are thriving.

Ami Kantawala serves as an adjunct associate professor in the Art and Art Education Program at Teachers College, Columbia University in New York and teaches in Boston University's online Master of Art Education program. She completed her BFA in Painting and Metal Craft at Sir J. J. School of Applied Art in Bombay, India, and went on to complete her EdM and EdD in Art Education at Teachers College. Her scholarly interests are grounded in critical historical research and broad-ranging methodologies. Content and methods investigated include revisionist histories of art education, women's histories, biographical research in art education, postcolonial studies, international histories, counternarratives, and traditional and emerging research methods. She further focuses on the role of using theory in history, cultural studies, mentoring, and leadership in art education. She currently is senior editor of the jour-

nal *Art Education*, published by the National Art Education Association. She identifies as a South Asian immigrant woman of color.

Amelia M. Kraehe is a socially engaged scholar, educator, sister, mother, and sometimes-artist. A Black child in a biracial family, Amy grew up in and around Atlanta, Georgia (USA) during the era of school desegregation and the ensuing flight of white residents to the outer suburbs. She learned early and often that race, sex, gender, class, and spatial proximity to power mattered deeply in terms of the access one had to quality education and health care, the distribution of public resources, and the shaping of a person's social imagination. She examines these entanglements of power, knowledge, and subjectivity through research, writing, curriculum development, and curating and making things. She is co-founder and co-director of the Racial Justice Studio and currently is an associate professor of Art and Visual Culture Education and an affiliate faculty in Human Rights Practice at the University of Arizona. She earned her PhD and MA from the University of Texas at Austin after receiving her BA from Wellesley College.

Pamela Harris Lawton is an able-bodied, cisgender, heterosexual Black woman of mixed racial heritage. She is an educator and a printmaker and mixed-media artist, who hails from a long line of artists, musicians, dancers, educators, writers, and actors. Her experiences growing up in Washington DC during the '60s and '70s in a predominantly Black or "Chocolate" city and attending a predominantly White university impacted her approach to both art making and teaching, which is social justice focused and inclusive. In her art, she combines both images and words to tell a story. Her work is printed under the logo, Pamela's Press, and is a visual narrative of the people, traditions, and sociopolitical events that influence her life. She holds a doctor of education in the College Teaching of Art, Teachers College, Columbia University; an MFA in Printmaking, Howard University; and a BA in Studio Art and Sociology, University of Virginia.

Mel Michelle Lewis (she/her/they/them) is a Black, queer feminist practitioner situated at the nexus of transdisciplinary queer critical race studies and pedagogies of social justice praxis. Originally from Bayou

La Batre, Alabama, Dr. Mel completed their MA and PhD in Women's Studies at the University of Maryland (2012). They hold an MS in Women and Gender Studies from Towson University (2005). Dr. Mel is a newly appointed Gender/Sexuality faculty in Humanistic Studies at Maryland Institute College of Art. They have held previous possions at Goucher College and Saint Mary's College of California. Recent publications include, "The Saviors of Gullah Identity: Teaching Daughters of the Dust and the 'Classics' of Black Women Writers" (*Feminist Formations*, in press); "Transcending the Acronym, Traversing Gender: A Conversation in the Margins of the Margins" (*Women and Language*, 2019); and their forthcoming book project, *Femme Query: Politics, Pleasure, and Queer of Color Pedagogies*, engaging queer social justice practitioners who articulate the power and possibility of femme liberatory praxis.

Vanessa López is an able-bodied, cisgender, queer Woman of Color. Vanessa is the granddaughter of Tulia Vasquez López, the daughter of Rosa Digna López, big little sister to Ramon Reynoldo Vargas and proud mother of Aszana LilaRosa López-Bell. She was born and bred on the streets of New York City back when White folks didn't go past 59th Street. Vanessa has papers from SUNY Purchase and the Maryland Institute College of Art. She contemplates and writes about race, urban education, the body, and art. She makes things that die.

Kaia Angelica Lyons is a playwright and memoirist based in Murfreesboro, Tennessee, who holds a BA in Drama from Washington University in St. Louis. Her nonfiction has been published in two different issues of *Stirring: A Literary Collection*. Her theater work has recently been seen as part of the PlayGround Experiment's Faces of America Monologue Festival and at Washington University in St. Louis. Her play *Like Hyacinth Flowers* has been developed with The Black Box Project NYC and at the Sewanee Writers' Conference in 2019, where she was a Tennessee Williams Scholar in Playwriting. As a queer Black woman, Lyons makes a point of expressing her identity in her writing and representing bodies like her on stage, because she believes that the identities we hold are inherently tied to the art and the academic work we create.

Sonia BasSheva Mañjon is the executive director of LeaderSpring Center, a California-based leadership development organization. Dr. Mañjon has completed numerous projects in areas of cultural anthropology research, dance, and film, as art informs her positionality and gives her the platform to create a world void of the -isms that haunt our existence. Several of her projects include *Invisible Identity: Mujeres Dominicanas en California*, *Crafting a Vision for Art, Equity and Civic Engagement: Convening the Community Arts Field in Higher Education*, and *A Snap Shot: Landmarking Community Cultural Arts Organizations Nationally.* Dr. Mañjon also directed and produced two video documentaries. She earned a PhD in Humanities, specializing in transformative learning and change in human systems and an MA in Cultural Anthropology and Social Transformation from the California Institute of Integral Studies, San Francisco. She received a BA in World Arts and Cultures with an emphasis in Dance from the University of California, Los Angeles. Dr. Mañjon lives in the San Francisco Bay Area with her sons Zyan and Ezra.

Shantel Martinez received her PhD from the Institute of Communications Research at the University of Illinois, Urbana-Champaign. Dr. Martinez's research explores practices of "homemaking" in systems of education, the surveillance of bodies of color / bodies of knowledge, and mentorship relationships within academic spaces for womxn of color through the methodology of testimonio. Currently, she oversees the Otter Cross Cultural Center at California State University, Monterey Bay and is affiliate faculty in the School of Humanities and Communication.

Jacquelyn C. A. Meshelemiah is the associate vice provost for Diversity and Inclusion at The Ohio State University. She is the author and co-author of numerous publications, presentations, and trainings on human rights and anti-trafficking work. She is a former BSSW and MSW Program Director; President and Provost's Council on Women (PPCW) chair/past chair/member; Office of Academic Affairs (OAA) faculty fellow; and Office of Diversity and Inclusion faculty fellow / Director of Leadership Initiatives for Women of Color. Her scholarship on anti-trafficking, human rights, and social justice has always been unapologetically bold, inclusive, and compassionate. As a social scientist, she

chooses to center her work on marginalized populations due to their invisibility and vulnerability. Speaking "truths" of women of color varies depending on the writer, but she has personally spent time with Black women who are sex trafficked and can attest to the fact that their truths are not included in the discourse on sex-trafficked women in the same way as their White counterparts.

Portia Newman is a Black woman scholar and lifelong learner who believes in the power of education for our kids. Portia's background in child development and education policy informs her service as a former teacher, organizational leader, and now, researcher. Her research explores the systems of power that impact leadership development and learning spaces, specifically for Black women. Portia believes in the possibility of our young people and acts on that by serving adults who aspire to best serve future generations. She earned her BA in Education from the University of North Carolina at Chapel Hill and then went on to receive her MEd in Instructional Leadership and Education Policy from the University of Illinois at Chicago. Currently, she is working on her PhD in Education Leadership, Policy and Justice at Virginia Commonwealth University.

Adriane Pereira is a faculty member in the master of art in teaching program at the Maryland Institute College of Art. She was born in sunny Miami, Florida. She earned her PhD in Art Education from Florida State University and taught high school art for nine years with Miami-Dade County Public Schools. She's a proud wife, daughter, and sister. Publications include "Baltimore Uprising: Empowering Pedagogy for Change"; "Becoming a Woman of Color"; and "Critical Thinking: Art Criticism as a Tool for Analysing and Evaluating Art, Instructional Practice, and Social Justice Issues."

Born and raised in Philadelphia, **Khaliah D. Pitts** is a writer, culinary griot, and curator. She considers herself a cultural memory worker, documenting stories of the African diaspora. Although her primary medium is writing, she explores storytelling through short films, curating events and spaces honoring cultural legacies, and, most often, cooking, eating, and sharing food. In 2016 Khaliah D. Pitts and her sister-friend, Shivon

Pearl Love, founded Our Mothers' Kitchens, a culinary and literature project for Black folk. Continuing traditions from the African diaspora, where art and life are one, Our Mothers' Kitchens takes vital steps towards building optimal health, self-awareness and cultural connection through the ritual and art of cooking and storytelling. A lifelong creative, Khaliah dedicates her work to preserving culture and documenting stories of the African diaspora, crafting spaces of liberation and joy. Learn more at www.khaliahdpitts.com.

Fabiane Ramos is an early career researcher and sessional academic in Gender Studies, Educational Studies, and Applied Linguistics at The University of Queensland, Australia. Her work is interdisciplinary, specialising in feminist and decolonial theories/methodologies. One of her most recent publications is an essay included in *El Mundo Zurdo 6: Selected Works from the 2016 Meeting of the Society for the Study of Gloria Anzaldúa*, where she focuses on the forced-migration experiences of students from refugee backgrounds in Australia framed through Anzaldúa's writings and theories. Fabiane is fascinated by jacarandas. These trees with beautiful flowers are the symbol of springtime in her adopted city, Meanjin (Brisbane). Jacarandas originate from Abya Yala, her homeland. Jacaranda trees give her a sense of belonging. She connects with this tree that traveled across the sea, searching for a place to call home.

Olivia Richardson is an interdisciplinary artist with a primary focus in printmaking, though her medium changes with the intention of each piece she creates. Richardson was born and raised in Northern Virginia, which exposed her to multiple art institutions between Washington, DC, and Richmond, Virginia. In 2019 Richardson earned her bachelor of fine arts in Printmaking with a minor in Art History from West Virginia University, summa cum laude. Richardson is currently studying at the University of Arizona where she is pursuing a master of fine arts in Printmaking and is interested in Museum Studies. Her work has been published in the online magazine *Synesthesia* and exhibited nationally and internationally in Utah, Pennsylvania, West Virginia, and the Czech Republic. Richardson's work is sociopolitical in nature, inspired by her experiences as a Black woman. She uses it to dissect the intersections of her own identity as well as to amplify the voices of individuals more

marginalized than she is. You can learn more about Olivia Richardson's work at oliviarichardsonart.com.

Sana Rizvi is a senior lecturer in Education and Early Childhood Studies at the Liverpool John Moores University, England. She teaches and researches issues on social inequalities faced by minoritized communities in the UK. In addition to her other publications, she has recently published her book with Palgrave, titled *Undoing Whiteness in Disability Studies: The Special Education System and British South Asian Mothers.* She has presented at national and international conferences such as the British Educational Research Association, the European Educational Research Association, and International Congress of Qualitative Inquiry.

Nozomi (Nakaganeku) Saito is an immigrant, feminist, writer, educator, and activist. She was born in Japan and at the age of five, emigrated to Colorado, USA, with her mother. Most of her family remains in Japan, specifically Okinawa. As an immigrant, she has always felt that that cultural belonging is like having a foot planted in each place and being caught in a whirlwind dance of loss and joy, longing and distancing, and finding her place with sisters of color. She is fascinated by stories of migration, women writers, and the radical coalitions and possibilities that arise from the friendships between women of color. She has had work published in The *Vassar Review*, book reviews in the blog for *Asymptote*, and an article in *Word and Text: A Journal of Literary Studies and Linguistics.* She is currently pursuing a PhD in Cultural Studies at the University of Pittsburgh, where she researches Afro-Asian connections, women of color feminisms, migration, displacement narratives, and memory.

Rae Scott is an African American poet, actress, activist, and accountant. She began performing in Columbus, Ohio's growing slam poetry scene in 2008, and she earned a spot in the National Women of the World Poetry Slam, representing Columbus, in 2011. Rae was first published in *Harness Magazine* in 2018. In 2019 Rae completed a writing residency contributing to *Write on Fire!!*, a dedication to the Harlem Renaissance publication *Fire!!* Rae also incorporated her poetry into workshops to aid young girls and teenagers with finding and utilizing their voice. A few of her favorite roles as an actress include Aminah Robinson in *A Place to*

Remember and Tituba in *The Crucible*. As an activist, Rae has contributed her knowledge of accounting to help build and sustain ROOTT, a Columbus-based organization that fights for reproductive justice for families and women of color. Rae Scott currently resides in Columbus, Ohio, with her husband and their six children.

Manisha Sharma is associate professor and chair of the Division of Art and Visual Culture Education at the University of Arizona's School of Art. She examines how perceptions of culture and community are formed, internalized, and acted out through the production and consumption of art and visual culture artifacts. Before her career in higher education, Manisha taught art and design at K–12 schools in the United States, India, Japan, and Mexico. Her research foci include social justice art education, borderland pedagogies, and South Asian contemporary art and visual culture. She has published and presented her research in peer reviewed journals, books, and at conferences on art and visual culture education. She co-edited *Makers, Crafters, Educators: Working for Cultural Change* (2018) with Elizabeth Garber and Lisa Hochtritt. In all her work, she is dedicated to encouraging feeling at home with in-betweenness and wielding this as a force for kindness and justice.

Tyiesha Radford Shorts is a Columbus, Ohio, native and literary arts enthusiast who enjoys writing poetry and essays. A lover of history, Tyiesha also conducts community learning groups where non-traditional students (both young and young at heart) are able to engage in critical analysis of history and current events. Tyiesha currently supports protected classes in higher education. She lives in Columbus's Bronzeville neighborhood with her husband, Marshall, and their dog, Bud.

Aram Han Sifuentes is a visual artist who works to center immigrant communities. Her work often revolves around skill sharing, specifically sewing techniques, to create multiethnic and intergenerational sewing circles, which become a place for empowerment, subversion, and protest. Solo exhibitions of her work have been exhibited at the Skirball Cultural Center (Los Angeles), Jane Addams Hull-House Museum (Chicago), Hyde Park Art Center (Chicago), Chicago Cultural Center (Chicago), Asian Arts Initiative (Philadelphia), and Pulitzer Arts Foun-

dation (St. Louis). She has been the recipient of the Smithsonian Artist Research Fellowship, Map Fund Grant, 3Arts Award and 3Arts Next Level Award. Her project *Protest Banner Lending Library* was a finalist for the Beazley Design Awards at the Design Museum (London) in 2016. She earned her BA in Art and Latin American Studies from the University of California, Berkeley, and her MFA from the School of the Art Institute of Chicago.

Sister Scholars was born in 2003, bringing together six women of color and one white woman in the field of language and literacy education. They are **Gertrude Tinker Sachs, Rachel Grant, Ryuko Kubota, Angel Lin, Suhanthie Motha, Shelley Wong, and Stephanie Vandrick**. Their relationship with each other—integrating sisterhood, mutual support, allyship, intellectual collaboration, and love—has led them to shared understandings and knowledge. They have listened to each other's stories, recognized their connectedness through the similarities, and presented their insight, resilience, and resistance with broader audiences through academic publications and conference presentations. They are an international group, and although geographically they have been miles and usually even continents apart, they sustain their relationship through emails, text messages, telephone, regular virtual chats, and meetings at conferences and in their homes to support each other and to explore how they can transform their institutions and wider society toward greater equity and justice.

France Clare Stohner is a Philippine-born, Montreal-raised diasporic community worker and psychotherapist. Committed to decolonization, she completed a master of arts degree in Counselling and Spirituality, specializing in Women's Studies at a collaborative program between Saint Paul University and the University of Ottawa. Her undergraduate years were spent at the Simone de Beauvoir Institute of Concordia University, where her education was built on anti-oppressive frameworks and commitments to the well-being of disenfranchised populations of the community. Feminist values profoundly speak to France, and she has a background in grassroots and community organizing work from a social justice and critical race feminist perspective. She previously worked for NGOs in urban development for women's safety in cities and

then focused her efforts on advocacy for the Filipino community. From 2011 to 2016, she was a radio host and content creator for the Sigaw Ng Bayan radio collective at McGill University's CKUT 90.3 FM.

Gertrude Swan is a woman of color who earned a bachelor of arts in Psychology and a master of education in Counseling and Development from George Mason University. After graduation she has invested more time in her first passion—reading and writing. She currently works as a higher education professional at a public state institution. Swan considers herself what Emilie Wapnick defines as a "multipotentialite," otherwise known as a Renaissance soul—a person with many interests and passions. Through her profession, community involvement, and writing, she advocates for multicultural awareness, intersectional equity and justice, educational success, leadership potential, and career development of ethnic minorities, first generation, low-income, and at-risk youth.

Kholofelo Theledi was born and raised in South Africa. She acquired her associate's degree in Swaziland and her bachelor's and master's degrees in the United States. She is currently enrolled as a rhetoric PhD student in the Department of Communication Studies at Louisiana State University. She employs various theories and methodologies, including Black and African feminist theories, as well as postcolonial and decolonial approaches, to study social movements and belonging. She is also interested in the ways in which structural and interpersonal oppression are discursively constituted and resisted in postapartheid South Africa in the context of capitalism, gendered violence, and white Western imperialism. She identifies as an African/Black woman.

Lisa Whittington, EdD, is an artist living in Atlanta. She graduated with a doctoral degree in Art Education from the University of Georgia in 2014. Lisa not only creates art but loves teaching art as well. She has trained artists from kindergarten to twelfth grade in Atlanta for over twenty-five years. Lisa created an Emmett Till painting in 2017 and was asked to participate in a news interview with NBC news that defused an art protest at the Whitney museum and created an international discussion about white people who have co-opted Black pain and used it as subject matter. This artwork caused audiences to compare the Emmett Till

paintings and discuss how differently a Black person and a white person handled the subject. During the United States presidential elections in 2020, Lisa created art for the NAACP Legal Defense Fund that depicted images of Breonna Taylor and Terence Crutcher in campaign posters that encouraged people to vote on their behalf.

gloria j. wilson is an Afro-Asian Black-Filipina air force military brat. She is the daughter of Henry Joseph Wilson (from Mobile, Alabama) and Gloria Rosario Wilson (from Cebu City, Philippines), sister to Mary Ellen Rosario Wilson Thomas, and "auntie jan" to Miles Thomas and Adyson and Lauryn Berry. gloria was born in Grand Forks, North Dakota, and grew up across various regions inside and outside of North America as part of a fishing family. She savors her dad's gumbo and mom's lumpia and pancit. A graduate of the University of South Alabama and University of Georgia, she spent thirteen years teaching middle and high school visual art in Mobile, Alabama, and Eastville, Virginia, before transitioning into teaching in higher education. At the University of Arizona, she is co-director and co-founder of the Racial Justice Studio, assistant professor in the School of Art, and an affiliate faculty in Africana Studies. She is a pop culture fan and critic, a maker of things, and forever rebellious.

Tamilla Woodard is the co-artistic director of Working Theater, former BOLD associate artistic director at WP Theater, and the co-founder of PopUP Theatrics. She also served as the associate director of *Hadestown* on Broadway. This season her work includes the Lucille Lortel nominated *Where We Stand* by Donnetta Lavinia Grays for WP Theater and Baltimore Center Stage, Caryl Churchill's *Top Girls* at American Conservatory Theater, and director and co-conceiver of *Warriors Don't Cry*, a co-production of The Bushnell Center for the Performing Arts and TheaterWorksUSA. Recently named one of 50 Women to Watch on Broadway, Tamilla is a graduate of Yale School of Drama, where she currently teaches, and she is a recipient of the Josephine Abady Award from the League of Professional Theatre Women.

Bianca Tonantzin Zamora is a coordinator for the Cross Cultural Center at California State University, Monterey Bay, where she works with identity-based student organizations, develops educational trainings, and coordinates cultural-based graduations. She utilizes intersectional

and arts-based approaches to explore issues of power, decoloniality, identities, and coalition building. She received her Master of Science in Student Affairs with a concentration in Diversity and Equity from Miami University and a Bachelor of Arts degree in Women's and Gender Studies (with distinction) with a concentration in Theatre and a Queer Studies minor from Sonoma State University. As a queer high femme Latina feminista, she claims the power and assets of being, bi, brown, and brilliant in the borderlands.

Susy Zepeda is a working-class, detribalized, queer Xicana Indígena assistant professor in the Department of Chicana/x Studies at the University of California, Davis. Susy's work is interdisciplinary, decolonial, and feminist in a community-centered and grounded way. Her research and teaching focus on critical race and ethnic studies, decolonizing spirit work, women of color feminist methodologies, queer of color communities, oral and visual storytelling, and intergenerational healing. Susy is part of the Santa Cruz Feminist of Color Collective, who published the collaborative article "Building on the Edge of Each Other's Battles: A Feminist of Color Multidimensional Lens" in the journal *Hypatia*. In 2014, Zepeda published "Queer Xicana Indígena Cultural Production: Remembering through Oral and Visual Storytelling" in *Decolonization: Indigeneity, Education & Society*. Susy co-curated the art exhibition *Xicanx Futurity*, and her first book manuscript *Queering Mesoamerican Diasporas: Remembering Xicana Indígena Ancestries* will be released in Summer 2022.